IAN TILTON & CLAIRE CALDWELL

SET IN STONE
IAN TILTON'S STONE ROSES
PHOTOGRAPHS

VISION ON

OMNIBUS PRESS

London / New York / Paris / Sydney / Copenhagen / Berlin / Madrid / Tokyo

Designed by Michael Bell Design.
Pictures edited by Jacqui Black (picture editor),
Ian Tilton and Michael Bell, with Claire Caldwell.

ISBN 978.1.780.38539.6
Order No. VO10549

Exclusive Distributors:

MUSIC SALES LIMITED
14/15 Berners Street, London, W1T 3LJ
United Kingdom.

MUSIC SALES CORPORATION
180 Madison Avenue, 24th Floor
New York, NY 10010
United States of America.

MACMILLAN DISTRIBUTION SERVICES
56 Parkwest Drive, Derrimut, Vic 3030
Australia.

Every effort has been made to trace the copyright
holders of the photographs in this book but one
or two were unreachable. We would be grateful if the
photographers concerned would contact us.

Printed in China.

A catalogue record for this book is available from
the British Library.

Visit Omnibus Press on the web at
www.omnibuspress.com

ACKNOWLEDGMENTS
IAN TILTON

This book is dedicated to the ones I love
Joey 'Boom' Tilton and Lottie Tilton.

I would like to express my gratitude to all those
who have helped make this book possible. I'm also
grateful to the people who have given me some
'good breaks', and who supported and encouraged
me to become the best rock 'n' roll photographer
I can be.

Claire Caldwell my ♥ for 'living the dream'. Marjorie
and Harry, my mum and dad, for their loving support
in good times and in difficult times.

My literary agent Isabel Atherton of Creative Authors.
For their guidance, enthusiasm and expertise:
David Barraclough, Jacqui Black and Helen Donlon
at Omnibus Press. For his superb design skills,
patience and artistry Michael Bell, it's a real pleasure
working with you.

The Blackpool posse: John Robb and my brother
Mark Tilton of The Membranes; my teachers
and photo mentors, namely Stan Mulrooney,
Robert Graham and Ted Bradshaw; my Blackpool
And The Fylde College photography lecturers;
Fiona 'Art' Clarke, David Holloway, Tracey McNamara,
Julie Delahunty-Seel, Carolyn Hine, The Lythgoes,
Jacqueline Morley of The Evening Gazette, Chris
Cummings and The Riverside Trio.

The Manchester years: Stella Hall, the staff at
'Intowork', Joan DeLivesey-Dixon for my first studio
on Bonsall Street in Hulme, Elanor Fern, Marc Riley,
Jim Khambatta, Andy Spinoza and the staff of
City Life and Gay Life magazines, the great staff and
freelancers I worked with at Sounds: Tony Stewart,
James Brown, Robbi Millar, Ann Scanlon, Sean
Phillips, Robin Gibson, Susie Hudson, John Robb
(again, yeah!), Paul Elliott, Keith Cameron, Dave
Simpson and loads more…

Still loving you Colette Arron, the legendary Greg
Wilson, Tracey Carmen, The Ruthless Rap Assassins
and Kiss AMC, Marian Buckley, Brian Cannon of
Microdot, The Stone Roses, Gareth Evans, Steve
Adge, the staff at Select magazine (especially
Mark Ellen and Andrew Harrison), Johnny Waller and
Marianne Lassen at S.I.N., Vicky Ash, Damian Morgan
of Brave UK, Sean Tipler and Joanne Moss.

All my hard working and greatly valued darkroom
and photo assistants over the years: Paul 'Stan
The Man' Stanley, Tracy Mahoney, Clive Hunte,
Helen Jones, Louise Crawford, Ben Blackall and
Richard Davis; Howard Kershaw of PFD Limited;
and my buddy Big Dave Boyce of S.I.D.s Limited.

ACKNOWLEDGMENTS
CLAIRE CALDWELL

*Dedicated to my guiding light, Zachariah Jose
Caldwell, I love you with all of my heart.*

*Massive love and thanks to the fantastic Ian Tilton for
inspiration, encouragement and rocking road trips!*

*Extra special love and thanks to my ever loving and
supportive Mum and Dad, John and Rhoda Caldwell.*

*Many thanks to the team at Omnibus Press:
David Barraclough, Helen Donlon, Jacqui Black
and Michael Bell of Michael Bell Design.*

*Heartfelt thanks to all the special and wonderful
friends who have supported me during the writing of
this book, Johnny Holme and Mia Wilson for
extensive babysitting duties and belly laughs,
Sophie Du Frayer and Corin (The Fixer) Phillips for
providing love and extra laptops! I cannot thank you
all enough.*

*Darryl Darling (Fellow Siren) for guidance and
mischief of the highest order. Sally Perkins for
dancing scrabble and providing a loving sanctuary
when needed. Mike Freear for amazing friendship,
guestlists and Slamboree.*

*Extra thanks to Colette Johnson, Paul Payne,
Bob Godlonton, Richard Davis, Pauline Johnson,
Michelle Bullock, Amanda and Jason Knowles,
Kevin and Liz Caldwell, Taylor Caldwell, Kieran
Caldwell, Mick Knaggs, Monchie Horror, Linda Rose
Fisher, May Craven, Kathleen Malone, Mark Smith,
Lisa Fleming, Craig Heerey, James Bradley, Edward
and Patricia Caldwell, Jean Fisher, Robin Breeds,
Leo Stanley, Pritam Pal, Kim Wong, Stephen Goundry,
Liane Bellamy, Grant McCleary, Marvin Chambers,
Connie Connelly, Liam and Charlotte Taylor,
Gary Foxcroft, Tracey Benson, Venkat Chennubotla,
Keith Robertson, Leah Marsden, Anne-Marie Flynn,
Rony Ghosh, Andy Nardone, Sam Close and the
Quay Crew, Stephen Brown, Voits Voitech Paliwoda,
Keir Benson, Andy Jenkins, The No.4 Posse,
Amanda Duckworth and everyone. One Love xx.*

KEY TO FOREWORD IMAGES

PAGES 6 & 7

A Deansgate Station, railway bridge, Bridgewater Canal and Deansgate Chapel (Pete Waterman's recording Studio) (1990).

B Salford High Rises (1990).

C Factory Records HQ (FAC 251), 1 Charles Street opposite The Lass O'Gowrie and Joshua Brooks pubs and near the Oxford Road BBC Building (1992).

D "We All Want A Cleaner Hulme" (1992).

E A Hulme crescent walkway, with Ian Tilton's friend and assistant Clive Hunte (September 1990).

F Exterior of the Haçienda, Whitworth Street West, Manchester (1992).

G The Spinners pub, next to Robert Adam Crescent, Hulme. A reliable drive-in to score (October 1992).

H The Aaben Cinema, Hulme. Derelict in this photo, it was Manchester's innovative, indie art house cinema until it closed in 1991 (October 1992).

I Peter Hook outside Jilly's Rockworld, Oxford Street (May 1995).

J Railway line overlooking Deansgate Locks towards GMEX and The Refuge Building (1990).

K View from Castlefield towards Town Hall and GMEX (1990).

L Road sign on the corner of Chorlton Road/ Bognor Street, Manchester (1990).

M One of the notorious Hulme crescents. Innovative award-winning 1960s design inspired by Bath architecture, deteriorated into a grim, deprived concrete dump, lacking any civic pride (September 1990).

N Interior of The International 1, on Anson Road, Longsight, Manchester (November 1987).

PAGES 8 & 9

A 'Fac Plaque' – Plaque (FAC 51) outside the Haçienda (1992).

B The Haçienda dance floor (July 1988).

C James fans outside La Locomotive in Paris (February 1990).

D Happy Mondays fans at GMEX (March 25, 1990).

E Flesh night at the Haçienda, Whitworth Street West, Manchester (February 1994).

F 'I Am The Resurrection' podium dancer at the Haçienda (February 1990).

G Foot Patrol dancers at the Haçienda (July 1988).

H Smiths fans tear apart Morrissey's shirt at GMEX. Tilton's image was used by Morrissey on The Smiths album cover *Rank* (July 19, 1986).

I The Haçienda's colourful interior (1987).

J Black & white interior of the Haçienda (May 1987).

K Foot Patrol at the Haçienda (July 1988).

L Podium dancers at the Haçienda (February 1990).

M Clothing fashion changes from mid Eighties Smiths to Nineties acid-coloured psychedelia in Paris (February 1990).

N Kissing clubbers Ann Dinan and her husband Fred at i-D Night at the Haçienda (July 6, 1988).

PAGES 10 & 11

A Polaroid of Morrissey for *City Life* magazine anniversary cover (April 1988).

B Rob Ward of Tools You Can Trust, Hulme (November 16, 1986).

C Johnny Marr (1998).

D The Ruthless Rap Assassins (Kermit Le Freak, Carson and Anderson Hines), Hulme.

E The Man From Delmonte (March 19, 1987).

F Vini Reilly of The Durutti Column, Manchester Cathedral (September 14, 1987).

G James photographed at Platt Fields (August 1, 1986).

H New Order live at the Haçienda (June 10, 1987).

I The Creepers: Phil Roberts, Eddie Fenn, Marc Riley, Mark Tilton (Ian's brother) (1986).

J Tony Wilson at Factory HQ (FAC 251), 1 Charles Street (November 18, 1991).

K The Chameleons, taken on infrared film (September 22, 1986).

L MC Buzz B, aka Shorn Braithwaite (July 1990).

M The Membranes breathing fire outside HMV, Liverpool (April 22, 1988).

N Section 25: Larry and Jenny Cassidy with their children Bethany and Nathaniel (November 17, 1986).

O The Fall at Mark Smith's house in Prestwich: Craig Scanlon, Mark E Smith, Steve Hanley and Si Wolstencroft (The Stone Roses' original drummer) (October 15, 1988).

P A Witness photographed beside the Bridgewater Canal at the back of The Ritz, Whitworth Street, Manchester (December 22, 1985).

PAGES 12 & 13

Images **A**-**G** are a selection of exhibition photographs from Ian Tilton's '36-Hour Party People', a photographic road trip documentary about a coach party of James fans travelling from the Haçienda in Manchester to La Locomotive in Paris to see their heroes play. Commissioned by Granada Television's magazine programme *The New* and by Cornerhouse art gallery in 1990.

A Paul and Josie (the lovers).

B Sarah and Graeme (from Fallowfield) with Tim Booth, vocalist from James.

C Jane, Eve and Sarah (from Manchester).

D Lynne and Janine (from Oldham).

E Phil, Andy and Paul (the backseat boys).

F Alexis (from Paris).

G Ang Matthews and Martin Mittler.

H The Mock Turtles 'Can You Dig It?' live at The International: Martin Coogan and Martin Glynn Murray (July 1990).

I Shaun Ryder of the Happy Mondays backstage at the Free Trade Hall, Manchester (November 1988).

J Bez of the Happy Mondays backstage at the Paradiso, Amsterdam (1990).

K The Charlatans (April 2, 1990).

L Kiss AMC (Christine Leveridge and Anne-Marie Copeland) with The Ruthless Rap Assassins (March 23, 1988).

M Tony Ogden, World Of Twist vocalist, recording at Granada TV, Liverpool (March 5, 1991).

N 808 State (January 1991).

O The Inspiral Carpets, London (1989).

P Identity clothes shop, Affleck's Palace, Northern Quarter, Manchester (1990).

Q Leo Stanley of Identity clothing, sporting his famous '...God Created MANchester' T-shirt (1990).

R The Paris Angels (October 1990).

S Greg Wilson, DJ and producer/musician in Mind Body & Soul (1991).

T Intastella (1991).

FACING PAGE 5

Ian Brown with Ian Tilton (hat) and his friends, celebrating at preview night of 'Haçienda 25 The Exhibition' (FAC 491) at Urbis, Manchester (July 2007).

SET IN STONE
INTRODUCTION

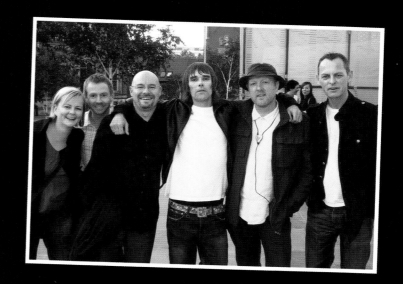

I first met Ian Tilton in early February 2011, when I braved a cold and wet winter's evening to attend a talk he was giving at The Dukes Theatre in my home town of Lancaster. The event had been arranged by our mutual friend and fellow photographer Richard Davis. Tilton was due to be waxing lyrical about his legendary photographs of such bands as The Stone Roses, Nirvana, Happy Mondays and The Smiths, and Richard had produced two photo documentaries of Ian's work, also featuring his iconic shots of the Haçienda, to show on the night.

Being a massive fan of the aforesaid bands and growing up in the north-west of England at exactly the right time to fully experience the hedonistic explosion of indie rave and acid house, I was intrigued by a Facebook notice stating that Ian would be coming to our local theatre to hang out with us. I say hang out because, being such a small theatre, it provides an intimate setting where the audience can converse freely with the subject, which is exactly what me and my mates were able to do with Ian. His affable and unassuming nature meant that before long we had dragged him out through the fire doors and into the dark alleyway for a ciggie. In this 10 minute interlude before he was due on stage I managed to weigh up what it was about Ian that The Stone Roses and others had liked, why they had allowed him into their inner circle and what had made him such a successful photographer. He was down to earth and glowed with the gentle positivity of a man who'd lived through both the peaks and troughs of life. Here was a man not without his demons, but one who embraced both the good and the bad. I was intrigued since, aside from being an ace photographer, he'd also studied to be a counsellor, and like myself specialised in older people's mental health.

What I found most exciting about Ian's photographic work is that he always seemed to be in the right place at the right time, photographing bands who were just starting out. He was the first to photograph Nirvana for the English music press and famously documented The Stone Roses as they embarked upon their rise to fame. I was intrigued by his stories and felt that they demanded to be told.

I said to him, "You must've seen it all." To which he replied, "No, not yet, there's so much more to see." I think this sanguine comment sums up the maverick spirit of Ian Tilton, and as I watched him give his talk on that rainy but cosy February night I thought, I wanna know much more...

CLAIRE CALDWELL *Lancaster, January 2012.*

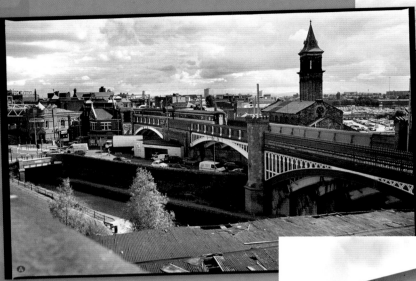

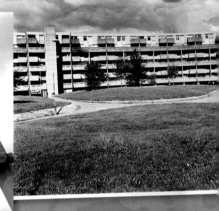

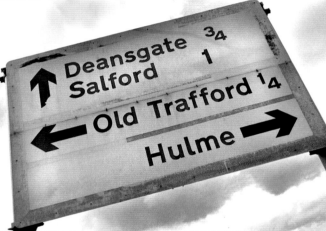

FOREWORD

The music scene in Manchester throughout much of the Eighties was dominated by three northern icons: The Smiths, The Fall and New Order, whilst the opening of the legendary Haçienda nightclub in 1982 proved hugely influential. The Haçienda, a joint venture between Factory Records and New Order, acted as a conduit for a stream of inspirational dance music to reach the city from Chicago and New York, facilitated by notable DJs that included the talented and pioneering Greg Wilson and Mike Pickering. When Ian Tilton arrived to live in Manchester in 1985 there was a thriving and innovative independent music scene. Despite the Haçienda being the venue which has gone down in history, there were other places Ian and his mates felt more comfortable, places where the beer was satisfyingly cheaper. They would start the night at their favourite traditional pubs: The Lass O'Gowrie, Peveril Of The Peak, The Salisbury or the Britons Protection.

Manchester city centre at this time was pretty run-down and had a dark, slightly dangerous feel to it. The city was gritty, old fashioned and Victorian in parts, with Sixties' concrete buildings sandwiched between beautiful Victorian facades. The Second World War had a hugely destructive effect and it wasn't until the Sixties that Manchester could afford to rebuild on sites where bombs had blasted away the beautiful and historic architecture.

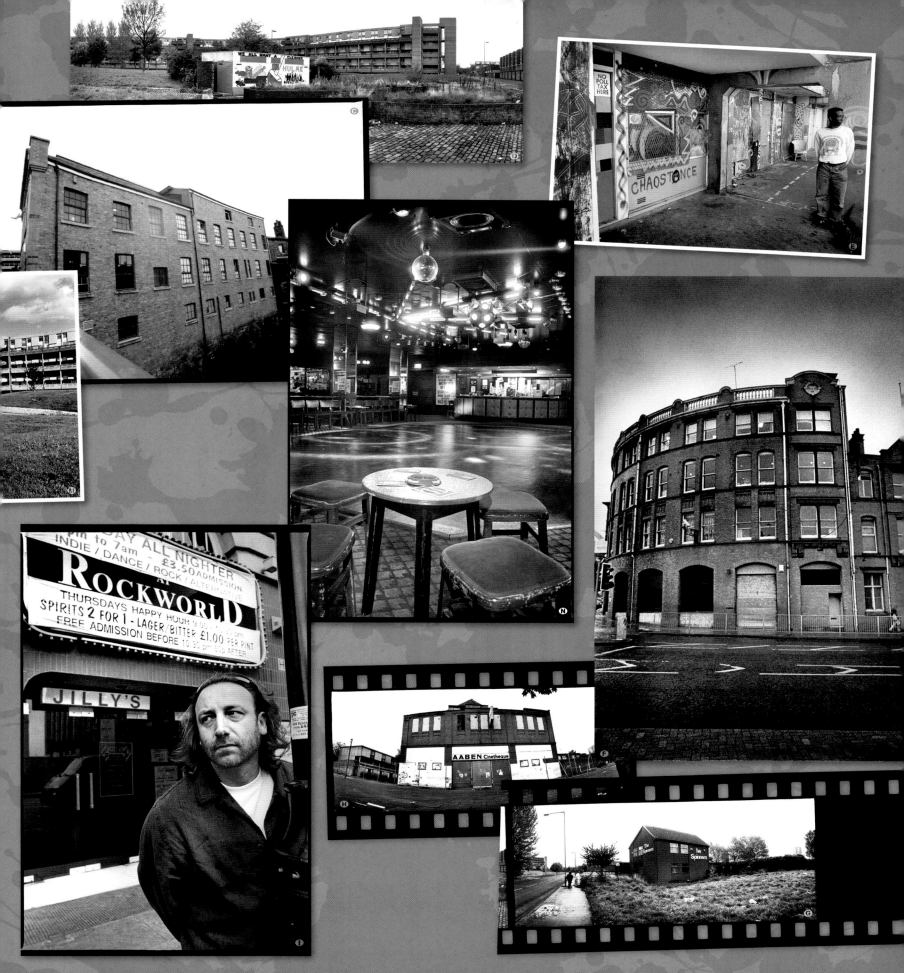

The centre of Manchester was heavy with buses and trains, ferrying workers and shoppers to and from the surrounding satellite towns. Today, thousands live in newly built, contemporary apartments, but back in mid-Eighties Manchester only a handful of people lived in the centre, most discouraged by a lack of amenities. After six o'clock in the evening everywhere shut, apart from the pubs and some restaurants. Most music venues only opened three nights a week. In the late Eighties some of the great venues were Jilly's Rockworld, The International 1 (owned by Stone Roses manager Gareth Evans), The Boardwalk, Band On The Wall and the biggest venue of them all, GMEX, formerly Central Railway Station. These venues put on gigs by many bands that made it, like the Stone Roses, as well as hundreds more who didn't, fading into obscurity and only vaguely yet fondly remembered today on their own Facebook and Wiki pages.

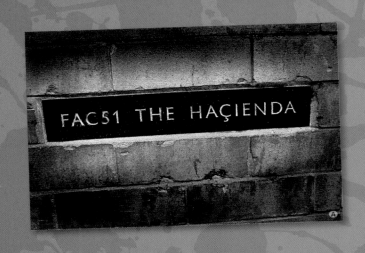

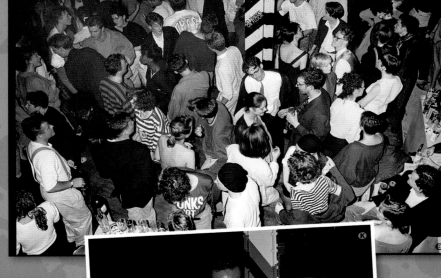

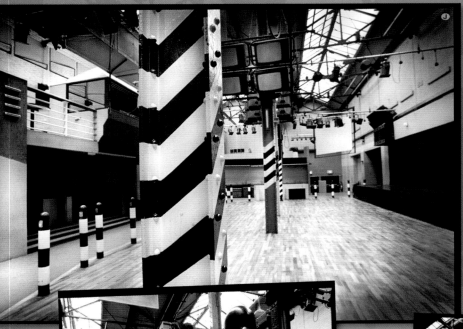

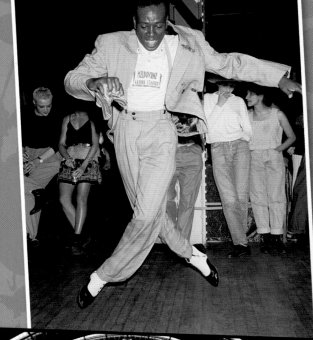

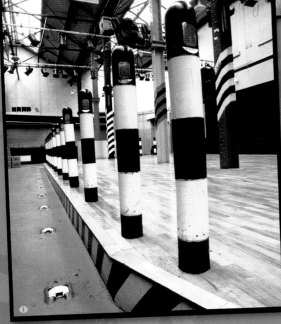

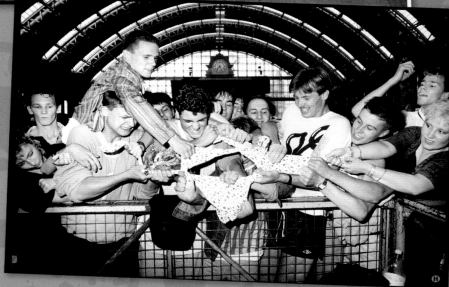

The Stone Roses were born out of a rich musical heritage spanning decades. If their parents had worked in the city centre in the Sixties, they may have spent their hour lunch break dancing, whilst eating their sandwiches and listening to the sounds spun by the late Jimmy Savile on his twin decks at The Plaza on Oxford Road. Manchester bands from the Sixties included The Bee Gees, The Hollies, Herman's Hermits and Freddie And The Dreamers. They were all contemporaries of The Beatles, Gerry And The Pacemakers and The Searchers who contributed to the north-west's pop music explosion. Savile also hosted *Top of the Pops* from a disused church owned by the BBC in Rusholme. The Beeb later relocated to a brand new broadcasting centre on Oxford Road. Hilda and Stan Ogden, Elsie Tanner and Ken Barlow were

Manchester's most famous exports as the TV programme *Coronation Street* became firmly established in the nation's psyche. Their tales of adultery and comedy from a northern cobbled street were filmed nearby at Granada Television Studios.

A quarter of a century later Tilton famously documented The Stone Roses' first television appearance at the very same studios.

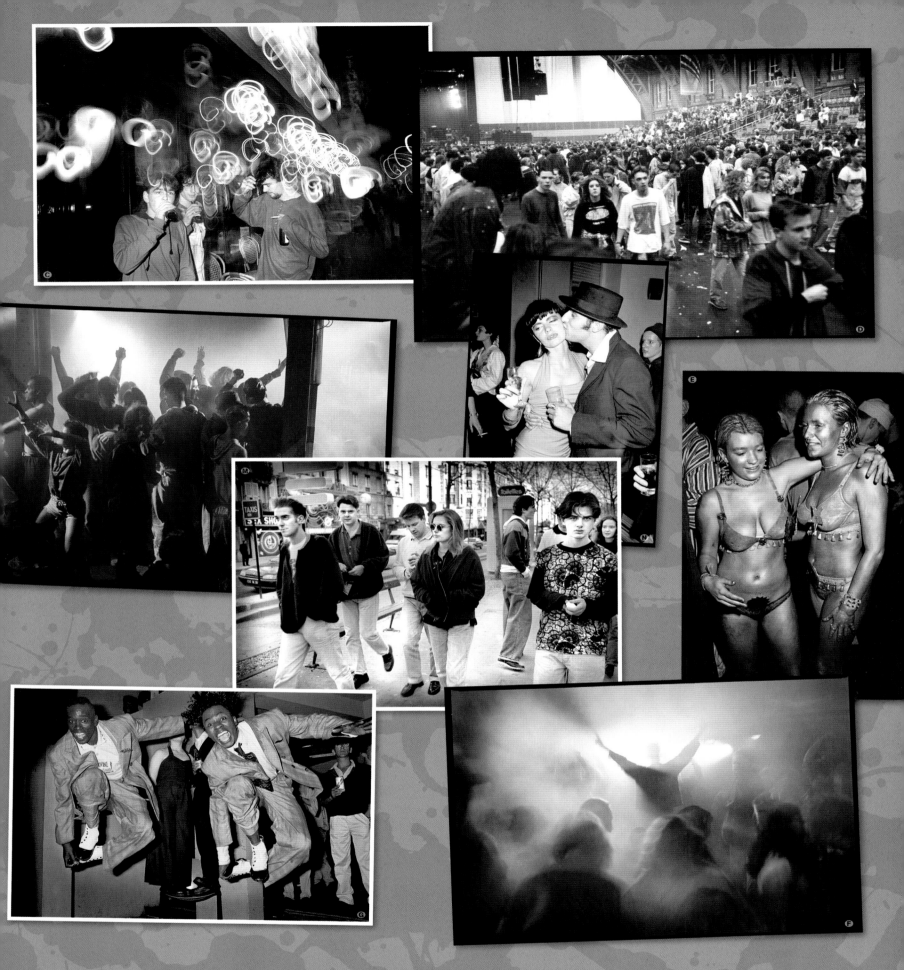

In the Sixties, The Twisted Wheel Club at 6 Whitworth Street was the place to be. It was here that Roger Eagle deejayed the sweet, head-spinning sounds of Rare Soul, later known as Northern Soul. Eagle had previously run famous blues and Detroit Soul all nighters. Among many other Manchester clubs were The Three Coins, becoming Beat City and later on Staxx in 1966, and The Oasis on one corner of Albert Square. Sliding into the Seventies partygoers glammed up, squeezed on their hi-stacked silver platforms and rocked out to live bands at The Hard Rock in Stretford. If they wanted to disco, they could have danced round their handbags at Fagins on Oxford Road.

Rafters, which was below Fagins, was an important venue for punk and post-punk bands. Manchester and Salford's gifts to the musical mainstream of the Seventies included 10cc, Sweet Sensation, Elkie Brooks, The Dooleys and Sad Cafe.

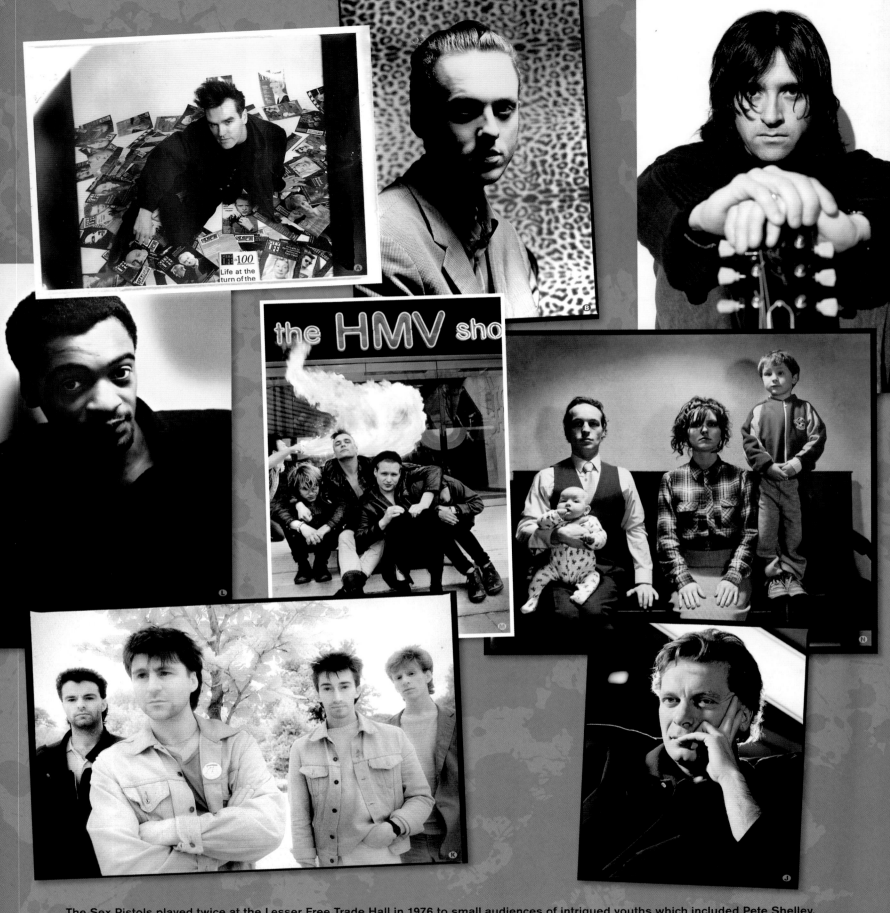

The Sex Pistols played twice at the Lesser Free Trade Hall in 1976 to small audiences of intrigued youths which included Pete Shelley, Howard Devoto, Morrissey, Peter Hook, Bernard Sumner, Mark E Smith, Mick Hucknall and Linder Sterling. It immediately motivated these individuals to form bands of their own. The Pistols, with their arrogant, raucous, anarchic punk rantings, fired a volley of destructive broadsides at the boring bands sailing on the becalmed sea of progressive rock music. The resulting waves surged far and wide.

The bands that formed in their wake were Buzzcocks, The Smiths, Joy Division, The Fall, Frantic Elevators, Ludus and Slaughter And The Dogs. The Stone Roses were heavily influenced by punk in their early days; their musical and political ethos echoed the anarchist ideal that it was possible to create a band without being musically competent – learn three chords, write a song, get on stage and you're a band!

One such stage in '78 and '79 was the Russell Club in seedy Hulme, famous for a regular Factory night on Thursdays, where inspired founders Tony Wilson and Alan Erasmus showcased great new bands such as Joy Division, Slaughter And The Dogs, Adam And The Ants, Buzzcocks, The Damned, The Durutti Column, A Certain Ratio, Section 25 and punk poet John Cooper Clarke.

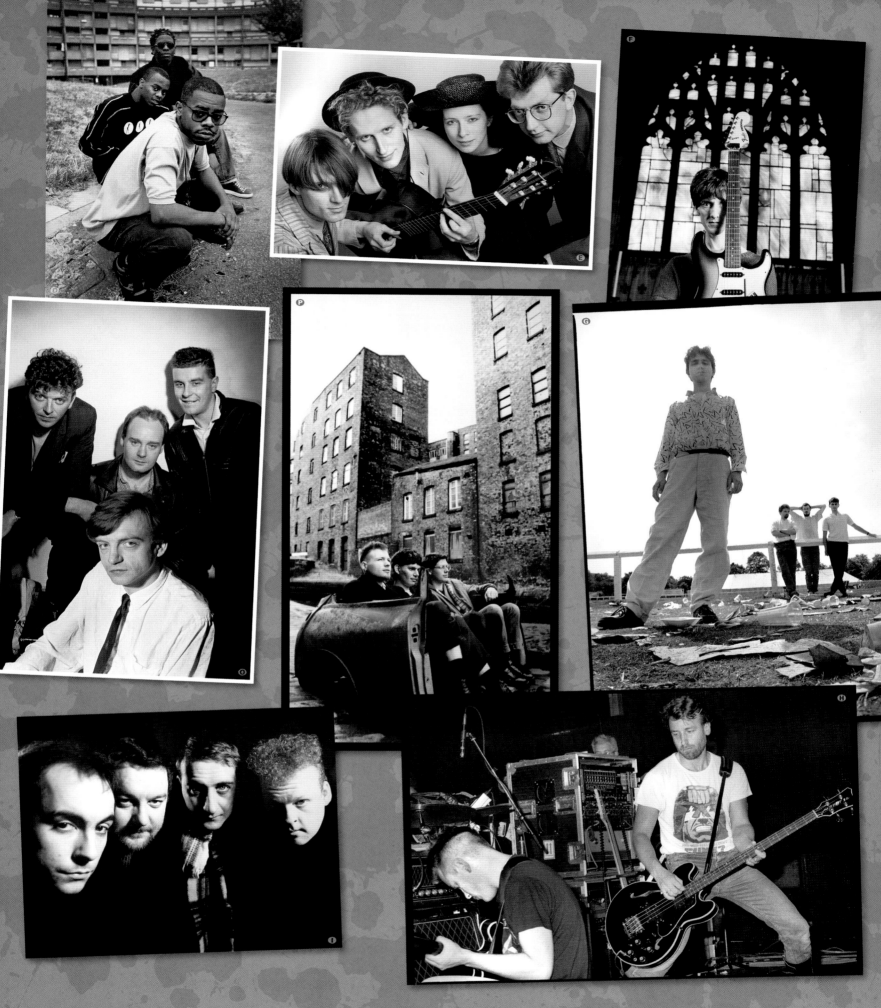

On the mid-Eighties scene in Manchester Ian regularly saw gigs by bands The Fall, The Membranes and others who were part of a healthy post-punk scene based around inner city Hulme. Further contemporary local bands included James, The Chameleons, Marc Riley And The Creepers and jangly guitar pop bands The Man From Del Monte and Raintree County. There was also a small yet significant hip hop/rap scene, which produced intelligent artists like MC Buzz B, the Ruthless Rap Assassins and Kiss AMC, who went on to achieve some success backed by Polydor and EMI.

11

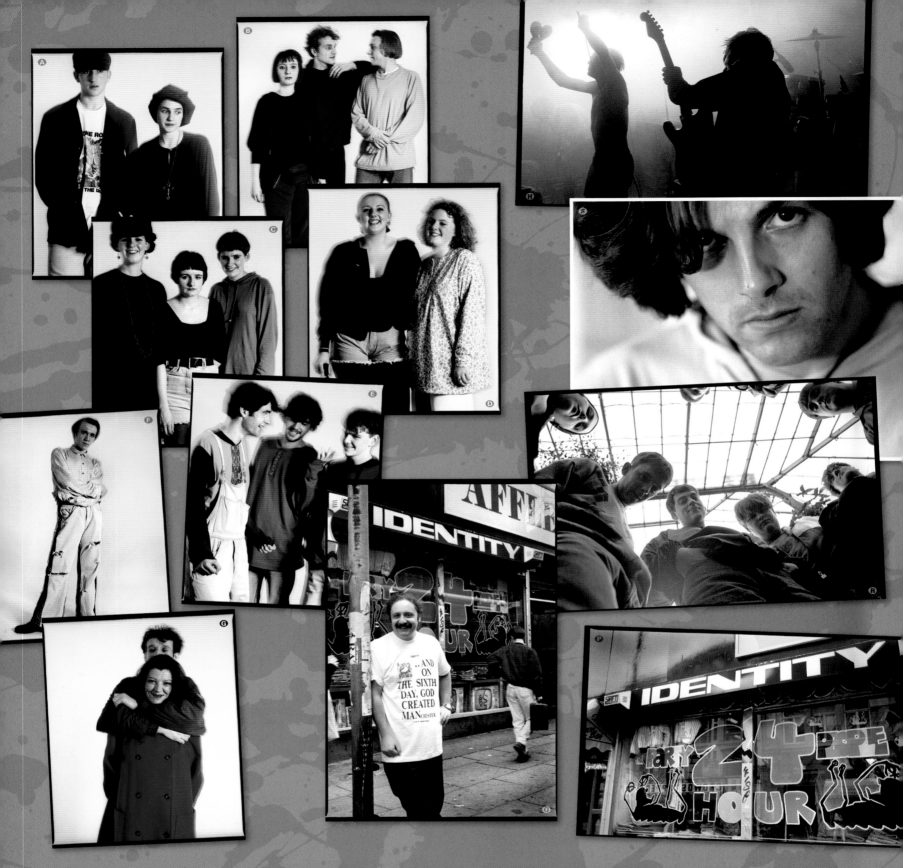

Ian and his mates would hang out in pubs like The Salutation in Hulme, kicking back on the grass on sunny days. Hulme, despite its rough and ready reputation and imposing concrete crescents, was a very creative area during the Eighties. It started as a proud regeneration scheme but evolved into a hideous dysfunctional concrete eyesore. Originally built to provide cheap concrete housing for lower income families, it ended up a marvellous Eighties melting pot of students, activists, creatives, bohemians, crusties, dealers, eccentrics and stray dogs. Ian Brown, living at Charles Barry Crescent, was surrounded by that. Students and ex-students chose it as a place to live and 'slum it' because it was a cheap area next to the city centre, as well as the university and polytechnic. Manchester was the biggest campus in Europe. Tilton had his first photo studio on Bonsall Street, Hulme and even though the area looked rough and felt dangerous there was a certain charm about the place due to its anarchic and colourful community spirit.

By the late Eighties Manchester had clearly developed its own sense of style. Afflecks Palace was bursting at the seams with second-hand fashions and brand new acid-coloured threads. It seemed that every floor of this Victorian Aladdin's cave glowed with psychedelic patterns and modern chic. Leo Stanley had a ground floor shop at Afflecks called Identity. He coined the famous phrase "On The Sixth Day God Created MANchester!" and emblazoned it on a line of T-shirts. Piccadilly Records and Eastern Bloc Records were key places to hang out and hear the latest white labels coming from the underground music scene.

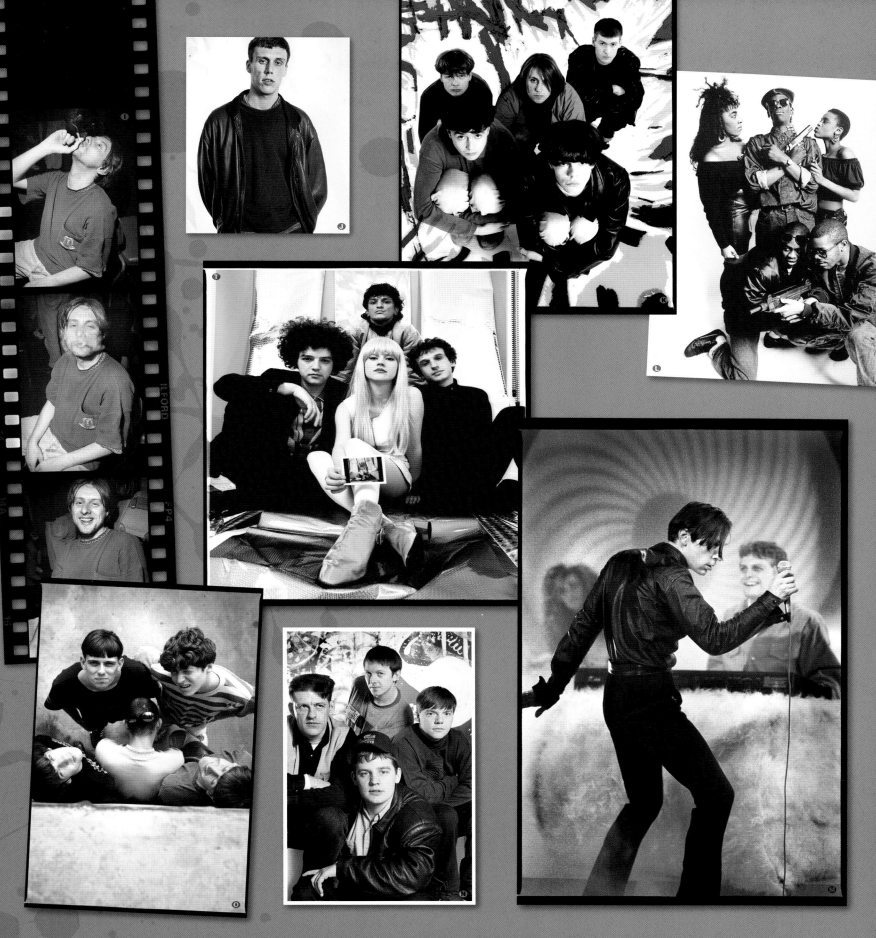

Nationally the youth in the late Eighties craved something different and in the acid house and indie scene they found it. Illegal warehouse parties and raves cropped up all over the north-west and The Stone Roses were the first band to hold one under railway arches in the centre of Manchester. Soon the nation found its musical inspiration in bands from Manchester, Salford and the surrounding district. The Roses, along with the Happy Mondays, James, A Guy Called Gerald, 808 State, The High, the Inspiral Carpets, the Mock Turtles, Northside, Paris Angels, The Charlatans, World Of Twist and Intastella, were to play a definitive part in the city's musical revival, and thus found themselves at the centre of the world's attention. Northern youngsters were proud of rainy Manchester and their own accents (strangely adopted by out-of-towners and affectionately mimicked and exaggerated by other jokers).

Musically, it was an optimistic period for the city now jovially renamed 'Madchester'. Record companies were willing to spend money in search of the next big thing, and England was lifting itself out of recession and into optimism... riiight, where's the party?

CHAPTER 1
DO YOU REMEMBER THE FIRST TIME?

"I took just one colour photograph during this session;
all the rest were done on my 35mm Pentax LX in black & white.
The one colour photograph was shot on a higher quality medium format camera.
I had a single frame left on a roll of film from a previous shoot,
and that's why I only took one."

On May 8, 1985 Ian Tilton first encountered The Stone Roses through their manager Howard Jones.

"I initially met and photographed Howard Jones at his flat-cum-office on Zetland Road in Chorlton. Here he showed me what I considered to be unimpressive photographs of the band, with John Squire wearing a red bandana. I was familiar with the Roses graffiti splashed rebelliously in prominent public places around Manchester, particularly in Chorlton where we all lived. Howard enthused unconvincingly that his band was brilliant, but I just couldn't bring myself to believe him, mostly because of the uncool image presented by his amateur photo efforts. I liked Howard though, especially his positive attitude and 'can do' approach to life. He had a touch of the wide boy about him.

"Howard lifted out a cassette from his desk and popped it in the player. I've a feeling it was a recording of 'So Young'/'Tell Me'. I tried to be diplomatic, but to be honest I didn't think much of it. Its melody was unmemorable."

It was two years later, on September 11, 1987, that Ian met and shot The Stone Roses for the first time. It was a commission from Sounds *and was the band's first photo session for a major music magazine.*

14 *Ian had been given half a page to run with an interview by up-and-coming music journalist John Robb, whose enthusiasm had led to the feature on The Stone Roses. Robb and Tilton had been childhood friends, growing up together in Blackpool and moved to Manchester around the same time.*

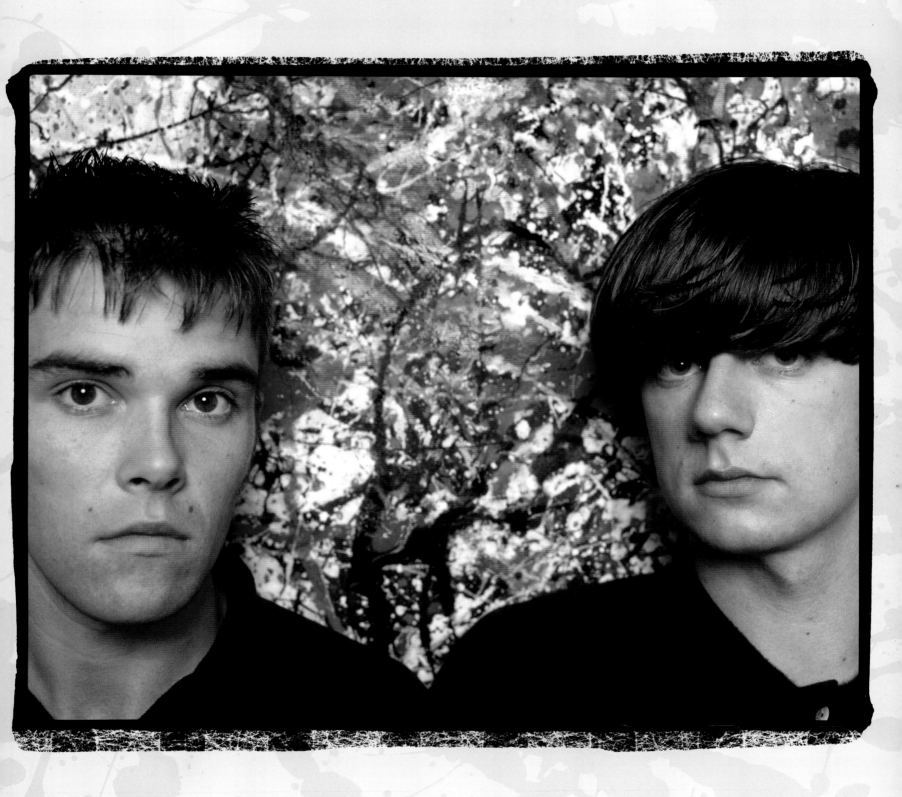

Ian recalls: "When the band arrived we discussed doing something a little different with the photos. It struck me how ahead of the game The Stone Roses were, and how passionate they were about projecting the right image for themselves. They wanted something different from the normal, boring four-piece line-up that other bands were presenting. Although I'd been inspired by some great photographers in the music press over the years (such as Anton Corbijn, Kevin Cummins and Mick Rock), I was also a little tired of seeing sullen faces in a classic four-piece line-up and was therefore now feeling a little bit guilty about sometimes falling into that trap."

The band brought a number of John's Jackson Pollock-inspired canvases to the session, which Tilton also photographed at later dates in his Chorlton studio for their single covers (both seven and 12-inch releases), namely 'Elephant Stone', 'Made Of Stone', 'She Bangs The Drums' and 'I Wanna Be Adored'.

"We put John's Pollock-style canvas on the wall.
It was massive, nine foot square, and it filled the whole wall.
I had an idea to take a graphic kind of shot, to use the guitar as an object of
design with Ian and John either side of it.
They didn't have to do anything, but it was unusual because I cropped the sides of their faces out.
That worked for me and I enjoyed using their idea of having two shots of two people."

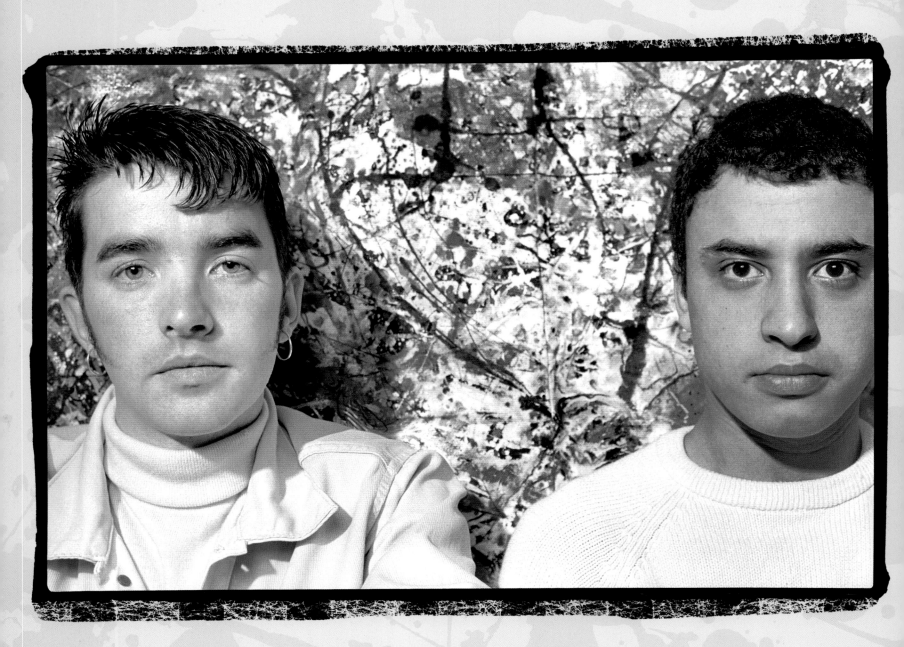

"The Roses brought along a copy of 'Sally Cinnamon' for me and said their previous single didn't represent who they were now, implying that they'd moved on from that sound. They gave me the distinct impression that they weren't happy with the earlier record but were really happy with this one. And what a single it was! I played it over and over on my turntable. I went out to buy 'So Young'/'Tell Me', that first 12-inch single, from King Bee Records in Chorlton-Cum-Hardy, and I could see why that sound just didn't represent them in 1987. It was rough and very punky and had been produced by Factory's Martin Hannett. It seemed to represent Hannett more than the band.

I wasn't keen on the vocal. I'd been listening to that sound since 1978 and to me it was a bit boring. The lyrics screamed, 'Tell me, tell me, you can't tell me anything!' and they were right. All their subsequent records had an original psychedelic and melodious feeling. The anger in their lyrics was now presented in a more poetic and confident way."

16

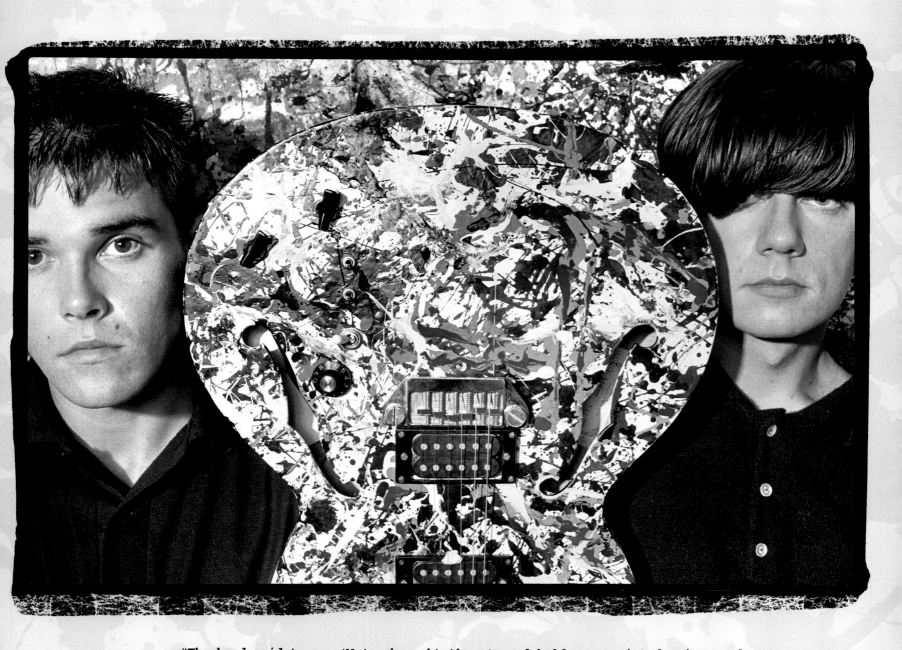

"The band said to me, 'We've brought these', and held up a painted guitar and
one of John's painted canvases to use as a starting point.
They had both been splashed with paint by John Squire in the style of Jackson Pollock,
who had inspired John's artwork.
It was later famously featured on the Roses' record sleeves."

"Whilst discussing the photo shoot's set-up, Brown and Squire suggested, 'Don't have one picture of four of us together on the spread. Have two pictures of two instead. Can you do that?' So I said to them, 'I like it, but if I submit two shots then I get paid twice as much as I'm paid per picture. My editor, Tony Stewart, might not agree, because *Sounds* has a limited budget.' However, because I really liked the idea I told them, 'Look I'll do it. I won't give them shots of all four of you, and if the magazine says we're not paying you twice, I'll just take payment for one because I want this to be good.'

Looking back, I think they appreciated that I had stuck my neck out for them, that I'd risked annoying my editor, since money wasn't ever a prime motivation for me. My motivation was always to work with the band to make great pictures.

"I photographed them with the same atmosphere and lighting knowing that the magazine's designers could put one picture above the other or could run them side by side. I shot a couple of variations, and went against the classic rules of composition by placing them at the edge of the picture and having the main body of the photograph as an abstract, showing the texture of John's painting.

"To me it's interesting what they are wearing, as Ian and John are both co-ordinated in black. John has leather trousers, which are a throwback to his Goth look from the early shots taken by Kevin Cummins, but by this point he had lost the bandana he'd worn in those sessions, thank God!

"Ian's hair is really short and punky. I hardly recognise him as being Ian Brown in these pictures. He looks very chiselled and healthy, almost like a male model. In all the later photographs he had long hair, more of a hippy look with his eyes always hiding underneath his fringe. John's hair is sometimes hanging over his eyes. It's possible that later on Ian followed suit and grew his hair so that it was long over his eyes too.

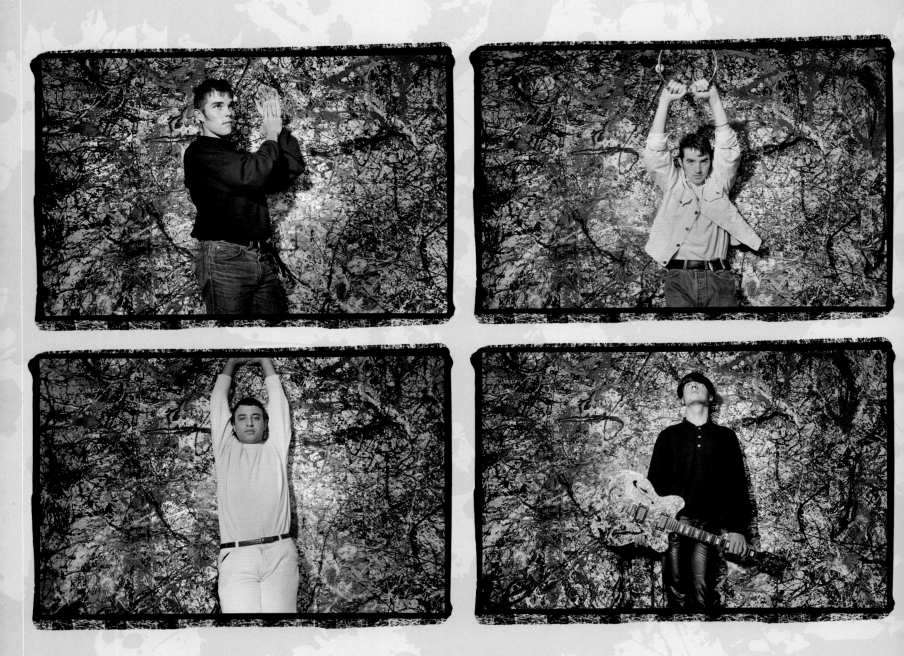

"Rob Hampson was the bass player at the time and is in these shots. Rob was in the band for just a few months from August '87. I don't think he even played a gig with them. Whether or not he was just filling in to be an extra head for this photo session, I don't know. I've done many shoots over the years where a member of the band has failed to turn up so we've asked a friend to stand in. Sometimes I've hidden their faces so it looks like all the members of the band are there. Anyway, I shot the ones of Ian and John with the guitar, and the one of Reni and Rob without the guitar, just with the Pollock style background.

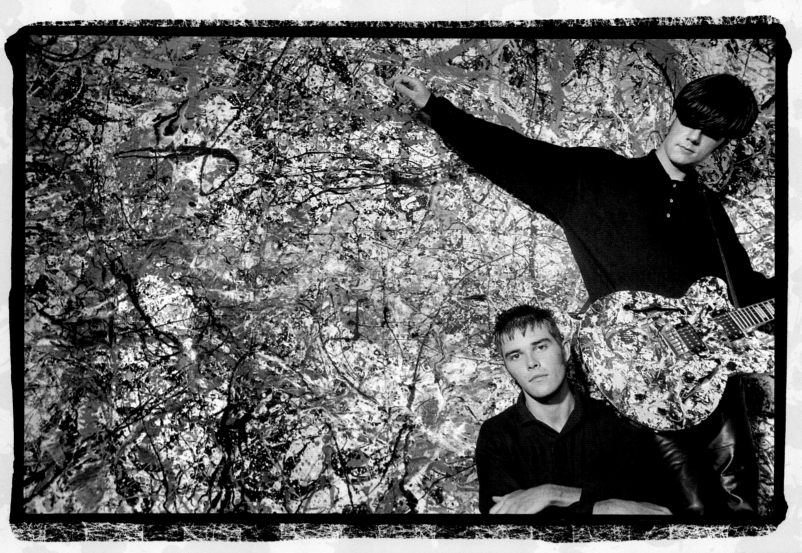
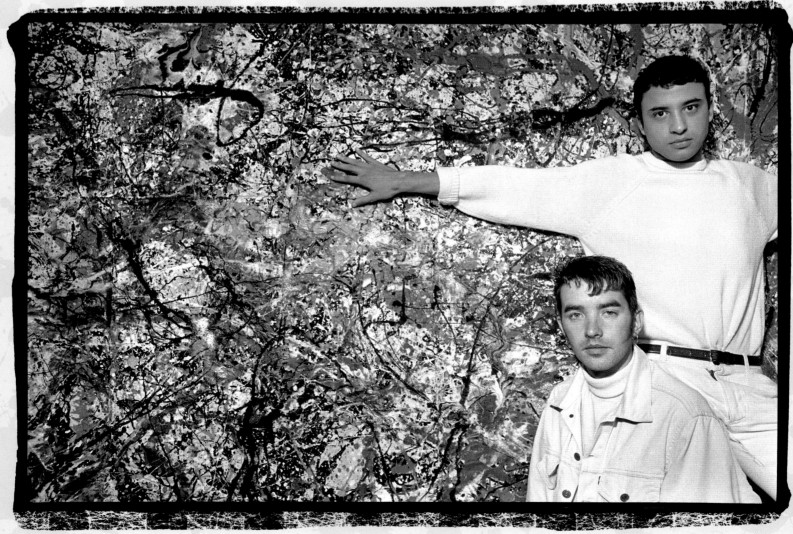

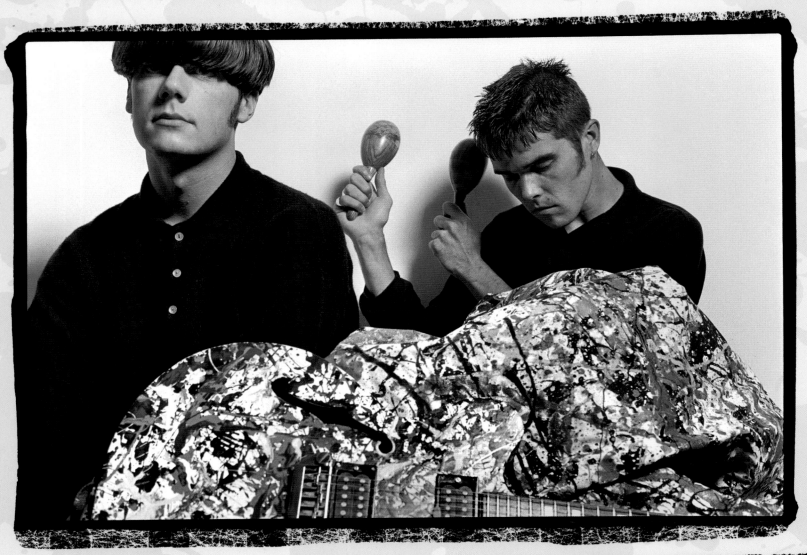

"I thought, 'I can't use John's guitar in my photos of Reni and their then-bass player Rob Hampson.'
So Reni got his tambourine out to give him something to do.
Often bands feel more confident if they can participate with props as part of
the creative process, rather than just sit there."

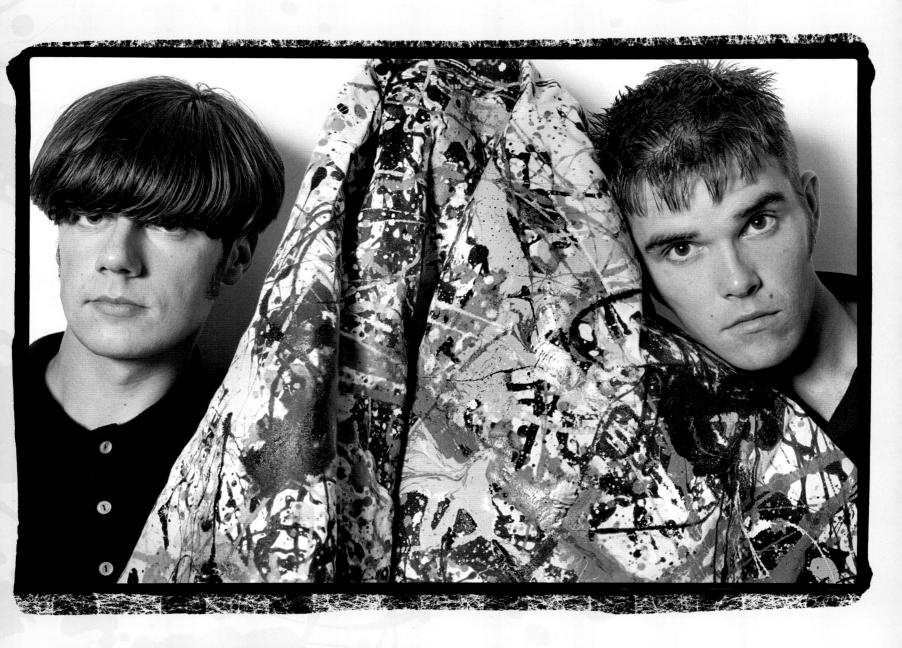

"Later I decided to take the background canvas off the wall and scrunch it up into a cone shape.
It was all pretty spontaneous. I didn't plan it, but it just happened to form the shape of a rosebud.
I didn't explain what I saw to the band, I just photographed it.
Months later, their roadie and mate Chris 'the Piss' Griffiths said to me,
'I see what you did there; you made it look like a rose.'"

"I did a series of singles covers for the band. John would bring round canvases of his paintings for me to copy onto high-quality film. I'd stick them flat against my studio wall and they smelled of really strong gloss paint. John would bring them round rolled up. The smallest one was about one metre square. We'd make a few exposures of the sections we both liked best. It was purely subjective – he might have liked the way a pool of red paint had merged with a line of yellow, whilst I might have liked how the red spot floated like an island in a mass of blue. The final choice was always John's, but then they were his paintings after all.

"I'd get the colour films developed in town at Colourpoint on the bottom end of Deansgate. There was also Rhino Labs near the Haçienda and RS Colour at Ardwick. There's no call for film processing any more, so the labs have all gone out of business.

"I felt really excited and proud about having my pictures published. I still do and I really like the 12-inch record format because they are nice and detailed. And I still play my vinyl collection. Old school!"

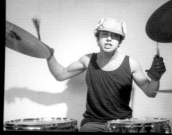

10A 11 11A 12 12A

16A 17 17A 18

CHAPTER 2
THE RENI FACTOR

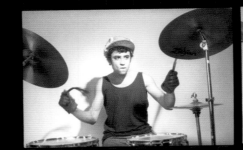

22A 23 23A 24

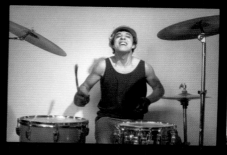

28A 29 29A

"March 28, 1988. I took some shots of Reni on his own. He came
into the studio at my house and set up his drum kit. I think Gareth had
an idea for getting him and the band some extra publicity. Reni wasn't
only a terrific drummer, he really looked the part. There were echoes of
Keith Moon about him, the way he moved around when he hit the drums.
He was really entertaining to watch. Gareth realised this and wanted
to get a piece about Reni in the *Manchester Evening News*, so he asked
me to take some pictures of him in action.

 The results were great, though I'm still not sure if they ever got
printed in the local rag!

22

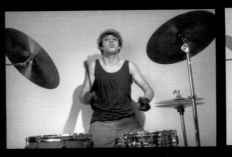

34A 35 35A 36

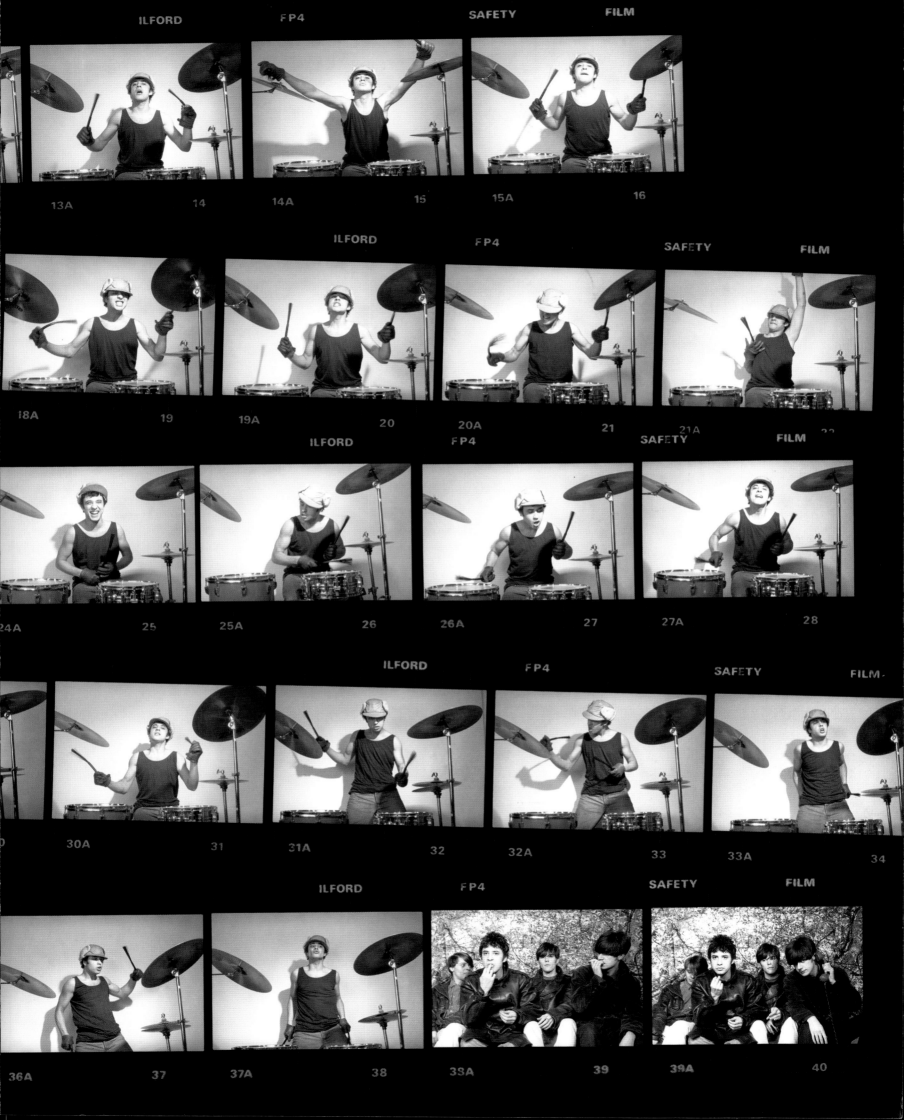

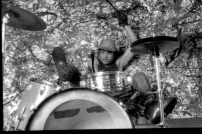

26A 27 27A 28 28A 29

FP4 SAFETY FILM

"Reni started drumming and the idea was to
 make him sort of dance whilst he was drumming.
He was throwing some good poses,
 which worked well right from the beginning
 because Reni was a great poser..."

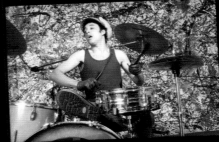
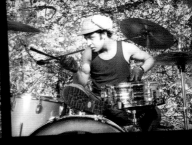

FP4 SAFETY FILM ILFORD FP4 4

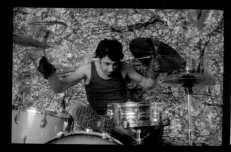
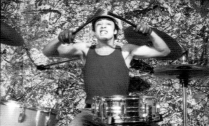
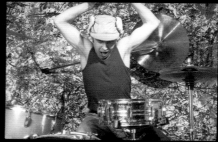
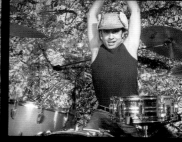

8A 9 9A 10 10A 11 11A 12

FP4 SAFETY FILM ILFORD

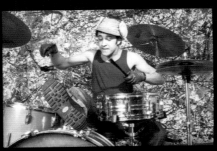
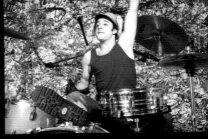
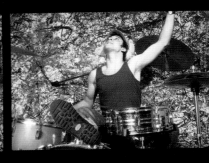

14A 15 15A 16 16A 17

"We set up in front of the white wall in my studio and I got this
terrific sequence of pictures. Gareth got back to me the day after and
said, 'We don't think it works without the Jackson Pollock-style
background. Will you redo it? It won't take you long. And we want you to
take some group shots with our new bass player.' So they came to my
house the next day, the whole band this time, and we hung John Squire's
canvas in the background and reshot it. These images have been seen
before, but the ones on the white background haven't.

 "The 20th anniversary edition of The Stone Roses' début album
featured the contact sheet of those pictures of Reni drumming with the
Pollock background, whilst this book shows the white background series
of photos for the first time."

FP4 SAFETY F

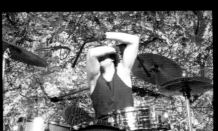

20A 21 21A

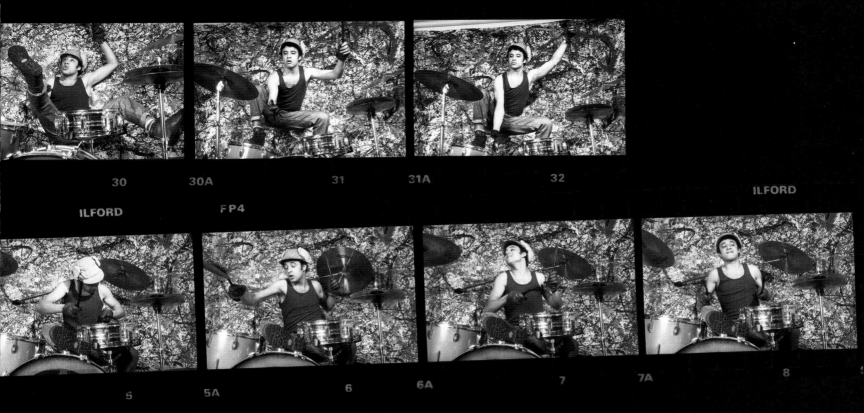

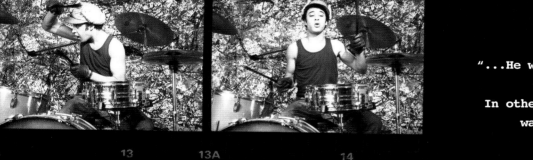

"...He would really give it plenty in some of
the studio sessions.
In others he could be quite reticent, but he
was always comfortable behind his drum kit."

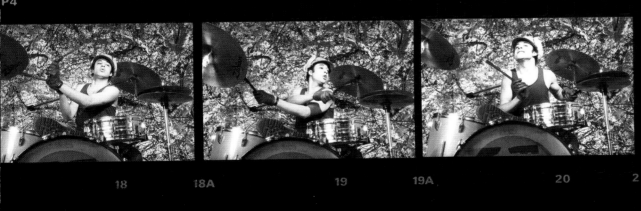

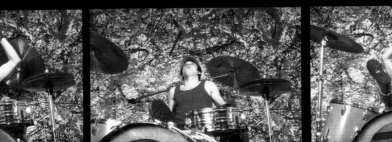
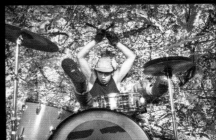
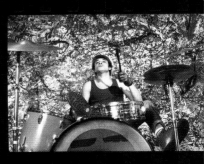

CHAPTER 3
THE INTERNATIONAL

"The bar, along the left-hand side, was covered with promo photographs of
the dozens and dozens of bands who'd played there.
I saw The Stone Roses play there once, in November '87 I think, and strangely
I don't remember there being a photo of them up in the bar."

"Roger Eagle was a very talented DJ as well as being an encyclopaedic mastermind when it came to music. He spun blues, soul and R&B in the Sixties at Manchester's famous club The Twisted Wheel. Gareth Evans (The Stone Roses' new manager) and his business partner, Matthew, ran The International. Roger chose the bands who played there, having previously performed the same task in the late Seventies at Liverpool's famous Eric's nightclub. I remember Roger as being very tall, hunched over, unshaven and casually dressed. He was quiet and intense.

"Gareth Evans, on the other hand, was gregarious, energetic, enthusiastic and an entrepreneur, having tried his hand at lots of businesses. He was also eager to tell us all about his diverse experiences, such as the time he was a Carnaby Street hairdresser back in the Sixties. I liked him a lot – he was a bit bonkers really.

"No one messed with Gareth and he enjoyed having a mysterious reputation, which was backed by rumours circulating around Manchester that those who had crossed him had allegedly received threats as a consequence. These stories were never denied by him as far as I heard, and led to Gareth having a tough, unnerving reputation that he seemed to enjoy. Personally I saw nothing thuggish about him. He was eccentric, dramatic and entertaining and loved business and the challenges that go with it.

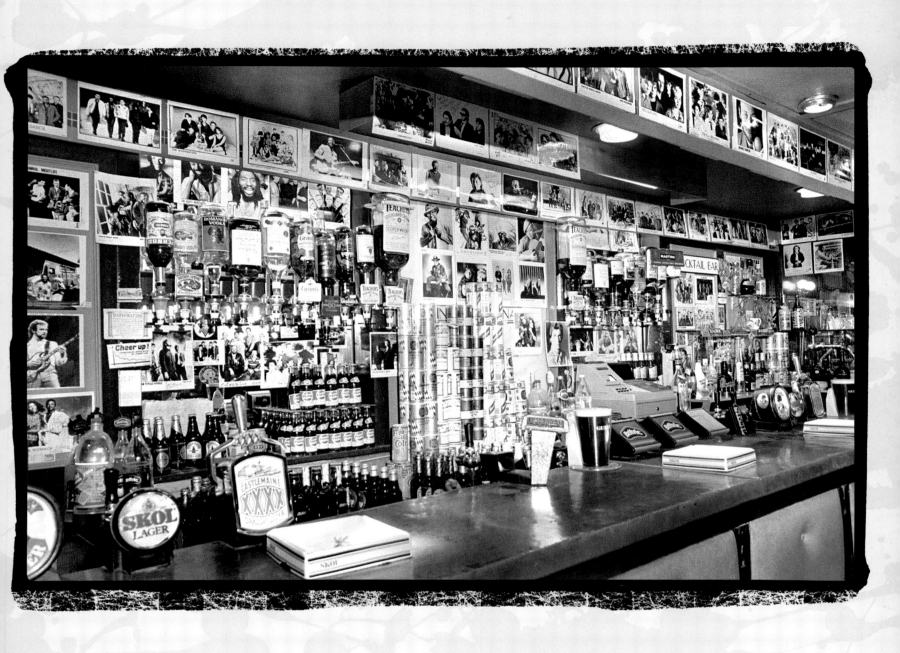

"The partners also owned a much larger club up the road on Plymouth Grove in Levenshulme. This was called The International 2, which led to some confusion amongst those punters unaware that there were actually two clubs close to each other with the same name!

"The International (1), situated out of town about two miles south of the city centre on Anson Road near to Dickenson Road in Levenshulme, had its stage at the far end of the long club, opposite the main doors where you walked in from the road.

"The Roses' manager owned it, so in effect the lads had their own club where they could play, hang out, rehearse, have free drinks from the bar and watch any band they wanted for free. I was very impressed by that and it was great to be given free drinks myself when I was there.

"I saw lots of live bands at The International: Julian Cope, Voice Of The Beehive, Luxuria, Faith No More, Suicidal Tendencies, Intastella, World Of Twist, Galaxie 500, Lenny Kravitz and so on. The venue closed its doors many years ago and reopened under different ownership. It's a Turkish supermarket now. The International 2, I heard, has been knocked down."

CHAPTER 4
MANI'S FIRST PHOTO SESSION

*March 29, 1988. Six months after Tilton's first studio session with the Roses, bass player Rob Hampson had been replaced by
Gary Mounfield, better known as Mani. Mani was a Perry Boy, a group of casual throwbacks from the original Scooter boys. He was already
a part of the Roses story after a riotous gig at Clouds in Preston, where he'd gatecrashed backstage to inform the band of his irritation
that the gig had been unceremoniously cancelled halfway through. Although he'd been known to the Roses for a long while, after joining his
favourite band Mani wasn't used to the camera being trained on his characterful face.*

Ian recalls meeting Mani for the first time. "Ian introduced me to Mani and said he was a mate whom they'd known for years and was now
their new bass player. He looked younger than Ian and John; about the same age as Reni. In actual fact he was the oldest in the band.
I put that down to the fact that he was the only one without 'sidies' – which made the others look older.

"Reni was preening himself and no one looked ready at all in the first takes. John was larking around, holding my old-fashioned, red dial-up
phone I kept in the studio. Mani wasn't looking at me, and seemed unsure of what he should be doing. Meanwhile Ian was twiddling his
fingers and looking at Reni's back, rather than at my lens or me. Reni kept looking at himself in the mirror I had behind my head. It was a big
mirror that was fixed to the wall and bands could check themselves out to see how they looked, which gave them a bit of
confidence to pose.

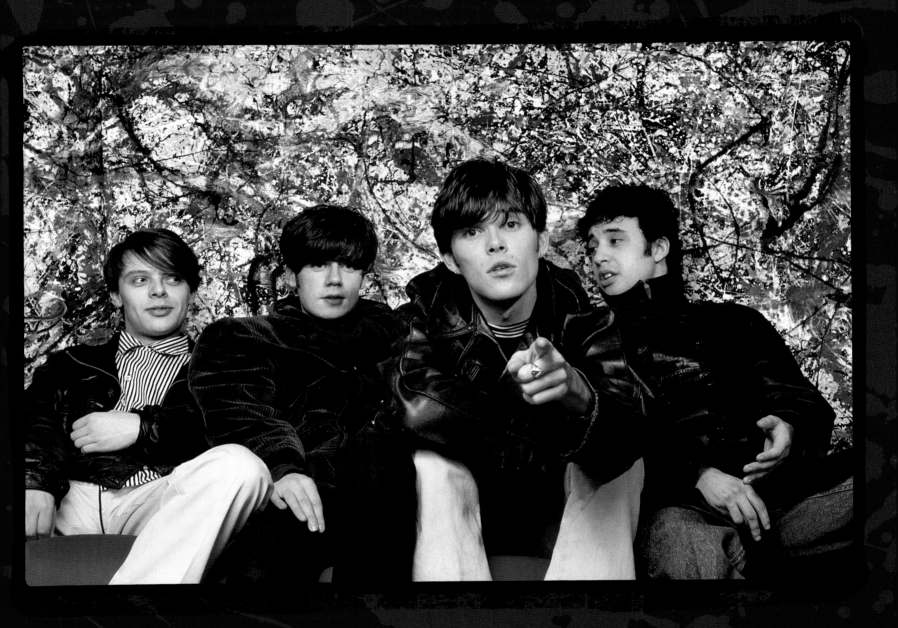

"They all turned up at my place together and had co-ordinated what they were wearing.
Second-hand clothes were the thing back then and they each wore heavy black,
half-length overcoats; three were shiny leather and John's was corduroy.
Three of the band had grown their sideburns ('sidies' or 'diggers' as we called them)."

"I started encouraging them and talking about what we were doing. I told them, 'I want something lively. You've got to bring this photo to life.' So immediately John yawns and Mani starts biting his lip, a sign that he may have been nervous and awkward, but then it was his first ever photo session. I tried to get them animated by saying, 'Talk to me, directly into the lens while I'm shooting.' Reni took the lead and yelled, 'Yeah, so what am I supposed to say? Should I do a hand movement like this?' Mani still didn't know what to do and pulled a weird face. They were all happy and started to look more comfortable. They were now having a laugh and trying to make the shot work. Ian began talking, John pretended to still be asleep, Reni was looking quizzical and Mani still didn't know what the fuck to do so decided to fall asleep as well, and that's how the shoot was starting to pan out.

29

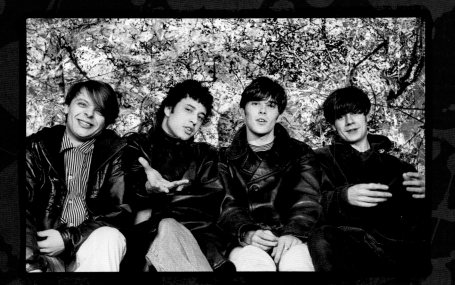
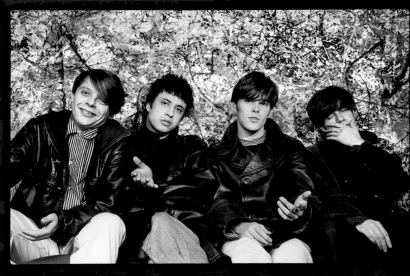

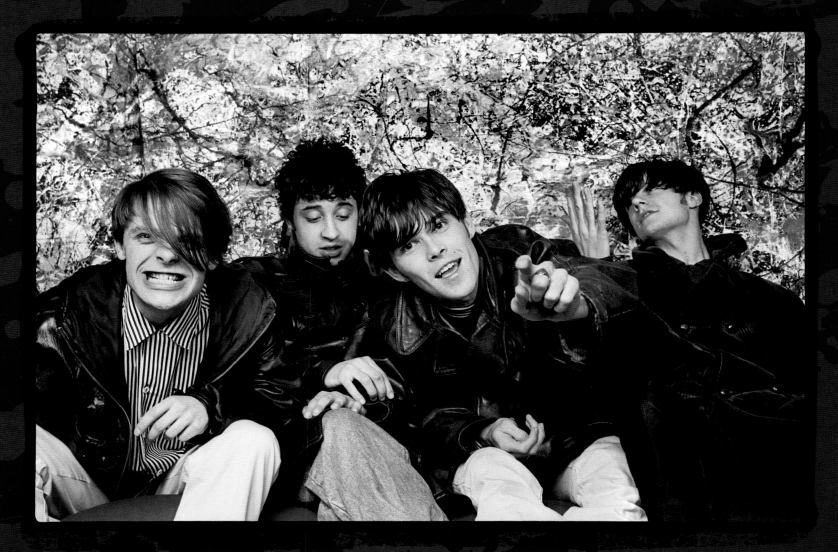

"My instinct at this moment was to take the reins by directing and co-ordinating it more. Everyone was doing what I'd asked of them and it was my aim to get one definitive shot, which I didn't feel I'd yet done. And then the magic started happening. Ian pointed his finger at me, so I took the cue and said, 'Speak to me, directly to me through the lens.' And he did. He spontaneously started bad-mouthing me, so I said, 'Well come on, swear at me, y'know, say anything you want.' He replied, 'You want me to swear? Well, FUCK YOU!'

"Then he started to act angry, which was brilliant because he'd become the main focus of the picture and was really bringing the shoot to life. Mani cracked up laughing 'cause Ian was swearing at me and in his heavy Manc accent shouted something like, 'Yeah 'ave it!' Then I caught a great series of shots as Ian looked directly at me and declared, 'Fuck you and fuck your mother!' whilst John pulled a stupid face at Reni. What a great moment! They all fell about laughing. I thought at this point I'd got the photos I wanted, but nevertheless told them I was going to take a few more in colour."

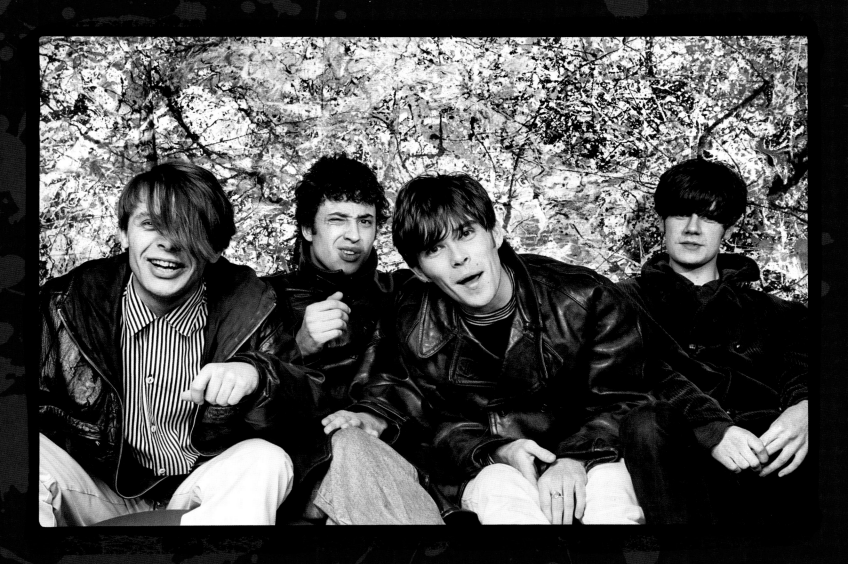

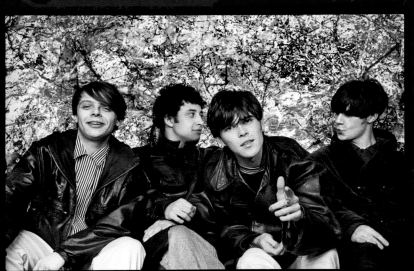

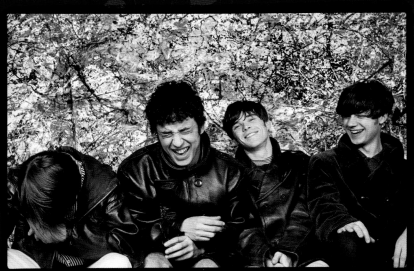

"Seeing the pictures from that shoot now, it's great to
recall what a good time we were all having.
Individual characters gelled and The Stone Roses looked like a
coherent band of lads, like a gang but without the violence."

Tilton quickly changed his camera to one which contained colour slide film and was desperate not to lose momentum. Both his cameras were always at hand with interchangeable lenses in his camera bag, so he could quickly move from one to the other without affecting the shoot's mood. He took a few more colour shots of Ian Brown pointing and swearing into the lens, after which the mood changed and the moment had passed.

"I love that shot right at the end of the shoot, of Reni laughing his head off and John grinning at him, with Mani collapsing in a heap, whilst Ian's looking at me smiling. Everyone now looked like they belonged. Mani had arrived."

CHAPTER 5
CLASH OF INSPIRATION

"So I said to the Roses, 'I want to you to kind of pose a
bit like the famous Pennie Smith/Clash photograph.
Lean on each other so you look close to each other. Look cool and cocky'.
So that's what they did, standing against the wall at my studio."

"September 6, 1988. I knew that the Roses were influenced by punk, particularly their first single, 'So Young'/'Tell Me', which had been produced by Martin Hannett. The band had different influences musically; Ian Brown loved the Sex Pistols and the Cockney Rejects and years later I was told he'd briefly been a roadie with The Angelic Upstarts. I think John Squire's appreciation of Led Zeppelin's heavy metal guitar was really obvious on *Second Coming*, although not on the first album. I was aware that John really loved The Clash and I liked them too, particularly Pennie Smith's great photographs.

"One of these pictures was a starting point for me. It was one where she'd photographed The Clash backstage. They had their bondage gear on and looked cool dressed in black. They looked like a hard, aloof and stylish gang; a close-knit bunch of lads who loved their clothes and had a punky fashion they had created for themselves. When I first saw that photo I thought, 'Yeah, I'd wanna be a part of that.' So I used Pennie's photograph as the inspiration for this session. It helps to have a few ideas before you start.

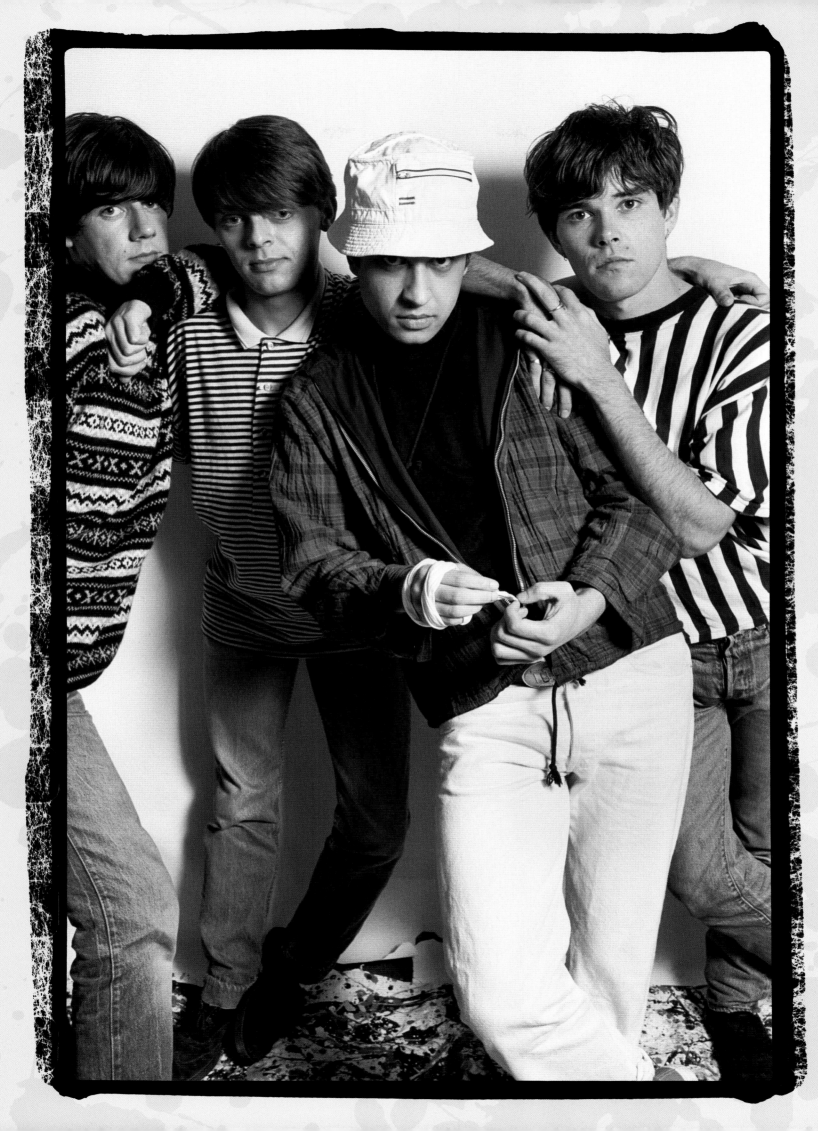

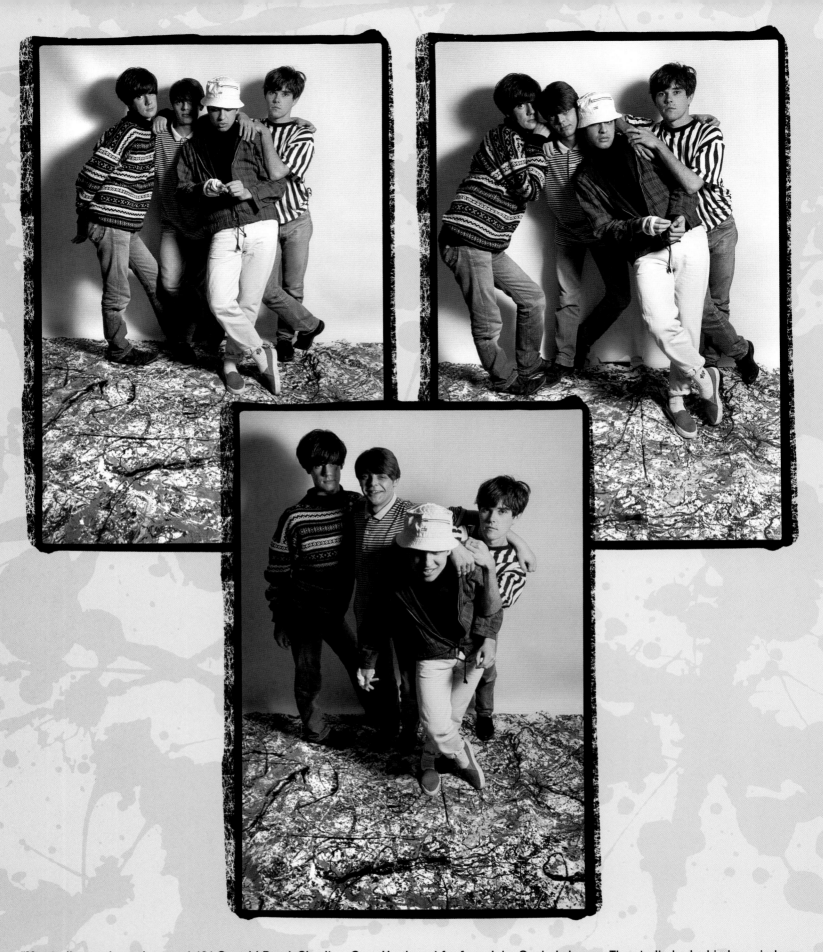

"My studio was in my house at 191 Oswald Road, Chorlton-Cum-Hardy, not far from John Squire's house. The studio had a big bay window letting in lots of natural light. It was a bedroom that I had converted and I still slept in that room on a futon. I'd hide away the duvet and sheets, fold the futon into a settee and would have loads of space to take photos, despite it being my bedroom at night-time. High up on the far wall I had two permanent rolls of background paper nine feet wide that I would unroll for photo sessions. It was commonly known as a Colourama background.

34 "Once again John had brought a giant canvas painting that he had splattered with all these great textures using gloss paint. John said, 'We can use this again.' It was the same canvas we'd used in the first studio session when Rob Hampson was the bass player. So we had to use it differently.

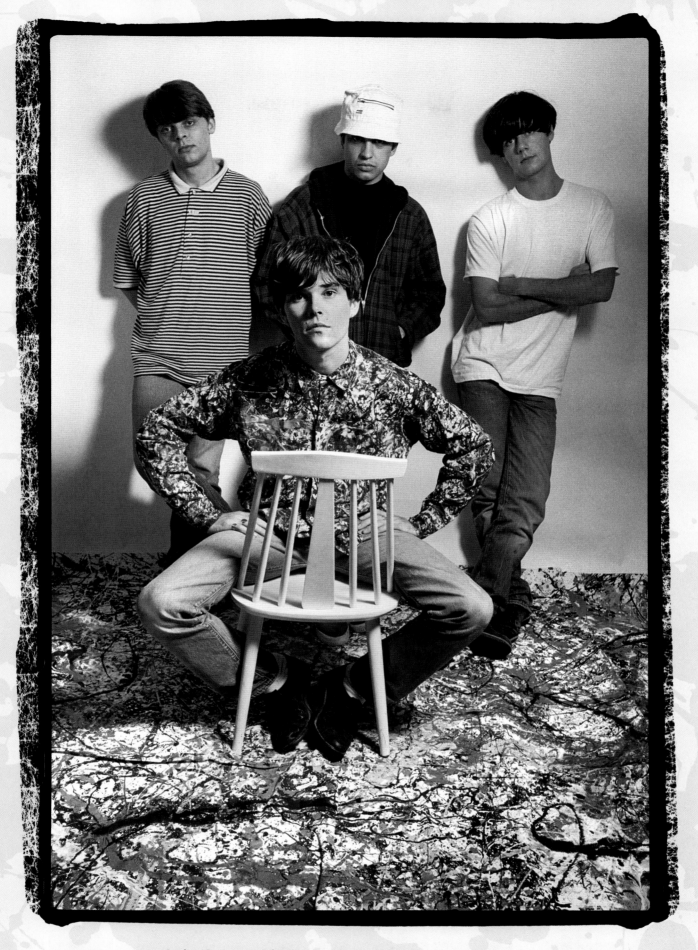

"We got a chair from my kitchen and Ian sat on it the opposite way round,
like a Manc Christine Keeler!
They were handsome lads in these pictures."

"Brown decided to change into a shirt that had been painted by John. The shirt was stiff with dried high-gloss paint. I remember thinking
that moving around in it must've been very uncomfortable. Nevertheless, Brown looked cool and didn't seem to mind. Not only did the Roses
create great music, they created their own clothes, customised their guitars and drums and understood the importance of creating a
good image for the camera. A good photograph can be an ambassador for a band and may encourage people to discover more about them.

"The band were all wearing jeans; Reni's jeans were white,
which reminds me of Aztec Camera from this era.
He had a boating-wear look going on; a hooded top with a tartan pattern on
the outside and a couple of tassels hanging from it, and was wearing boat pumps,
like he had his yacht moored up outside on the Manchester Ship Canal."

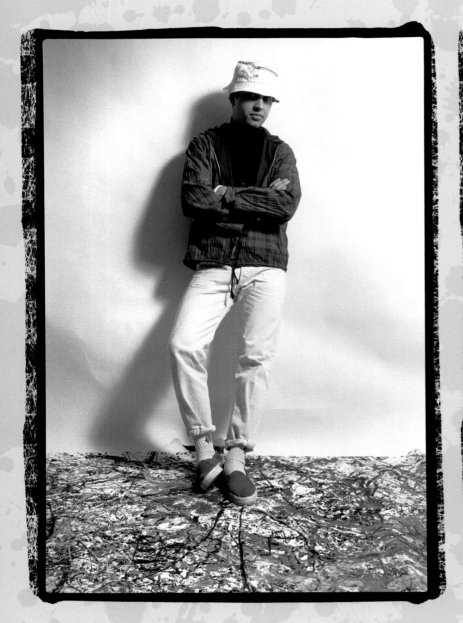 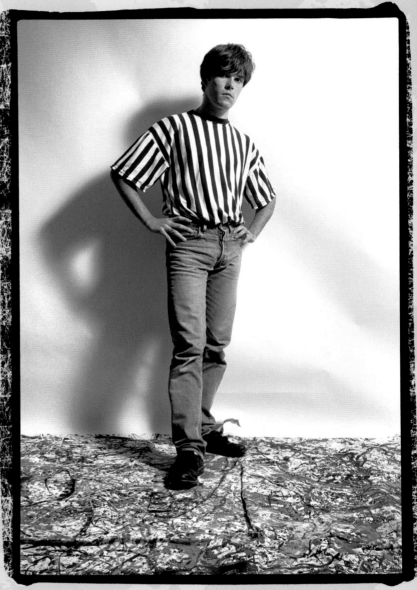

"I think this is the first time that I thought the lads looked really, really good. Reni had his Reni hat on, with a design feature of a zip pocket and badge on the front. Ian was wearing a vertically striped black & white T-shirt and beat-up looking shoes. Mani had a T-shirt with horizontal stripes and still had a Perry Boy look going on. John surprised me because he was wearing a thick Fair Isle jumper that stood out a mile, but it looked fine. I remember wearing Fair Isle back then too; it was a very granddaddy-type look and straight out of the charity shop.

"We all bought our clothes second-hand. Not many of my mates could afford to buy new clothes; maybe just our jeans and Doc Martens. It was only later when the trend for Lacoste and so on happened that people started buying new and expensive clothes as a way of showing they could afford it. It was a status thing which I've never got into. I was always a second-hand shop/Oxfam kid and people thought I was a bit weird because of that at times.

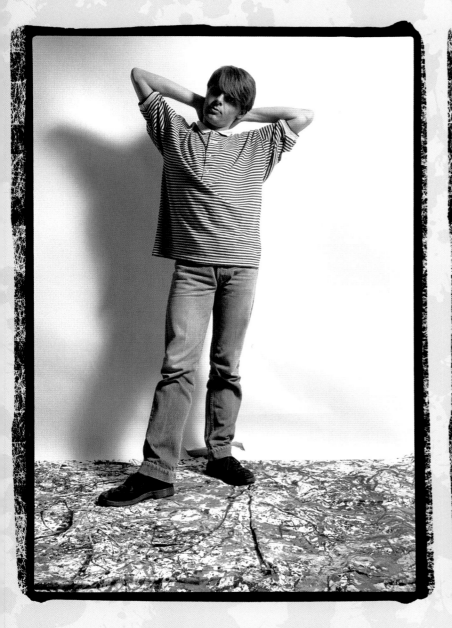
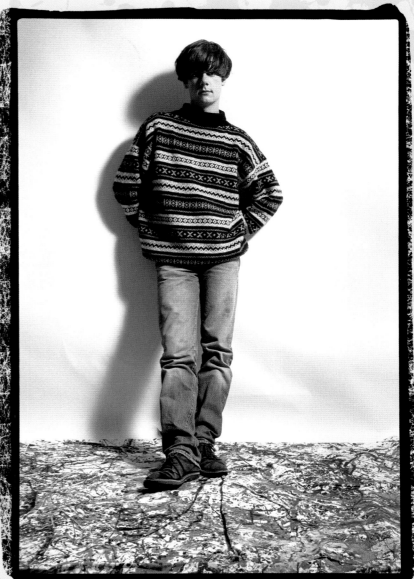

"They appeared more relaxed and comfortable in their casual threads.
It seemed like they had found a certain unified style, as now each of
them looked great individually but they also looked fantastic together."

"I directed a few poses and the band certainly looked good for this shoot. I recognise now that they were a unit, and that Mani had become such an integral and confident part of that gang. I was a loner, so the idea of this lads' gang intrigued me. It certainly felt great to be on the outside of that looking in, but then I always kept a distance. It was wrong to get too close, as I needed to keep a certain distance to be a good rock'n'roll photographer. It was the same with all the bands. I felt like I was on the periphery looking in, like some kind of voyeur.

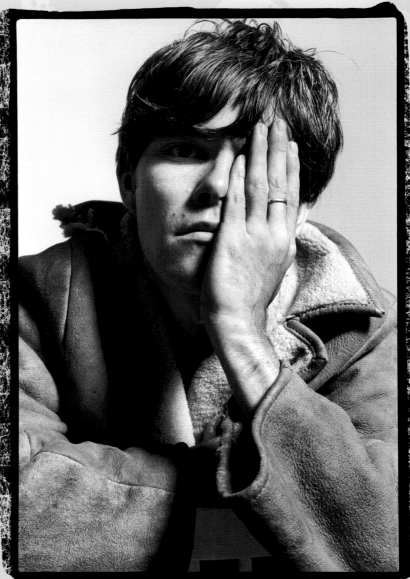

"Ian was in his big jacket with his hand over his eye;
see no evil, one eye peeking defiantly through his fingers."

"I took lots of individual shots of them on this shoot. There's a great one of John where he looks a little bit like he is praying. I like the
sharp symmetry of his pose.

"Reni looked handsome, although he had a bandage wrapped around his hand.
He had a scar like a large burn along his wrist.
Part of the bandage is loose and hanging down, but this look worked.
John's pose also has a good symmetry to it."

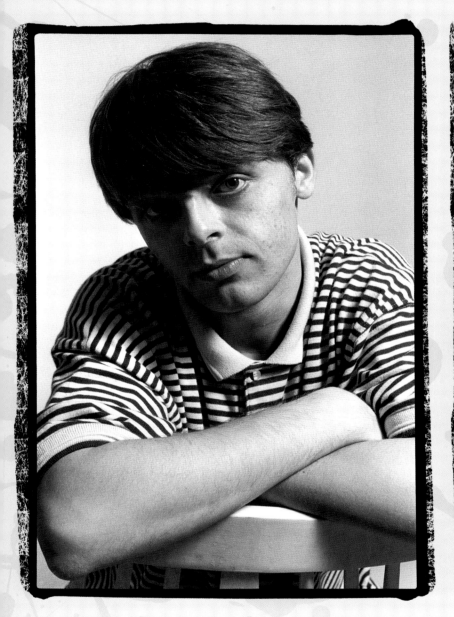 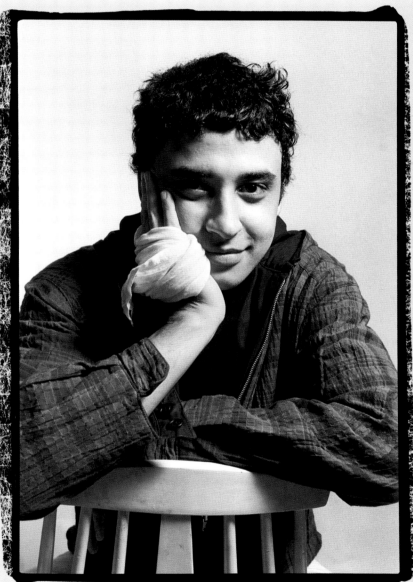

"The Roses had a key phrase they would use, unbeknown to the photographers and journalists,
if they felt a shoot had gone on too long or they were becoming bored.
One of them would say, 'Time for a Coke.' That was their cue.
I know this because Reni said it at this photo session.
'I think it's time for a Coke.' I was told by Adge (their tour manager) after the shoot
that the 'Coke' cue was their polite way of getting the hell out of there!

"Some bands don't have a clue about visual imagery. They want to be in a band for the love of music, so why should they want to have their pictures taken? Some musicians I have known dislike photographers and consider photo sessions to be an unnecessary evil. There was a period in the early Nineties where loads of bands just didn't want to have their photos taken. They rebelled and said, 'Just listen to the music, we're not having our pictures done.' And all power to them for their honesty. I found it interesting even if it was annoying at the same time."

INFRARED ROSES

"John had lots of different colours and paint pots and set to work,
carefully and artistically dropping the glossy paint.
He used a wooden stick a few inches above the glass surface,
making arc shapes and throwing movements in order to
apply the colour and give the splashes some life and texture."

"The band organised this shoot, which took place on September 7, 1988 at Gareth Evans' farm in Cheshire. It was a cottagey, quaint detached house, with grass fields all around, yet near the motorway which would take you north into Manchester or west into Liverpool within 40 minutes. John's idea was to use a massive piece of plate glass, which they'd already bought and he was going to paint on site. The glass was about seven foot square and really heavy, so there were two roadies helping to carry it around the field.

"So we then all stood around and watched John paint it. And he asked for my guidance: 'How thick shall I paint it? How much texture should I paint?' So I advised him. 'Well, you need to imagine you guys standing behind it. I need spaces in between, so that I can photograph you through those spaces. Just do it kind of evenly. Make sure the paint splashes and the dribbles are fairly even.' I was encouraging him by saying, 'Yeah, that's a good bit, that'll work really well' and 'Make sure you don't put any paint there 'cause I want to use that gap to see you through it.'

"It was a warm, sunny day, so within 10 minutes it began drying. When Chris and Phil lifted the glass upright a 'skin' had formed on the surface of the thickest paint but it was still runny underneath. Gravity caused the paint to ripple and undulate and this added to the overall visual effect. Mani, Ian and Reni were pretty quiet and chilled out, and they seemed to enjoy watching John, who was creatively absorbed in making this experimental piece of artwork.

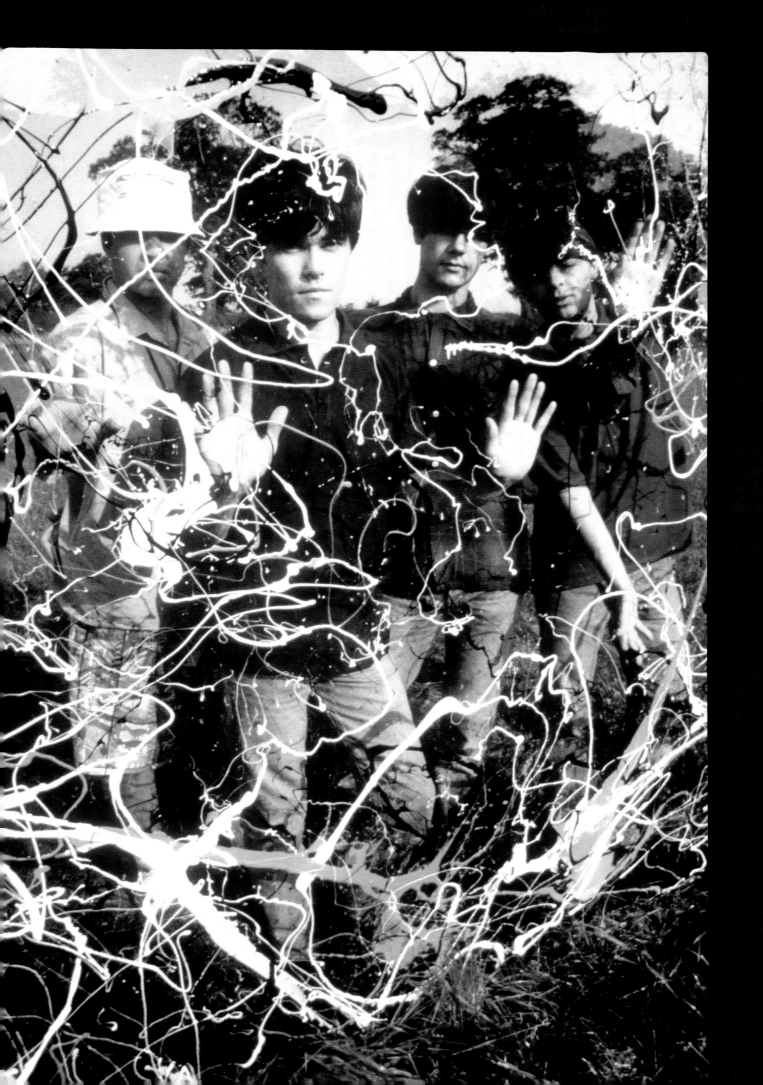

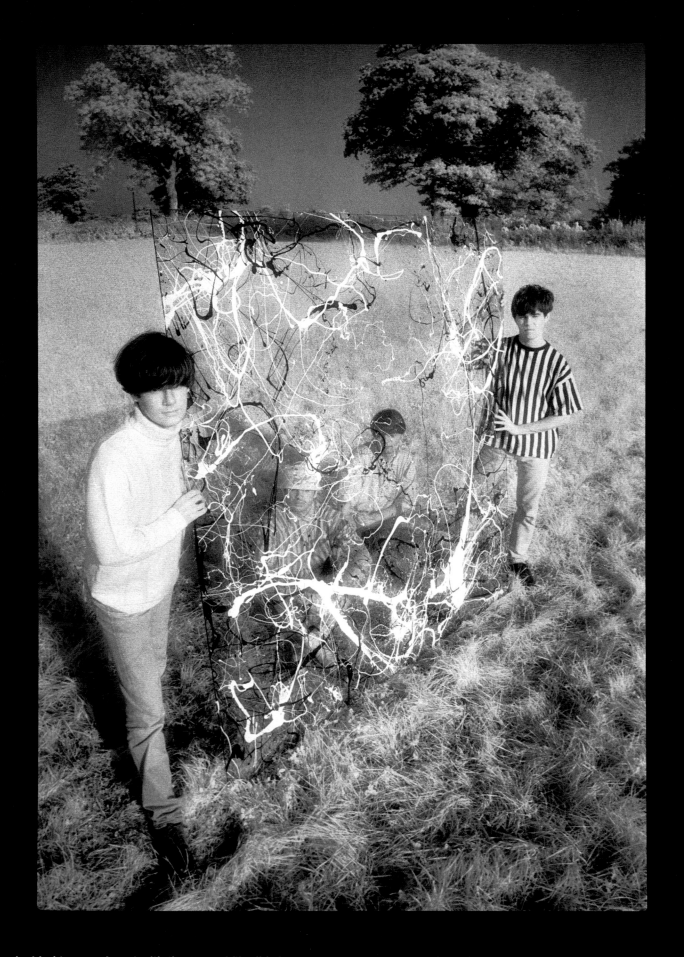

"I had also decided to experiment with the type of film I'd chosen to use that day. I'd used infrared effects film before and had been pleased with the results when working with Manchester's The Chameleons. You have to bracket with infrared as it is difficult film to expose correctly, so you have to hedge your bets. You take your first shot at what you think is the correct exposure, then on the second shot you increase the exposure by one stop and on the third shot decrease it by one stop. This should ensure that one of them is going to be right. You won't know which one it is until you've processed the film, and it's tricky to expose, so you'll need a dark red filter over the front. When you look through the SLR camera you can't see what you're looking at because it's too dark. I put a special deep red filter over the lens, so only the infrared part of the spectrum is reflected on to the film. I also had to load the film in a dark bag in the middle of the field, since you can't take infrared film out of its plastic container in daylight or otherwise it will fog.

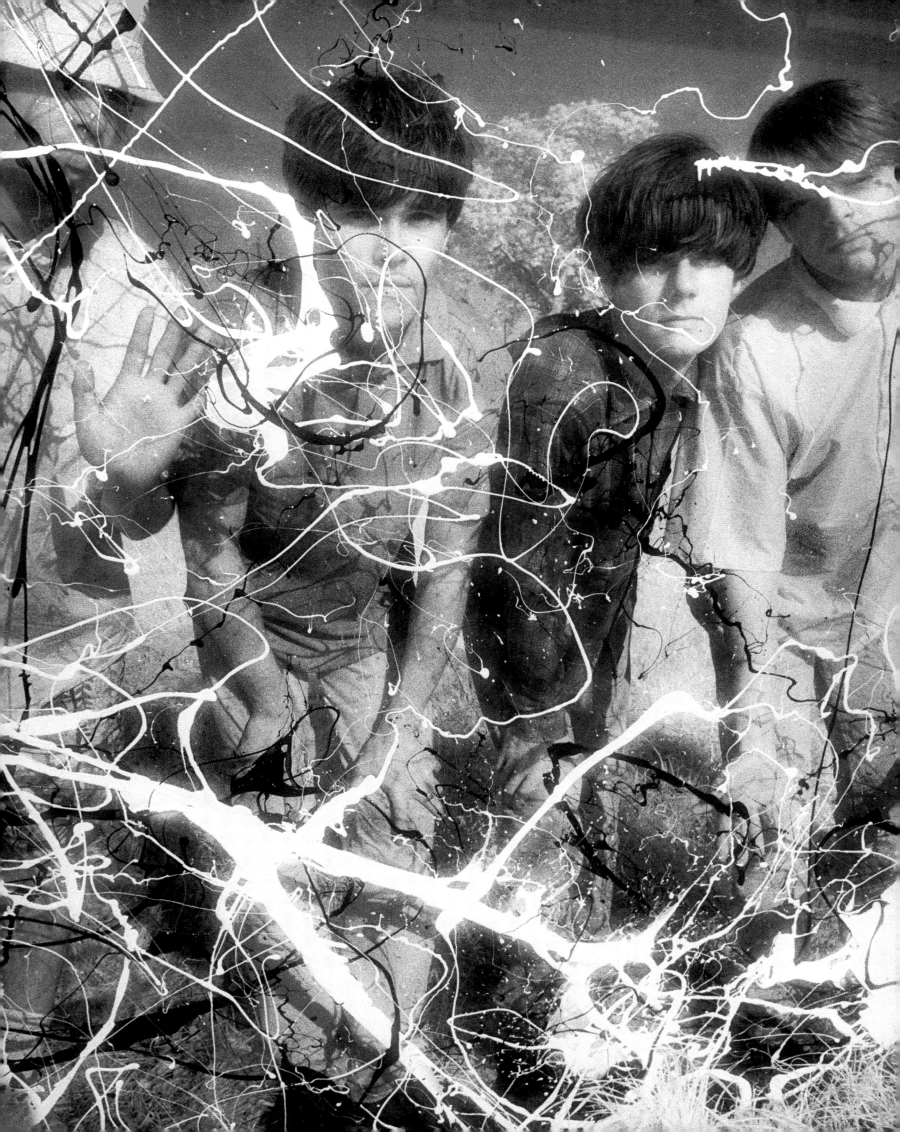

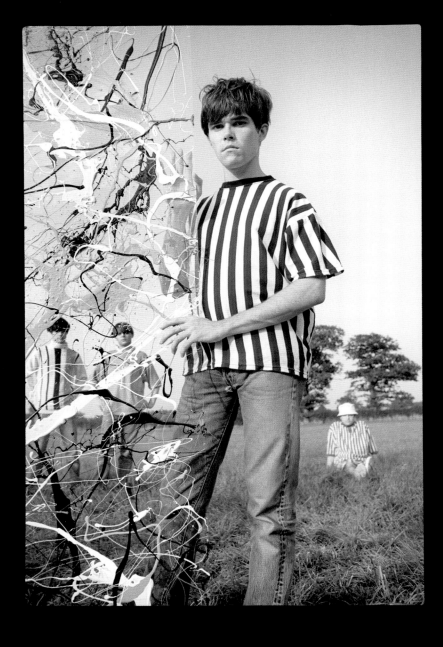

"After I had shot a roll of infrared black & white, and a roll of infrared colour, I put a roll of normal black & white through. The sun was moving lower in the sky and it was clouding over a little. I composed the first shot so that the left side of the picture was the painted glass, with John and Mani partly obscured behind it whilst the other half contained Ian, who was holding the glass upright, and Reni, who was sitting down in the distance. Two tall trees were also part of the composition. However, I was wondering whether John and Mani could be seen clearly enough. So I repositioned the band so everyone was behind the glass looking through, ensuring I could clearly see each individual through the spattered glass.

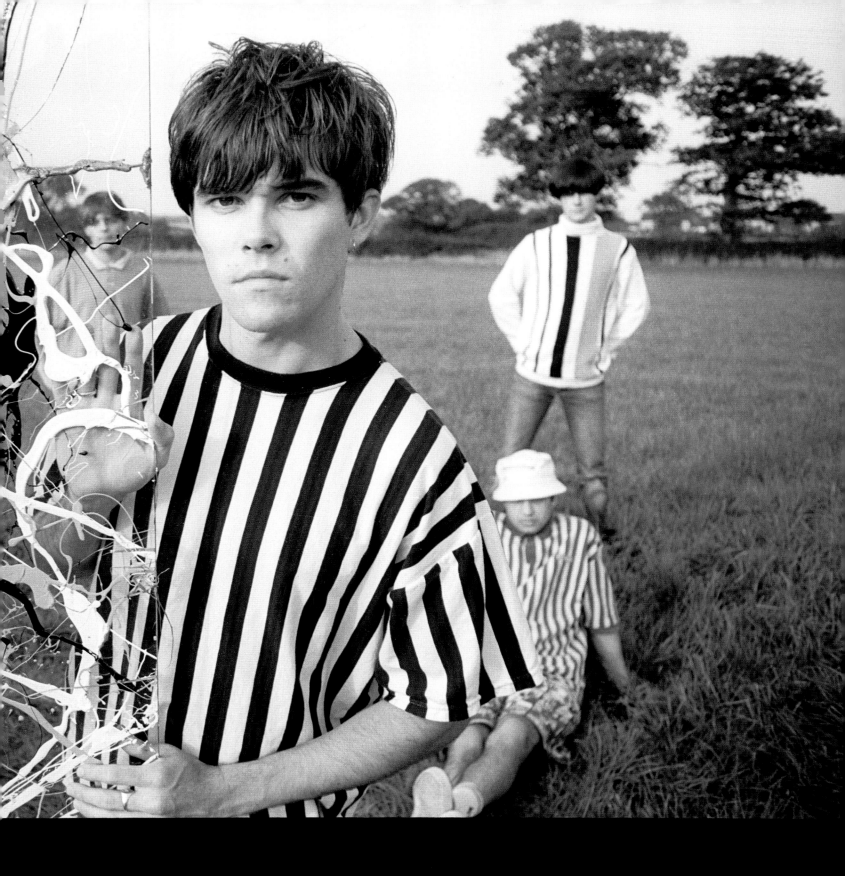

"Their clothes are an interesting reflection of their then-current influences. They evoke a Sixties psychedelic vibe, especially John with his Buffalo Springfield haircut. They're reminiscent of the LA band Love, too. Mani was dressed in his north Manchester 'casual' look; Ian Brown had a Sixties Roger Daltrey mod look going on; and Reni was wearing a striped Fred Perry-style top with his characteristic white Reni hat. His shorts, though, were markedly different, possibly a 'symbol of his individuality and belief in personal freedom' – bright batik squares of

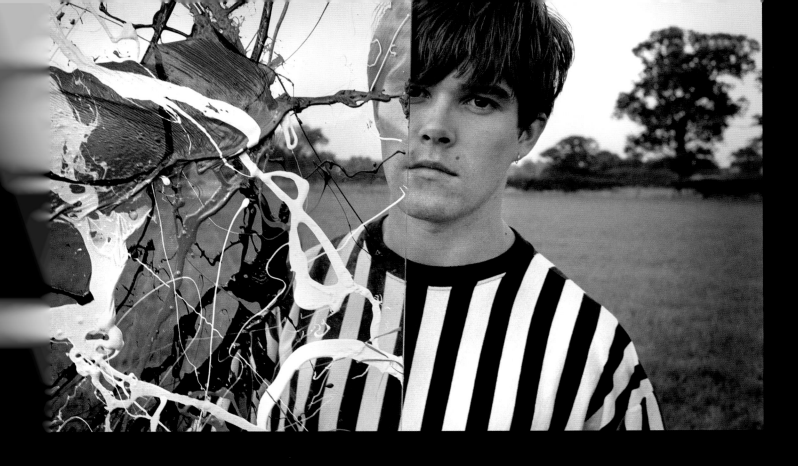
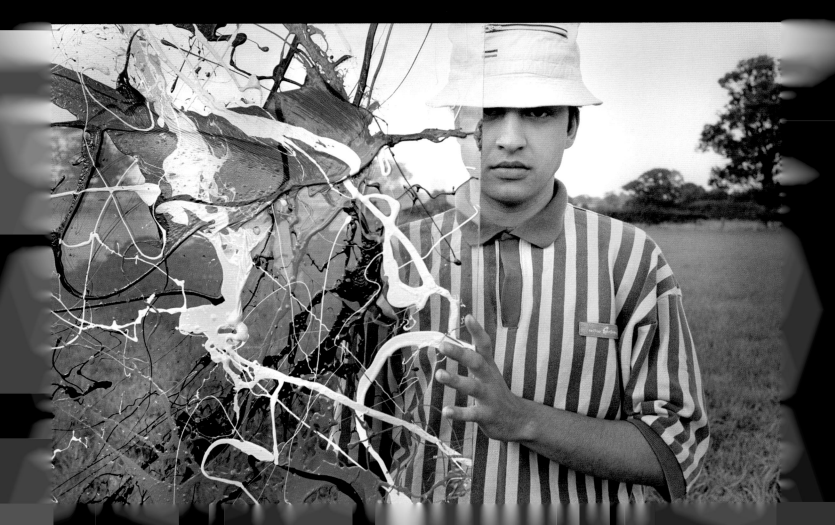

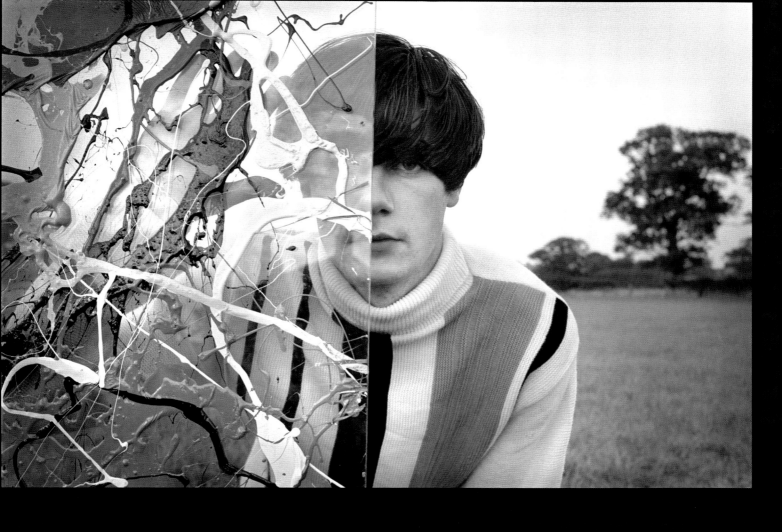

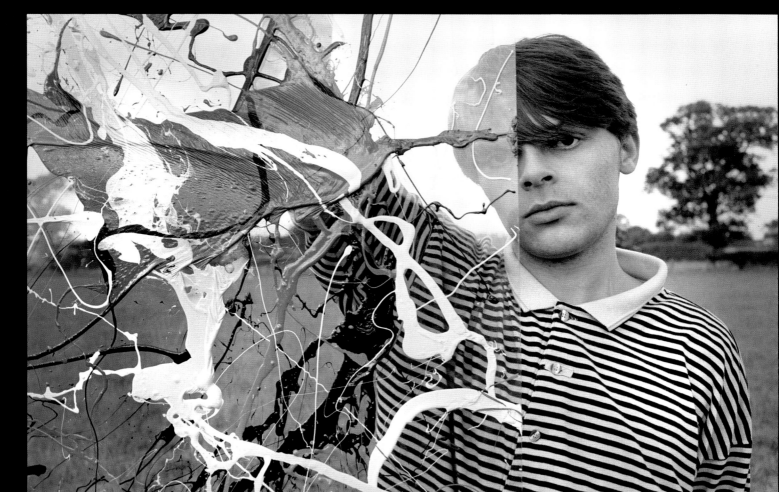

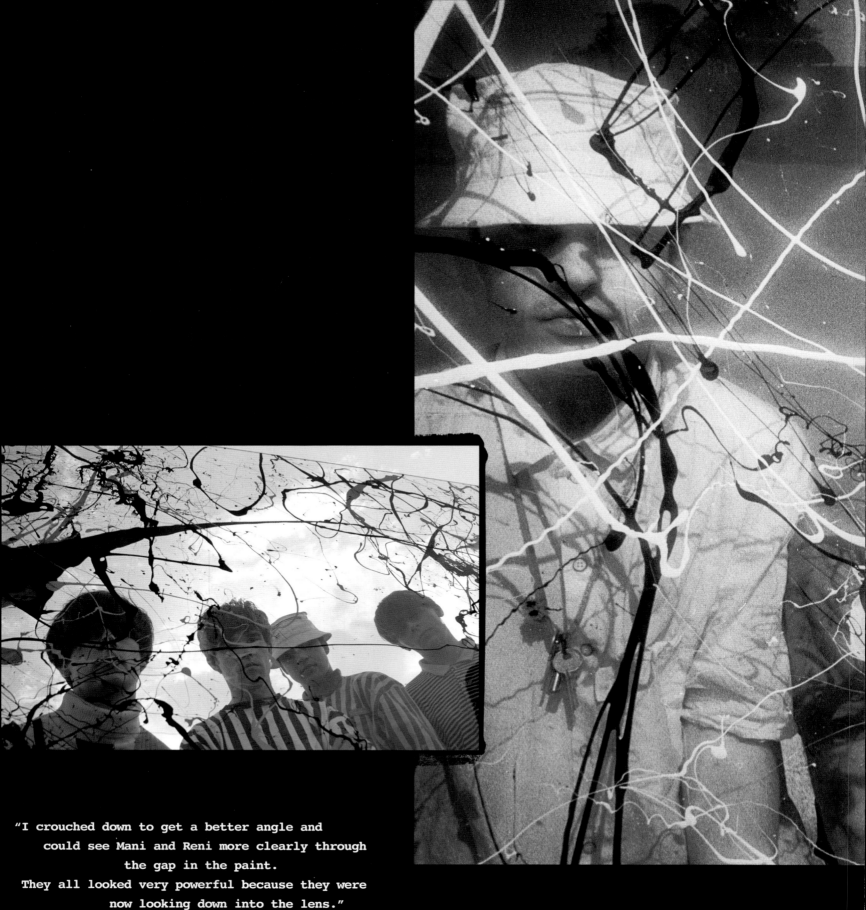

"I crouched down to get a better angle and
could see Mani and Reni more clearly through
the gap in the paint.
They all looked very powerful because they were
now looking down into the lens."

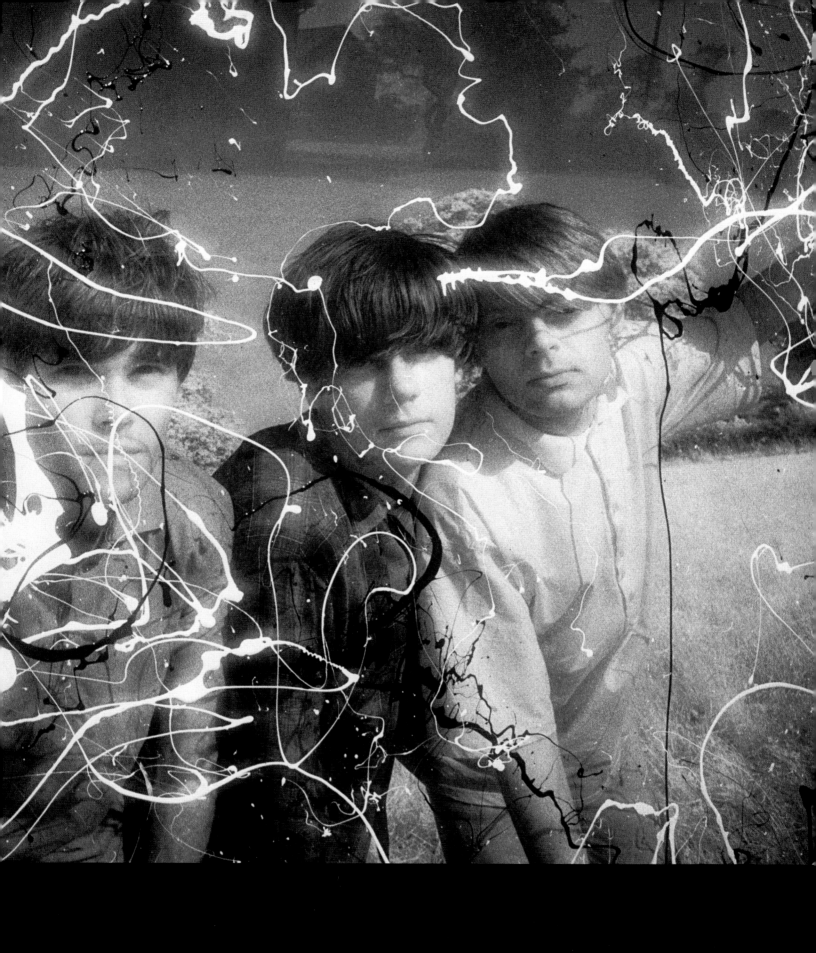

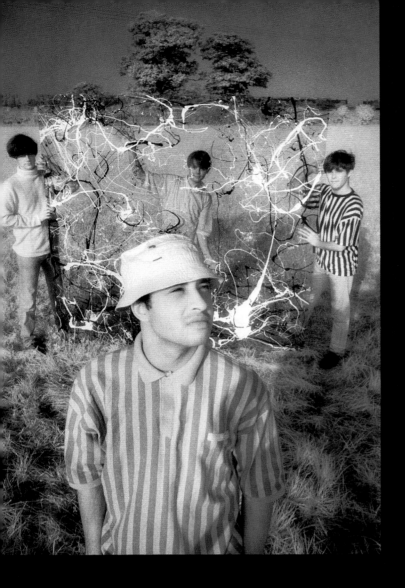

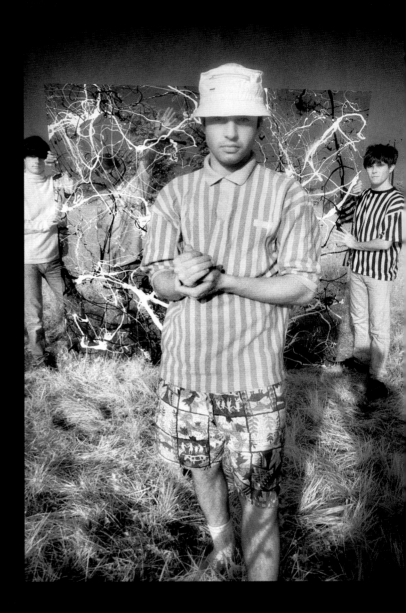

"In my experience pictures taken in infrared always come out well in
sunny conditions and that day the sun was shining down on us.
I used the trees and the field as major features in some of the shots.
It looks very snowy. The infrared does that to grass."

"I was less happy with the pictures taken later on in the session and that's why people haven't seen these outtakes before. I put Reni at
the front because he photographed very well. It makes a change for a drummer to be up front since they're usually shoved to the back of
both the stage and the photo session. It always seems to be singers and spunky guitarists at the front.

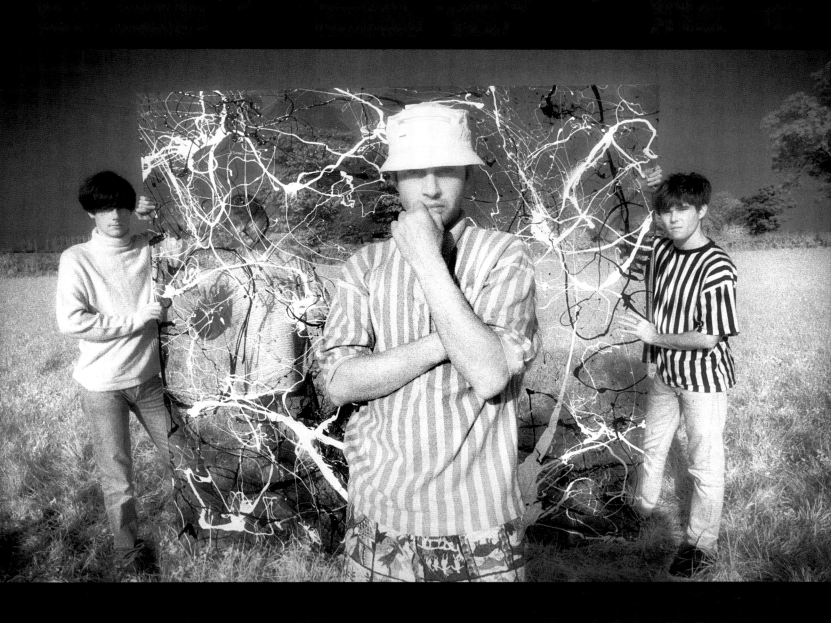

"Reni had a great voice that was used to complement Ian's lead vocals.
He was also one of the best drummers I had heard plus he could play keyboards and guitar.
All the members of the band were very talented musicians in their own right.
I thought Reni had a great look too, so on this shoot I decided to put him at the front."

Ian Brown had a really cool Chuck Berry T-shirt on and I asked him to cover it because I realised it said, 'Don't Fuck With Chuck'. I knew his T-shirt wouldn't get printed in the papers. It was a great shirt though."

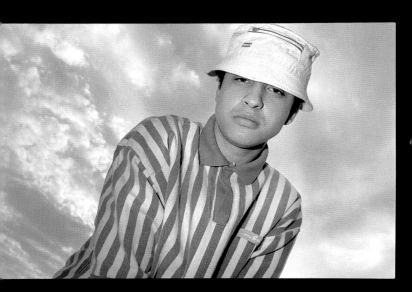
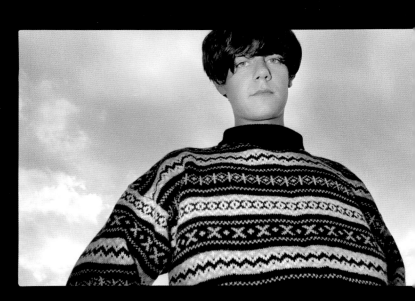

"John's photo is all jumpers, so I'm noticing the jumper rather than him and it makes it look like he's got a big beer belly, which he hadn' No wonder he wasn't keen on these."

"I'd taken a ladder along to use for some of the infrared photographs. I thought that if I could get high up it would show more of the grass and trees. I've still got that ladder, after all these years, and I still use it. It's splattered with years of paint. So I asked the Roses to stand on the ladder, one at a time, and I used a fill-in flash. I had wanted to photograph them from below, but it didn't really work because of the angle. On this series of photos I don't think they look as good as usual, probably because I shot them from below. It's not a very flattering angle because it emphasises a double chin and you end up looking right up their nostrils. However, if you're looking down it emphasises the eyes and hides those chins.

"These images don't work as well as the others I took of the Roses that day and that's why I've never used them. Unfortunately it was simply an effect that never really worked but we were really pleased with the infrared photos

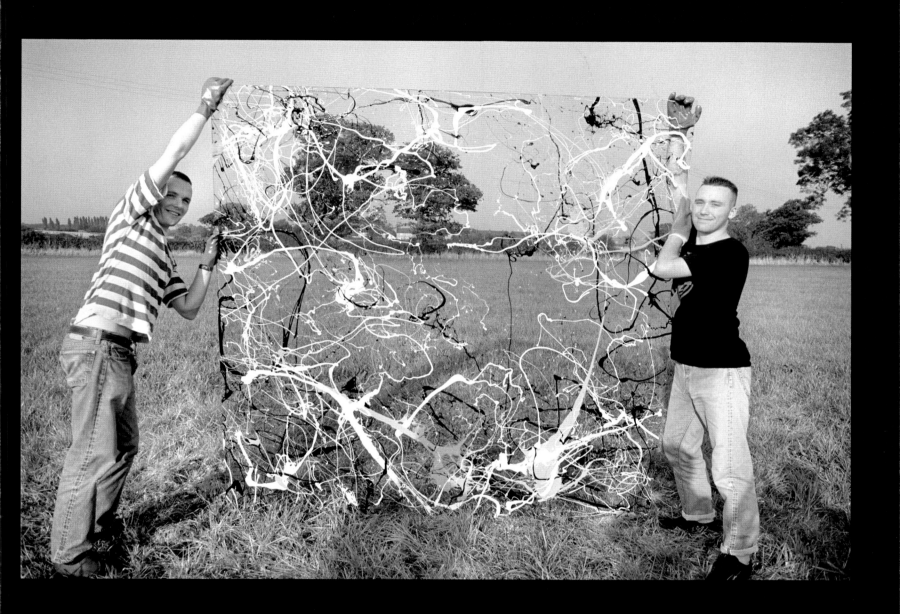

"Chris 'the piss' Griffiths and Phil Smith.
Be careful with this giant sheet of glass, lads.
If these shots don't come out right we might need to use it again."

"The shoot went well and I told them we're done. The band and I accompanied Chris and Phil, who were carrying the glass sheet in an upright position, all the way back through the field to Gareth's, where we decided to lay it down flat on the grass, near to where John had painted it just a few hours earlier. With our roadies at opposite ends and the glass about one foot off the grass, we could see that it was bowing stressfully under its own weight. So John alerted them to the situation: "Just be careful with th..." CRACK! CRASH! The giant glass sheet splintered into five or six triangular pieces and a few sharp shards flew up threateningly into the air. Ooops... The band smirked amusedly at the sight of Chris and Phil's expressions of bemusement while fragments of artistic debris lay shattered on the grass in front of them. John, still smirking, looked over at me and dryly remarked: "No reshoot on this one, eh, Ian?""

53

CHAPTER 7
STONE ME, WE'RE ON TV!

In early January 1989 Ian Tilton shot a series of photographs, which would later feature on the cover of The Stone Roses' groundbreaking début album, at Granada Television Centre, Quay Street, Manchester. This famous studio was also used in 1977 by photographer Andrew Kent for his portrait of a young Iggy Pop, featured on the Lust For Life *album cover.*

Ian recalls the day's juxtaposition of these indie rock radicals and television dinosaurs and details his creative processes.

"These pictures are featured on the album sleeve of The Stone Roses' début album, which came out on March 13, 1989. I photographed the lads for this in early January 1989, Gareth Evans having phoned me up on that same day. It seemed to be really spontaneous. Gareth said that the Roses were appearing on Tony Wilson's show, *The Other Side Of Midnight*, a pre-recorded programme. Wilson's show was at the time one of the only saving graces of Granada Television. We didn't have many programmes that featured good indie music.

So Gareth asked me, 'You're our photographer, what are you doing this afternoon? Can you come along?' He was really excited about it and declared, 'We've gotta get it documented!' I was free for the day, so I said, 'Yeah, absolutely! I'll come along.'

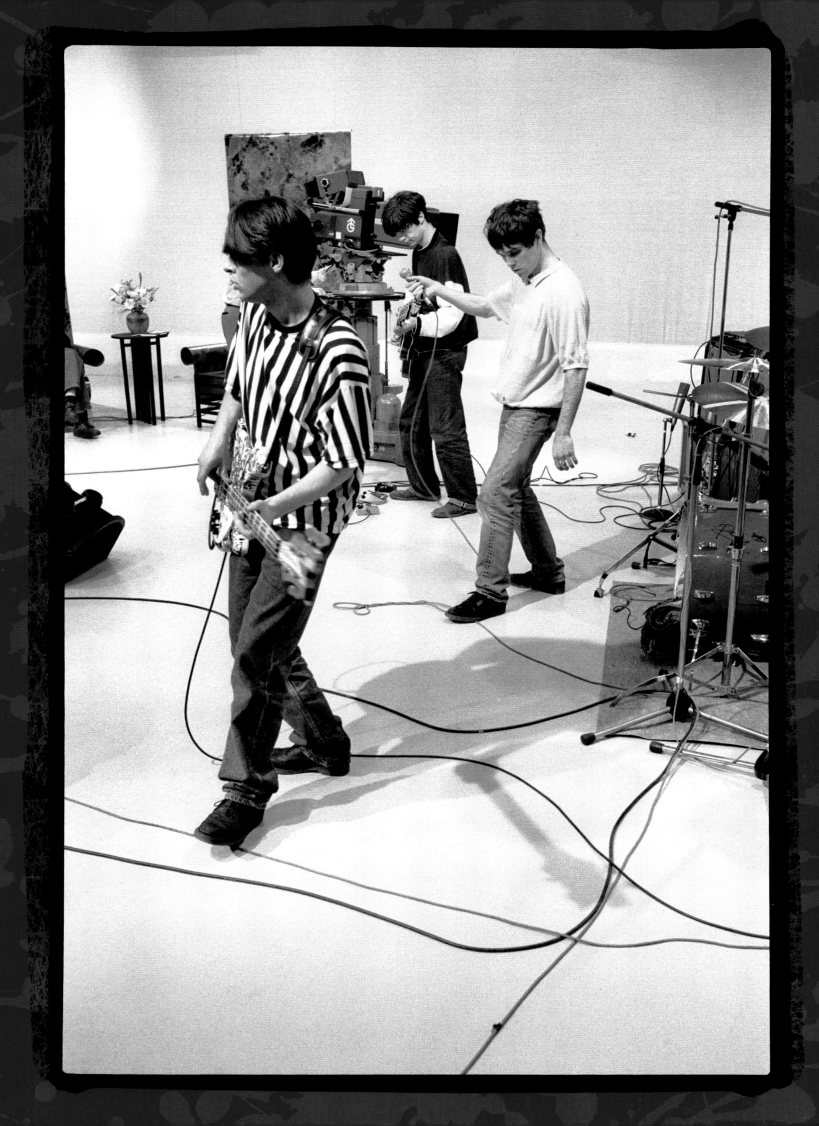

"To be honest, I think Tony got the Roses on the show because someone else had dropped out.
I don't think Wilson would've chosen them himself —
perhaps people were putting pressure on him 'cause the Roses were what people wanted to see.
They were even recommended to him by Ringo Starr."

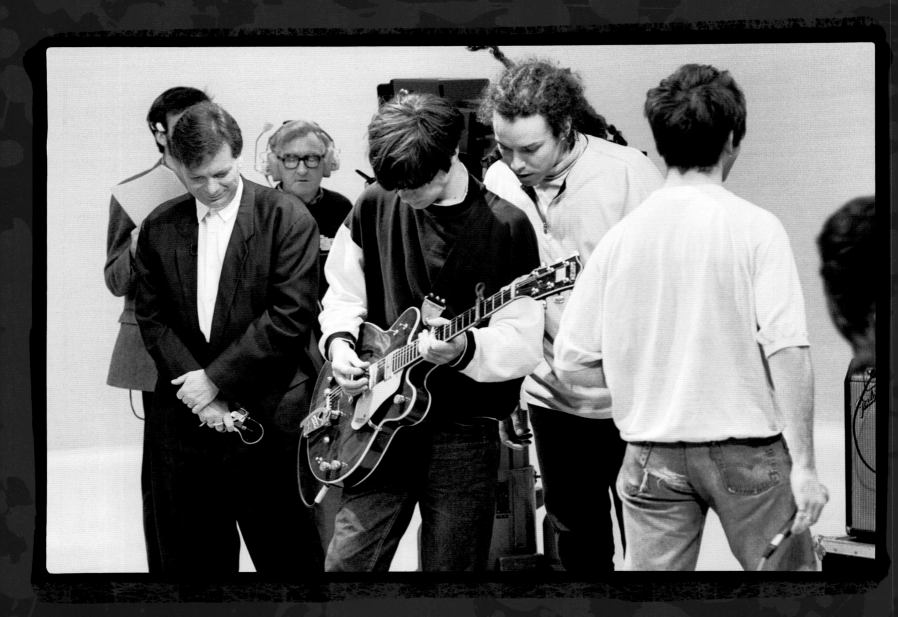

"Relaxing in between takes at Granada TV.
Tony Wilson is pictured on the left looking dapper in a smart suit and holding a microphone."

"We all went over to the studios in Gareth's car. The studio seemed pretty large, I remember. We didn't wait around, we just went straight in. The Roses' instruments were already set up, which surprised me. It just seemed really efficient compared to other shoots I'd been used to. I don't know how many big TV cameras there were, but I remember they were absolutely massive. They looked archaic, like Granada had been using them for years. They were like giant blue Robby the Robots.

"The production crew were all men, all older men, which seemed to add to the archaic-ness of the cameras. The production manager warned, 'You mustn't tread on the cables because they'll snag, or trip you up... And also watch out for the cameras 'cause if they bump into you they'll hurt as they're really heavy.' So I said to him defiantly, 'I'll pick my spot right here.' He laughed, 'Well, be prepared to leap out the way if they make a beeline for you!'

"I remember Wilson introducing the Roses live and he seemed apologetic. I think he was a little bit regretful that he hadn't signed them for Factory Records. But I can also see how he may have thought they weren't a Factory band. Even though Martin Hannett had produced them, they were guitar/rock orientated which Wilson didn't seem to like.

"The cameramen and their cameras moved around the floor really quickly and smoothly.
The cameras were taller than the men who were operating them.
They were really bulky-looking contraptions that had loads of wires trailing behind them."

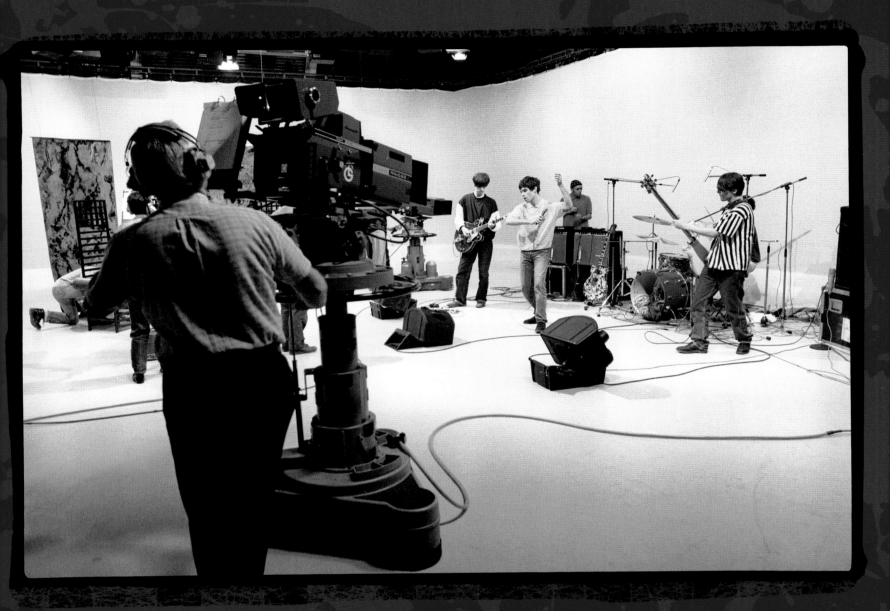

"Considering this was their first time in front of the TV cameras, the Roses were cool and took to it like groovy ducks to water. Brown skanked confidently around the studio doing his gangly, funky monkey dance.

"They did two takes of 'Waterfall'. There was a fantastic vibe about them as they weaved their way through 'Waterfall' and, despite the threat of the looming Robby the Robot cameras, I managed to capture a series of great shots.

"It was weeks later when John said, 'We're gonna use these photos, if you're all right with it, on the artwork for the album cover.' We hadn't planned to use the shots for the album cover, as at the time they just asked me to go along to document it. I hadn't charged them for the photo session. I just did it because I was their mate and I was pleased to be there.

"John came around to my house after I'd done the contact sheet and picked a load of prints. He said, 'I'll have that one, that one, that one and that one. Can you print them up? We're gonna use them on the album cover, and I've got to cut and paste them.' Back then design literally meant you had to cut the pictures using a scalpel and paste them using spray mount on to a piece of paper. Then you'd submit it to the printer, and they would do a copy of that on negative and then print it off.

57

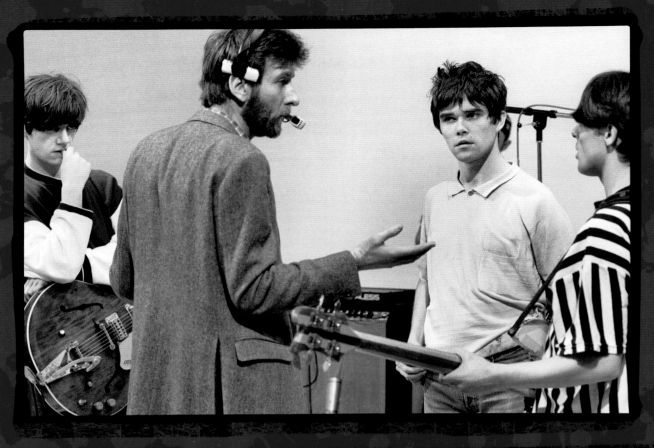

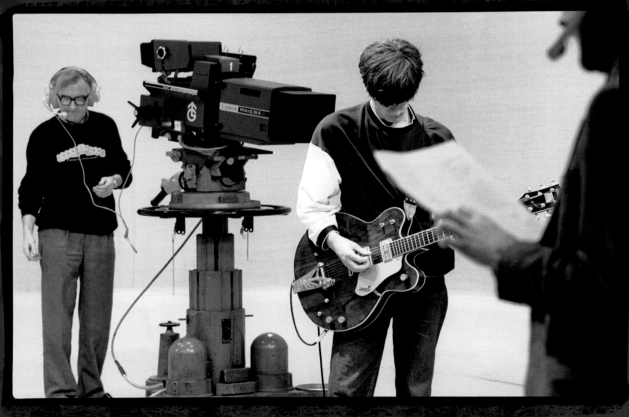

"So I printed up a load of pictures. I did charge them for these – I think I've still got the invoice for that. I charged something like £1.77 per print! They paid me for the ones they used. Surprisingly, at that time I didn't know people should pay you if they're gonna use your photos on a record cover and I just let it go. We never really talked about it. I think I was just really chuffed that the prints were gonna be used on the album sleeve.

"A week or two after that I got a call from Gareth, who said, 'The picture that John has chosen for the back sleeve is too dark. It needs to be clearer. It scums up too much when it is printed.' So I had to reprint that one overnight and get it back to the printers the next day. The printers posted me a test sheet of the album cover, not folded, on one large sheet of card. The photo on the back did look too dark, so I redid it for them in my darkroom. The proof print they sent me I still have. It's the only one in the world with a darker picture on the back sleeve and lemons on the cover, which are embossed and raised off the paper. It is the original prototype – a genuine Stone Roses artefact and collector's item."

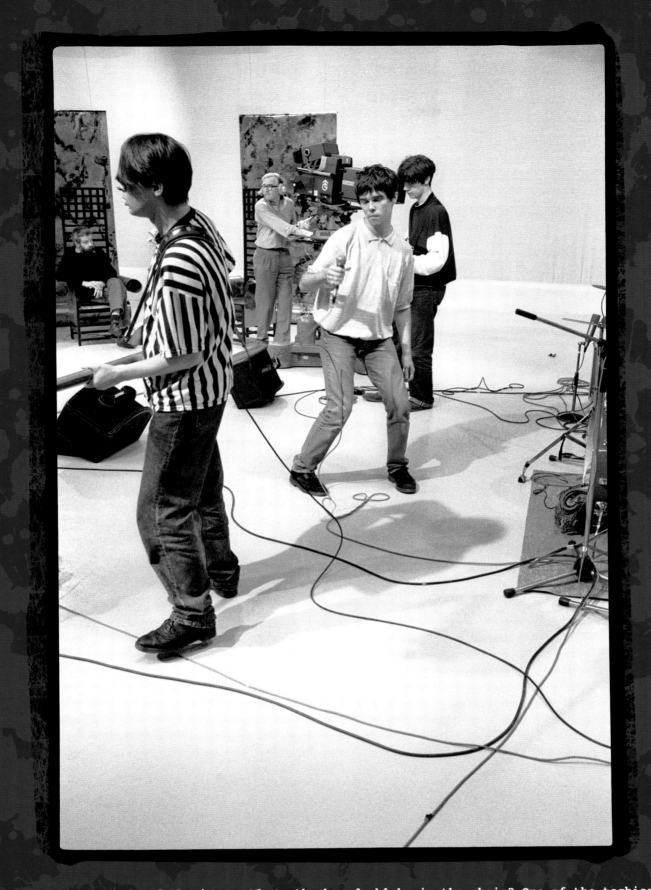

"Look to the left of the image. Who's the beardy bloke in the chair? One of the techies?
No, it's Mike Leigh, director of *Life Is Sweet*, *Naked* and *Secrets And Lies*.
Wonder what he was doing there? An early fan of the Roses maybe?"

"Once I'd done the reprint I went to John's house to drop it off. John and his partner Helen lived a few hundred yards from my house in Chorlton, just round the corner from where the Bee Gees went to school. He lived in a regular Manchester red brick, two-storey terrace on Longford Road, with a brass fox's head on the door knocker. When I got there he'd cut up the photos and pasted them to a big whiteboard. He'd laid them out in a grid-type montage, which looked great; slightly thrown together, but it worked.

"All of the pictures on the sleeve were mine, bar one which belonged to my friend Simon Taylor; he'd photographed them live as well. He now calls himself Gene Taylor, and Gene was road manager of The Fall for years. He was also in a band called The Miseries and I took some publicity shots for them a lot later on.

59

"Cressa was there looking brilliant in
the background like he always did.
I think he was operating some of
John's effect pedals as well.
He always had a kind of mixing desk in front of
him on top of a squat speaker, and he
would skank around and dance behind it."

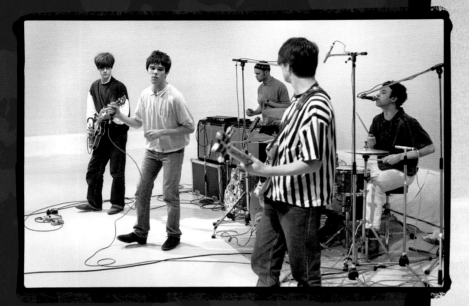

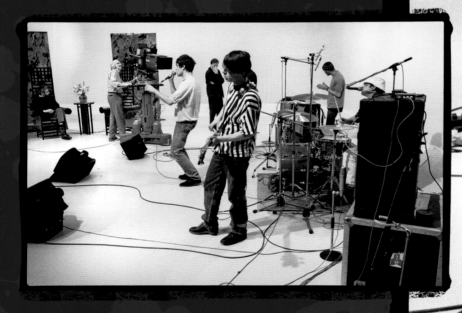

"You can see from my photographs that
Reni did one take with his white Reni hat
on and one take without it.
In the final take the hat's on."

"We sat on the floor of John and Helen's front room. Squire placed a cassette of the Roses' unfinished recordings in his ghettoblaster.
He was excited about their recent experiments of recording the guitar and playing it backwards, using the sound to produce the tune.
I later recognised it as 'Don't Stop'. I loved it the first time I heard this 'guitar track playing backwards' idea when John Lennon did it in the
Sixties on the *Revolver* album tracks 'Tomorrow Never Knows' and 'I'm Only Sleeping'. It was reminiscent of The Beatles' work and I wasn't
impressed. I knew it had been done before. In my head I was thinking, 'I don't think you should do that.' I couldn't say that to John, but I'm
sure he picked up that I wasn't into it. But, how wrong I was! I was wrong and John Squire was right. That's why I'm not a musician and
he is a world famous guitarist. I changed my mind about originality and what it means when I read a quote by Jim Jarmusch – the one that
begins: 'Nothing is original. Steal from anywhere that resonates with inspiration or fuels your imagination...'"

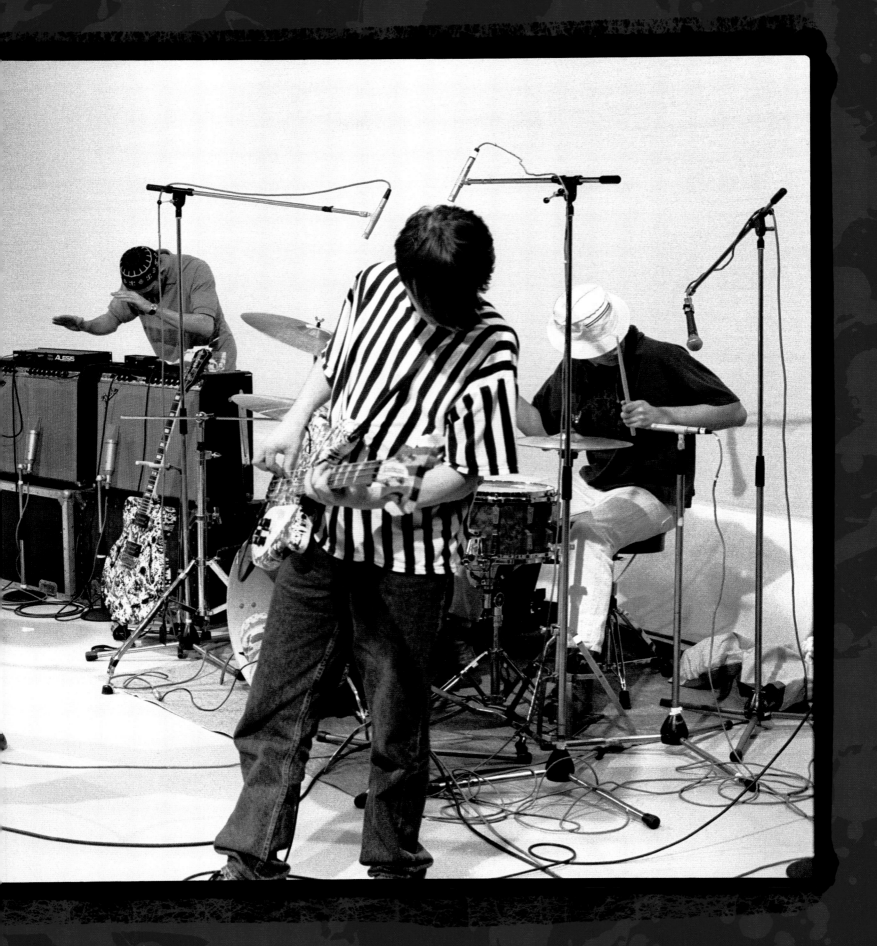

Ian recalls the first time he saw his photographs on the album sleeve: "I felt fantastic! Particularly about the one on the back. I liked that one. They'd given me a photo credit that was the same size as the one John Leckie got for producing the album! I thought, 'Yeah, they've honoured me nicely on this one.' They showed me that they valued me. I've had work in books before where they've missed my name off or credited my work to another photographer. The photo credit always seems to be the last one that goes on. So I was really pleased with the credit and really felt encouraged. I didn't have a clue that this album, their début, would sell millions, become a classic album and be loved all around the world. And my pictures were a part of that. But if you'd have told me that at the time I would've found it difficult to believe, because although I liked The Stone Roses I couldn't see them going mainstream.

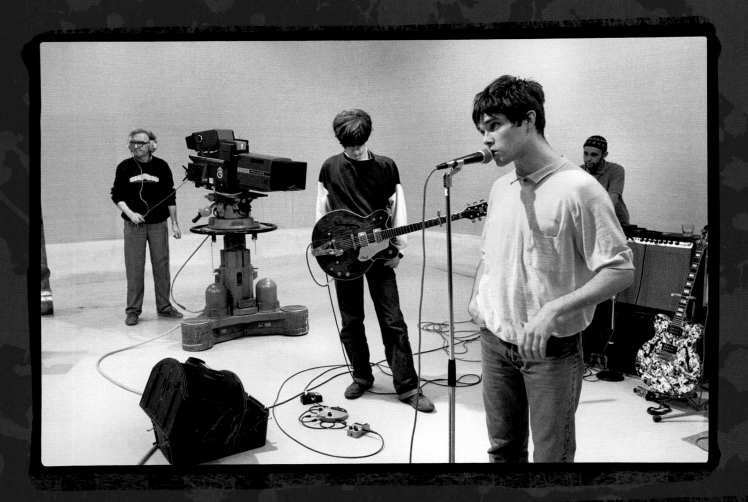

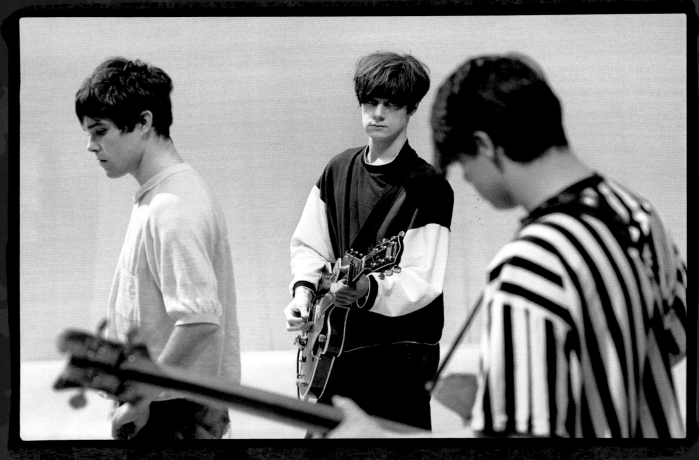

"There were a few disparate things happening around Manchester and there was some great music especially coming out of Hulme. There was some pretty hard stuff coming out that was interesting, plus some avant garde music like Tools You Can Trust. I covered a small rap scene in Hulme and documented early English hip hop bands like The Ruthless Rap Assassins. I found this scene really exciting. The only big indie band at the time was The Chameleons, and they'd just split up. Who'd have thought then that The Stone Roses, the Happy Mondays, James and the Inspiral Carpets would be the centre of attention in a year's time. Later the entire world seemed to want a piece of this Manchester scene.

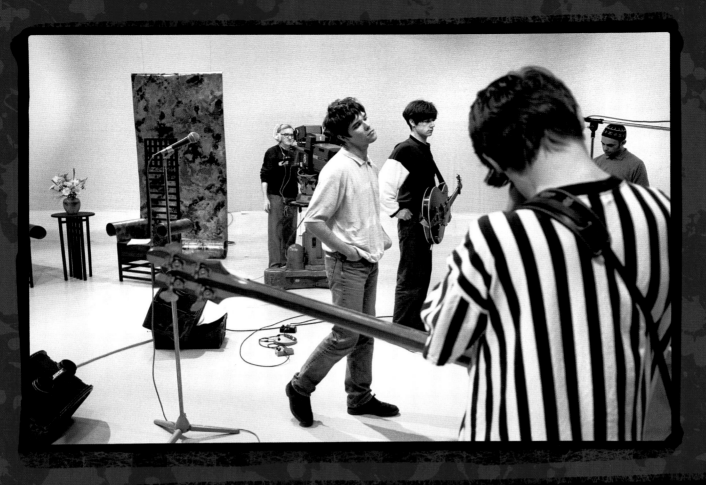

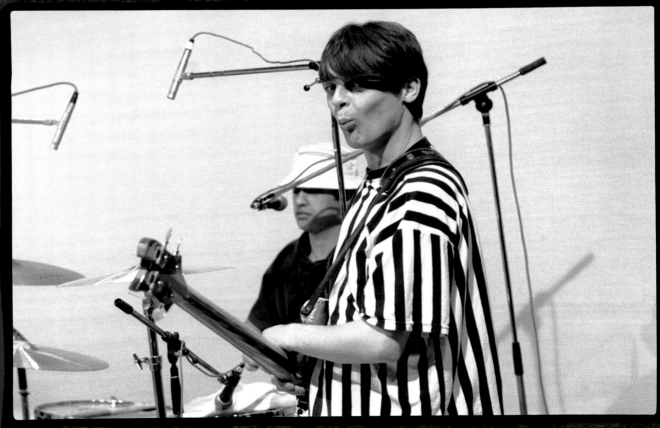

"Perhaps because the music scene had gone stagnant and London-centric, the world seemed ready for both the Roses and Happy Mondays. The world was waiting for something better, something to be a part of. The Manchester scene, which later became Madchester, was new and interesting. In 1988 the word 'MADchester' wasn't used by us. It was created by the media. We didn't think we even had a scene. What happened was The Stone Roses built up a great fanbase in north-west England, as did the Happy Mondays and later on The Charlatans. So they were already popular before the press knew it. Then when the press realised something brilliant was happening in Manchester, they came up to investigate. At which point they saw we had created something on our own without needing the press to market it. The press thought that for anyone to be famous they needed to get their faces into the *NME*, so it surprised them that the fanbase was already so big up in the north."

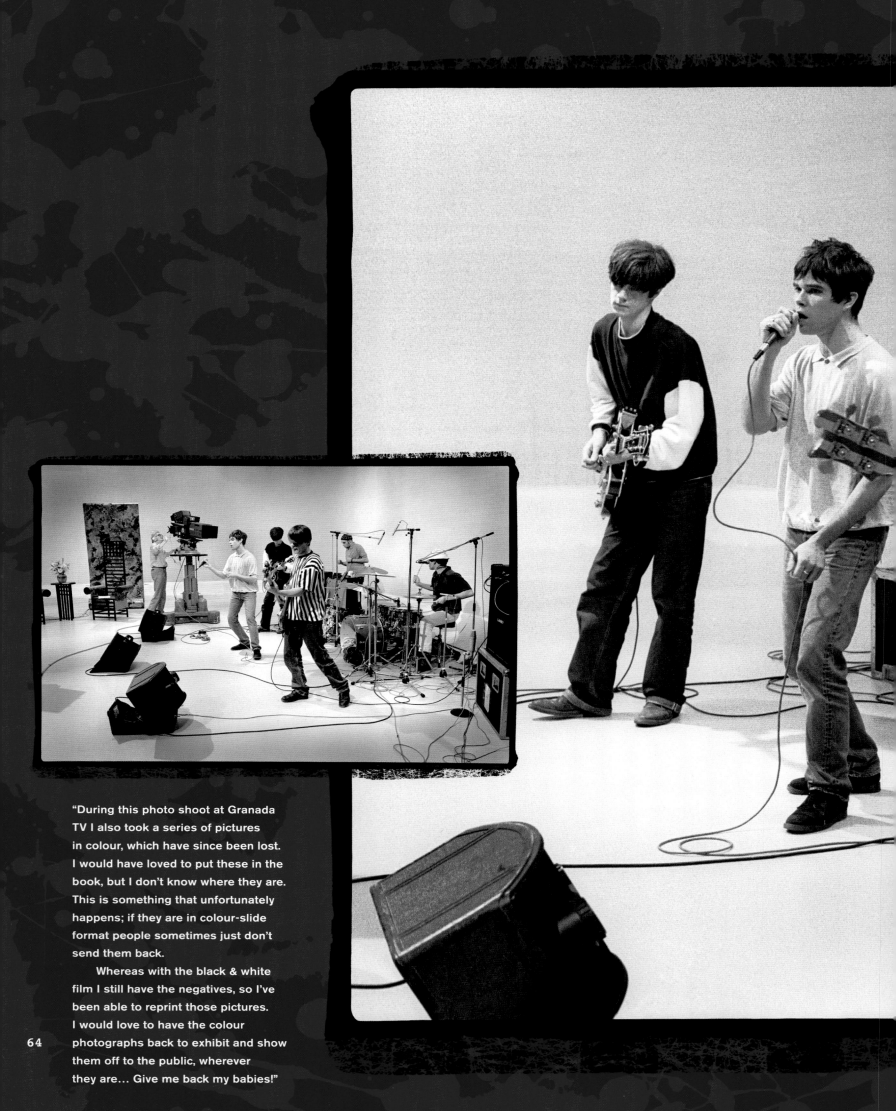

"During this photo shoot at Granada TV I also took a series of pictures in colour, which have since been lost. I would have loved to put these in the book, but I don't know where they are. This is something that unfortunately happens; if they are in colour-slide format people sometimes just don't send them back.

Whereas with the black & white film I still have the negatives, so I've been able to reprint those pictures. I would love to have the colour photographs back to exhibit and show them off to the public, wherever they are… Give me back my babies!"

64

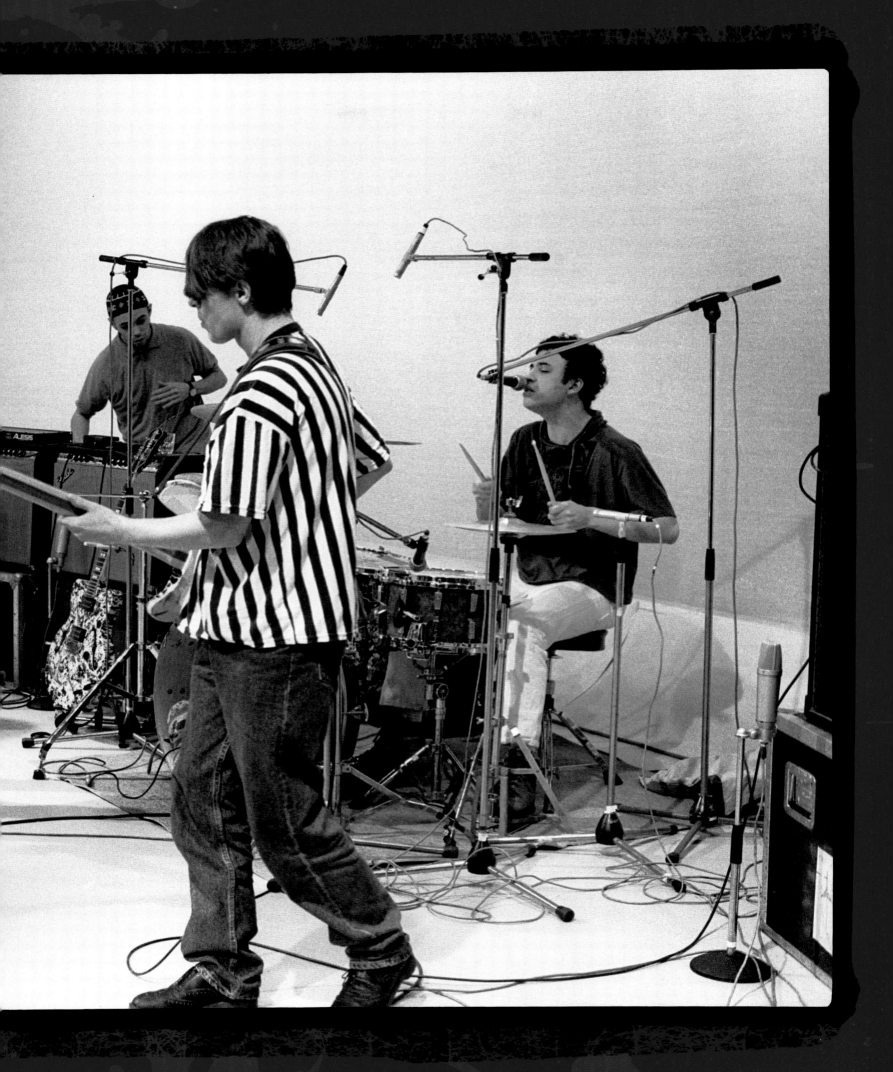

CHAPTER 8
TWO MANCHESTER ICONS:
THE ROSES AND THE HAÇIENDA

When The Stone Roses played Manchester's Haçienda on February 27, 1989 it was a moment to go down in music history. Both the Haçienda and The Stone Roses were fast becoming not just local icons but national institutions.

The London press was unaware that the gig had sold out, not realising that the Roses together with the Happy Mondays, the Inspiral Carpets and 808 State were going to lead the next youth culture scene. And it wasn't going to be a London-centric one.

Tilton explains: "I phoned up the live gig editor on *Sounds*, Sean Phillips, and asked him if he wanted me to cover this? He said, 'Leave it with me and I'll get back to you.' I phoned up again two days before the gig and said, 'You didn't get back to me over the last two weeks. Do you want me to cover it for you?' Sean paused, and said, 'Err… I've not really thought about it.' So I told him, 'You know they're gonna pack out the Haçienda?' Sean was totally surprised and replied, 'Well I suppose so, but I don't know who's gonna write it up. Do it anyway and we'll worry about that later.'

They ended up with just the photos since *Sounds* hadn't sent a journalist to cover it. Sam King put together a piece enthusing about the demo tapes that he had heard, but he couldn't make it up to the gig from London. However, journalist Andrew Collins managed to be there, penning a classic quote in his article for *NME*: 'Bollocks to Morrissey at Wolverhampton, to The Sundays at The Falcon, to PWEI at Brixton – I'm already drafting a letter to my grandchildren telling them that I saw The Stone Roses at the Haçienda."

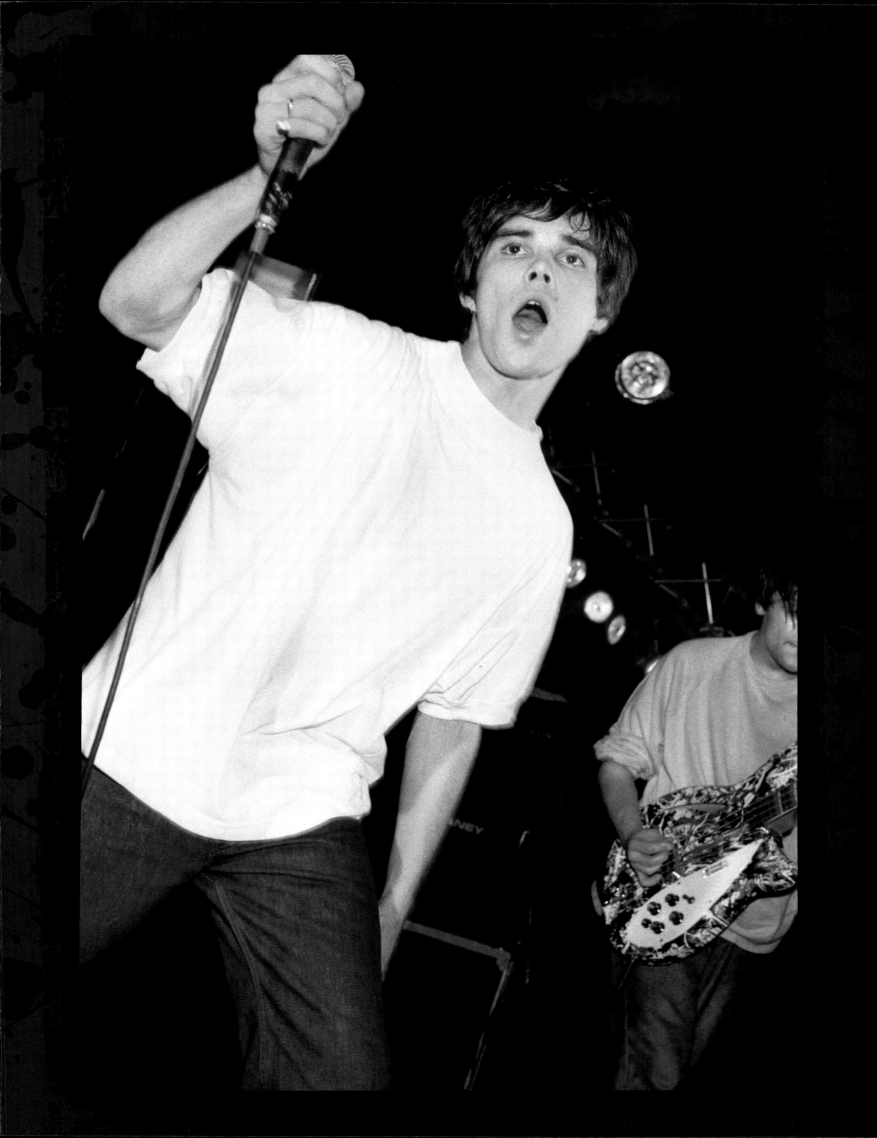

"Snub Television filmed the whole gig, which is another reason the gig was
such a big deal, because the Roses were getting more TV coverage.
I made sure that I didn't place myself in the line of the video, so that the operators could do their job.
I took a lot of pictures with flash and a few without.
The ones with flash froze the action but it flattened the atmosphere of the photos.
The lighting was bright enough for video but not bright enough for film,
so I only took a few pictures without flash."

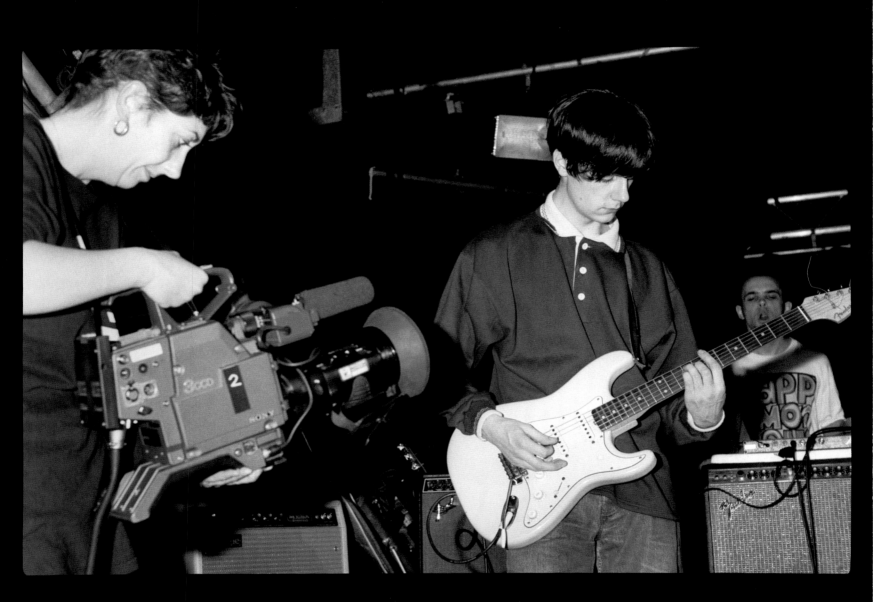

By 1989 The Stone Roses had managed to build up a big following in the north-west, largely through the gigs they played throughout the region, and gained a loyal fanbase amongst Smiths fans, whose earlier idols' light went out in 1987. Johnny Marr's fans found their new hero in diffident guitarist John Squire.

The Perry Boys were another important part of the Roses' fanbase. They were the north's equivalent of the spiv, dressing casually, drinking copiously and living raucously. Throwbacks to the football hooligans of the early Eighties and heavily connected to the Scooter Boys,

Andy Couzens (original Stone Roses guitarist), Mani and Cressa had been part of the Timperley boys of south Manchester. The Perry Boys seemed to originate in north Manchester, especially in the burnt-out industrial towns of the north-west; places where there was nothing better to do on a Friday night than get arseholed on a concoction of strong booze, strong drugs and equally strong bullshit.

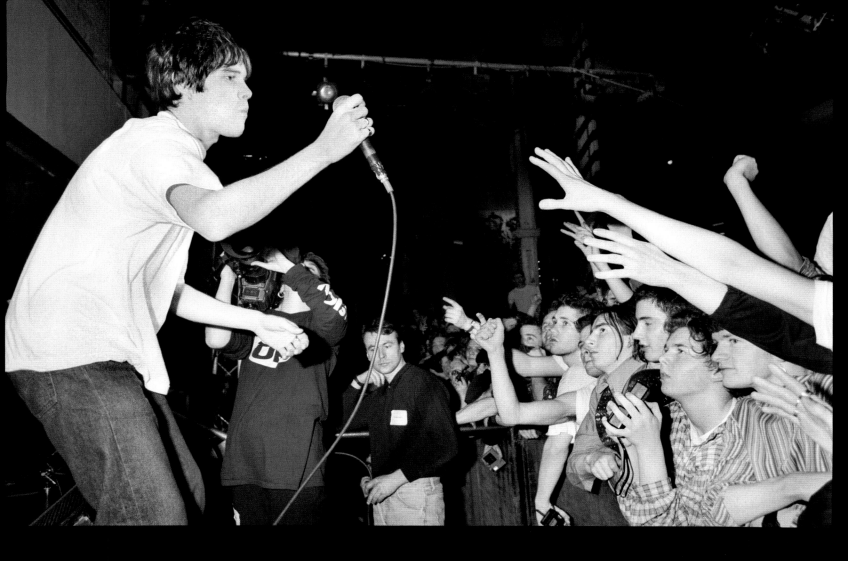

"The place was sold out and people were pressed up against the safety barrier at the front.
Many of the faces I recognised from other gigs at Gareth Evans' club, The International.
On the balcony above the dancefloor, crowds of people were watching the band."

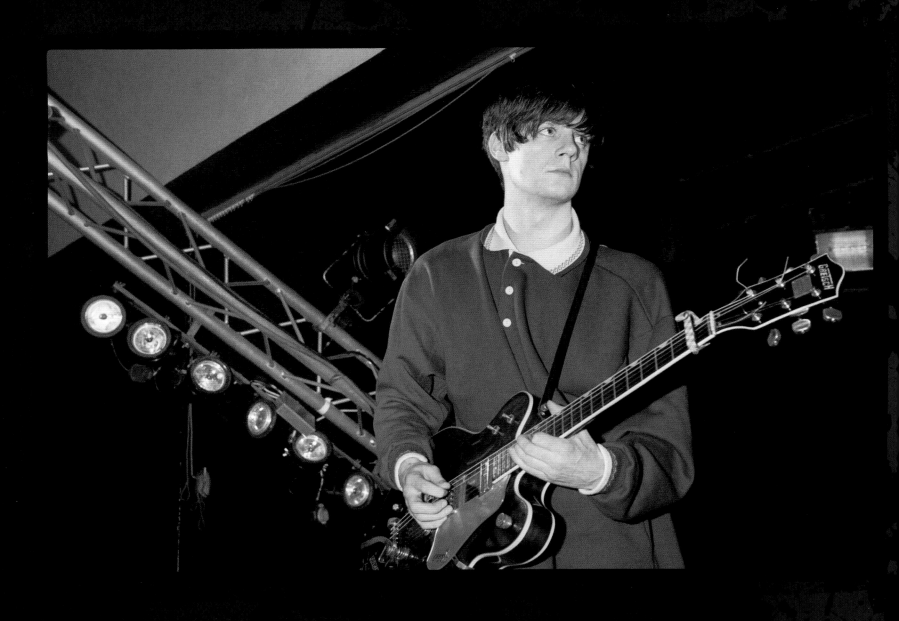

"John Squire playing his treasured Sixties Country Gent Gretsch semi-acoustic guitar.
Gents were also seriously favoured by Robert Smith of the Cure,
Brian Setzer from The Stray Cats and Billy Duffy of the Cult."

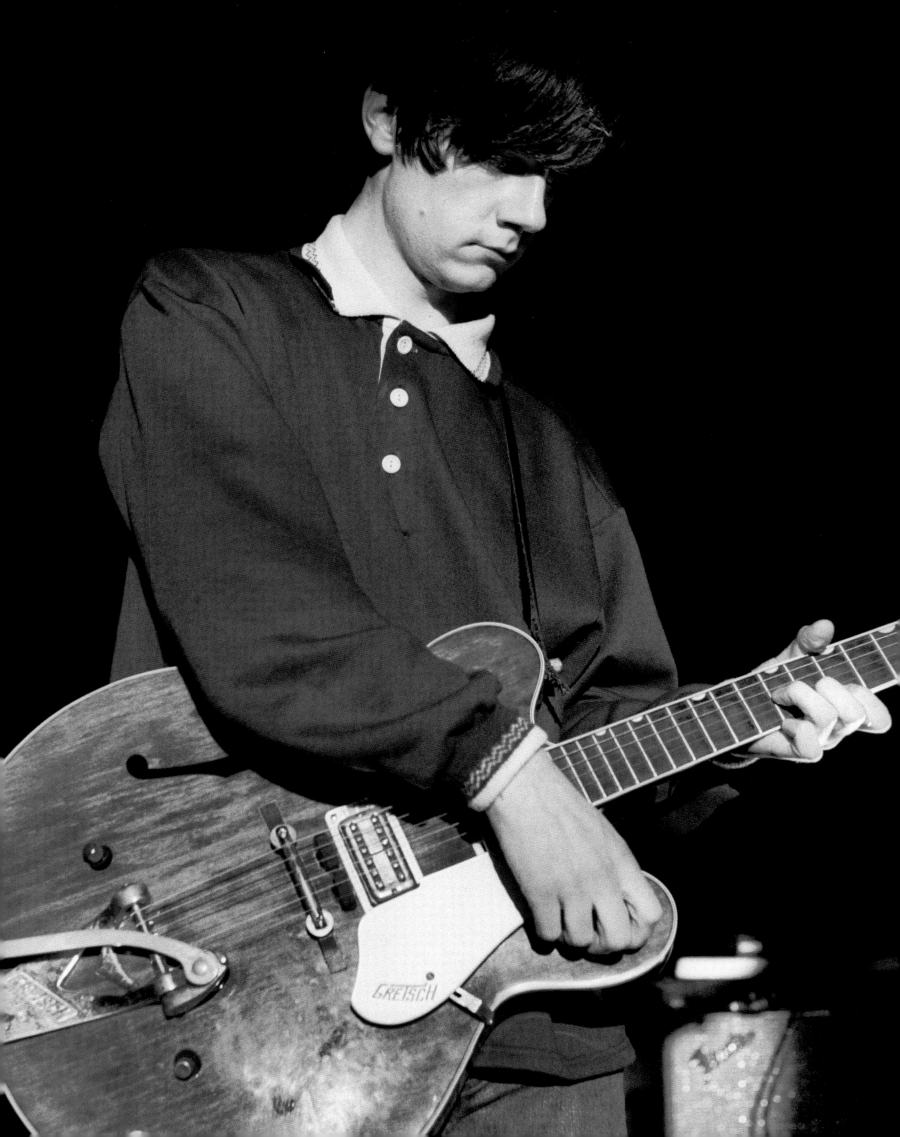

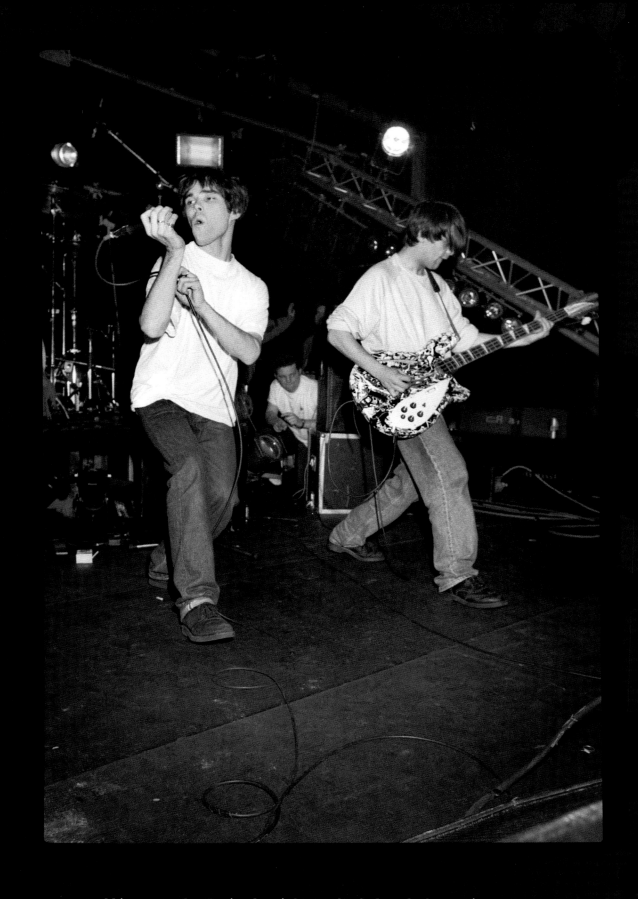

"Selling out the Haçienda without the help of the music press
felt like the lads had really cracked it.
The press now had to catch up with the Roses."

"For live bands the Haçienda fell short, especially sound wise. If you were a paying punter it was hard to see the band, with the low stage and the low ceiling above the stage. But as a dance venue it was an amazing place! We were so lucky to have fantastic DJs like Greg Wilson, Mike Pickering and Dave Haslam. It's interesting that the DJs weren't revered at the time, but they knew which songs got the crowd dancing and how to create an atmosphere. These guys were the pioneers.

"At the end of the gig I had to go quickly back to my darkroom in Chorlton to process the film. Following the unexpected success of the Haçienda gig the *Sounds* deadline had suddenly become very urgent."

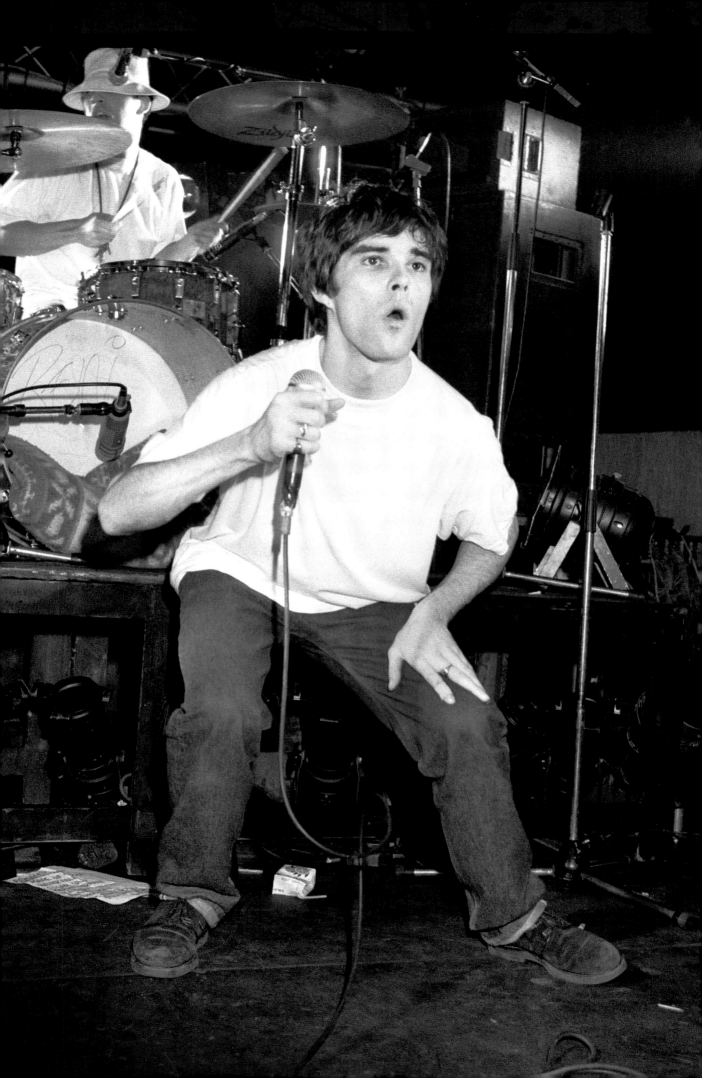

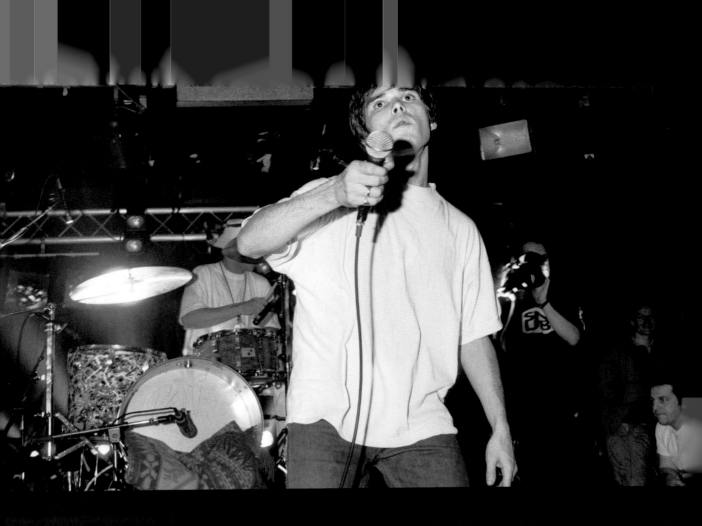

"The Stone Roses were well received; there was a real buzz about them.
Ian was skanking around the stage really well.
He was monkeying around, enjoying the vibe, and also sat down to play bongos."

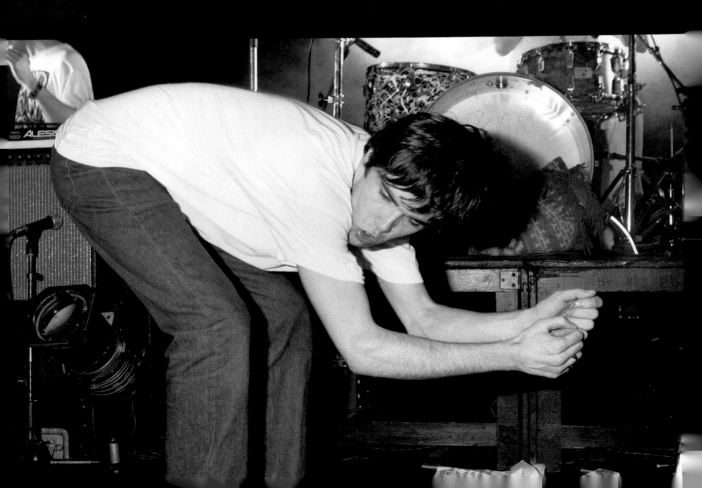

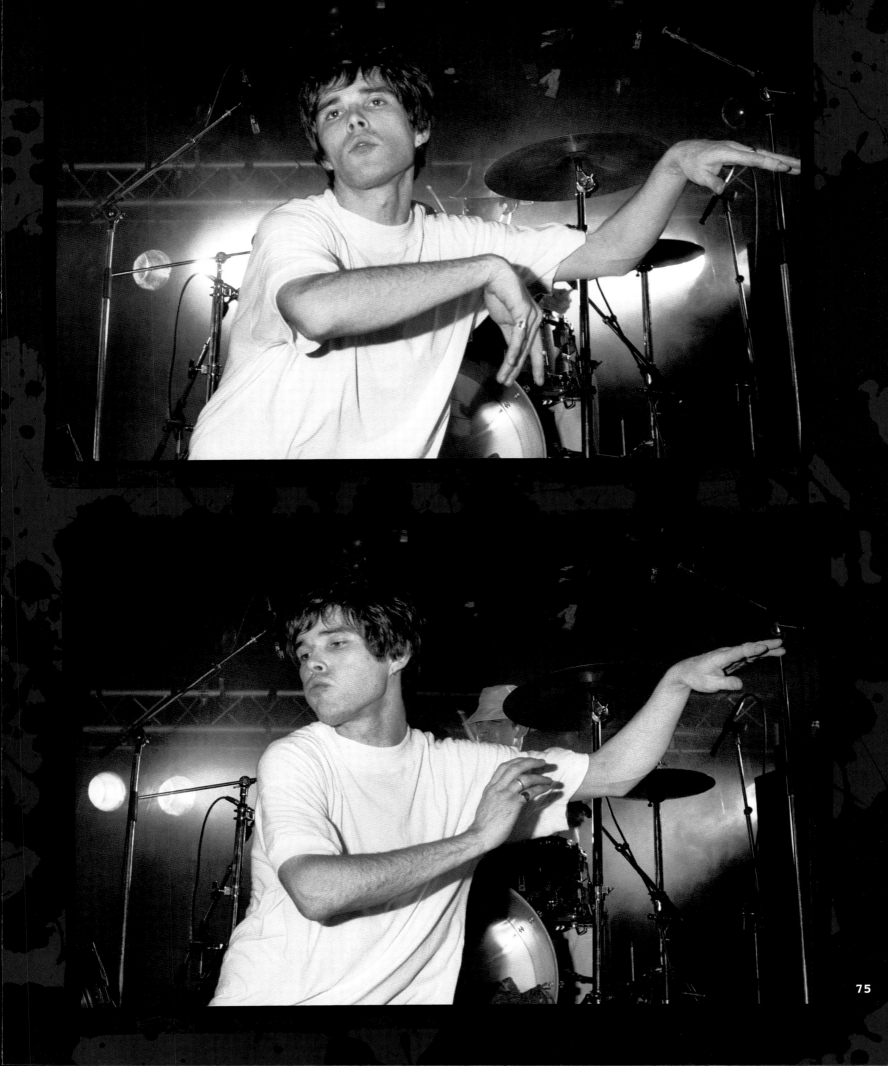

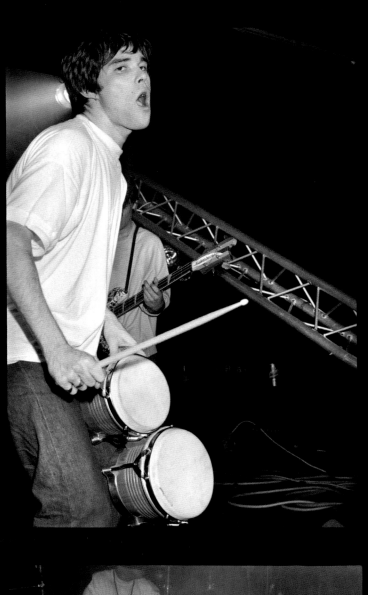

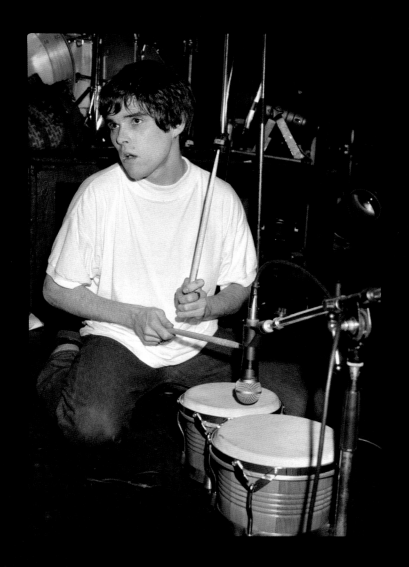

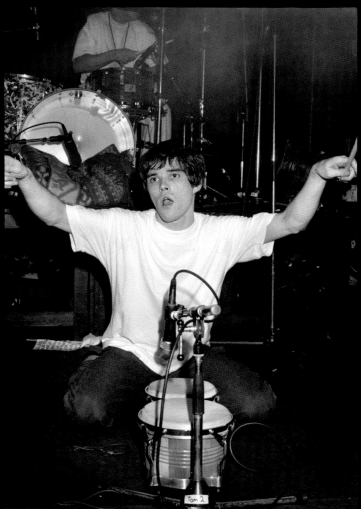

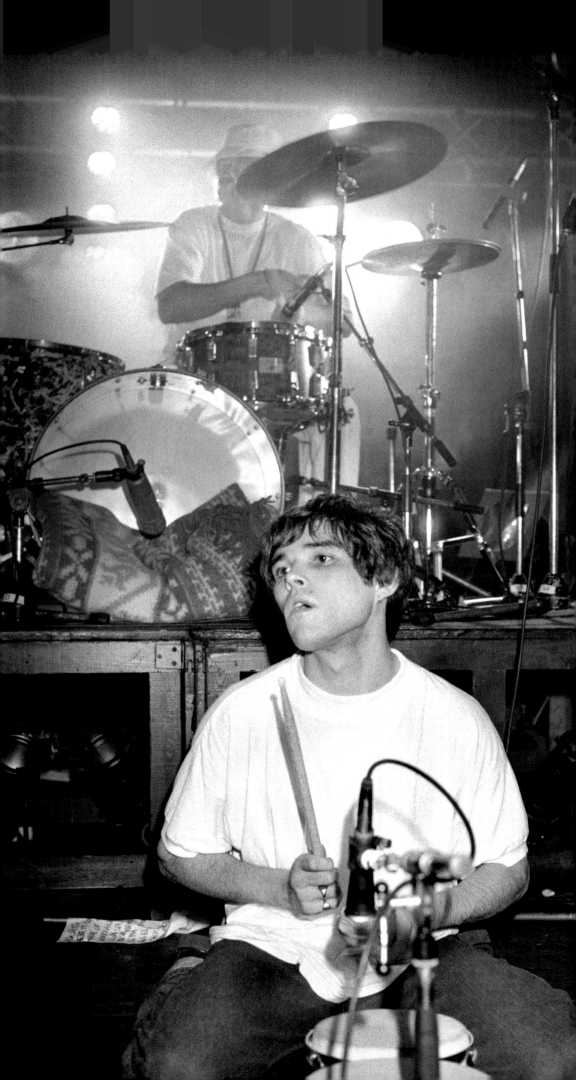

...y we wear them communicate so much about ourselves and make a definite statement about who ...

...that emerged in the late Eighties was the 'Baldricks'. Or were they a tribe? Tilton recalls how the Ba...

...nes came round to my house unannounced and asked, 'Can you do some pictures for us? We've ...

...a story on Cressa, little Martin and the lads down the Haçienda.' These lads had started wearing fla...

...a wearing straight-leg, drainpipe jeans with turn-ups. Most of the women wore high-waist jeans, ...

...nd Doc Martens. It seemed really risky at the time to stand out from the crowd by wearing flares; i...

...eople laughed at flares and wouldn't have been seen dead in them. Nonetheless, somehow *i-D* ma...

... lads down the Haçienda going against the accepted grain of fashion. Howard told me, 'Look, we'v...

...or the press, so we've called ourselves... the Baldricks.'"

...*likely gang of flared fashionistas and the images appeared in i-D. Soon, the cut of the nation's jea...*

(A) Steve Cressa. (B) Al Smith and Lee Severin. (C) Howard Jones.

"It was Phil Saxe. I first met him when he was the original manager of the Happy Mondays, when I went to the Boardwalk to ask if I could take pictures of them. I'd met Phil a few days prior on his clothing stall in the old Arndale Centre, and he'd told me to come to the Boardwalk and ask the Mondays myself. At the same time he tried to flog me some baggy jeans. They were dark denim. He claimed to have hundreds of them and that they were gonna be the next big thing, so I should buy a pair right now before they went up in price. As a stoic straight-leg wearer it just didn't attract me! Nevertheless, the combination of Phil Saxe with his surplus loose fit and the so-called Baldricks with their anti-fashion flares changed the nation's dress sense almost overnight."

CHAPTER 9
TALK OF THE DEVIL

"This image has never been published before;
it's my favourite image of this session.
This is the first time it's been seen."

In April 1989 Ian was commissioned by a hip Scottish magazine called Cut, *which was based in Edinburgh. Glasgow journalist Dave Belcher asked Ian to suggest a good place for the shoot and interview and they settled on Manchester Victoria railway station. Ian and the band met Dave off the train, although Reni was unexpectedly missing. Pictures without Reni were out of the question, but they could at least start the interview and so decamped to the station coffee bar.*

Ian Brown told Dave that he had been asked deceptively strange questions at the end of two recent interviews, just as the journalists were about to turn off their tape recorders. The casual way these questions had been asked made him wonder if it was a trick of the journalistic trade, an attempt to illicit an unguarded response. "They'll say something like, 'Oh yeah… and one more thing. Are you the son of the Devil?'"

Dave took it in good humour and assured Ian that he didn't go in for that type of ridiculous music-press japery. Tilton admired his honest response and hoped his reply would pave the way for a good interview.

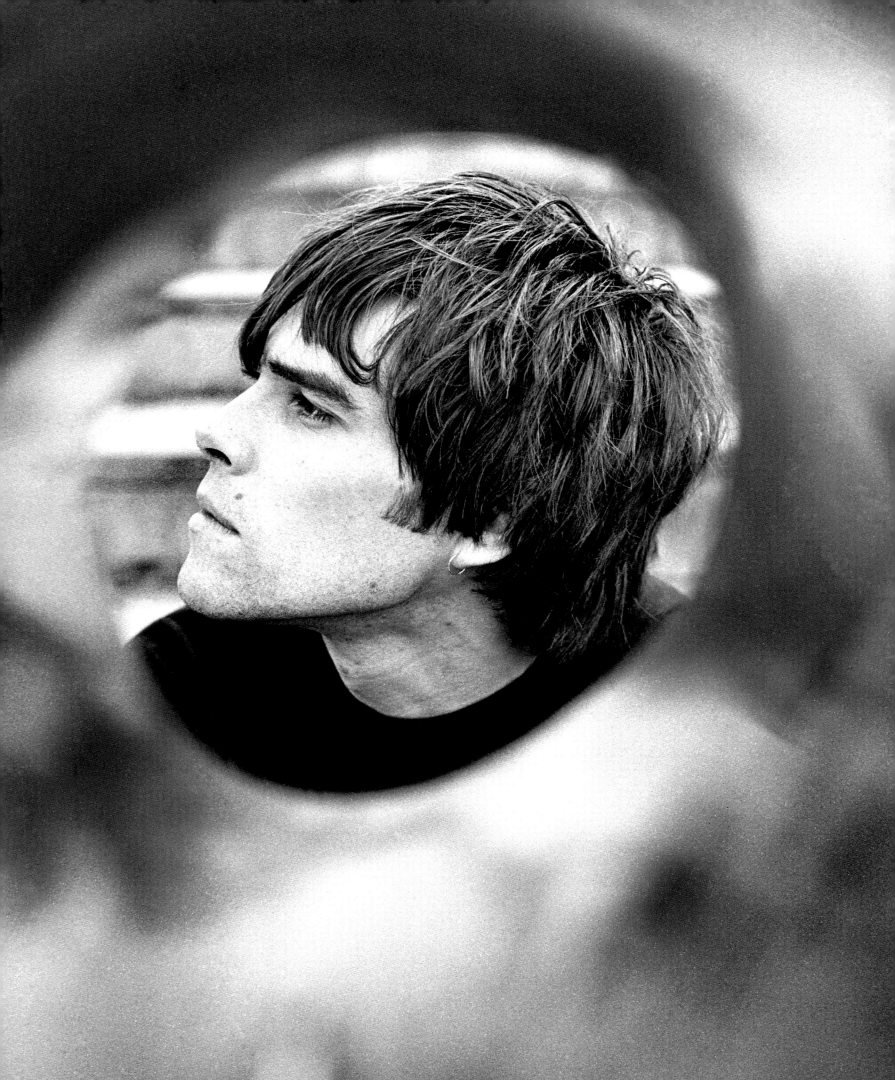

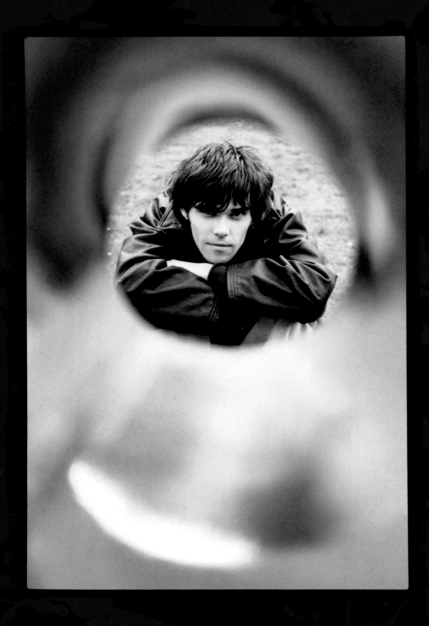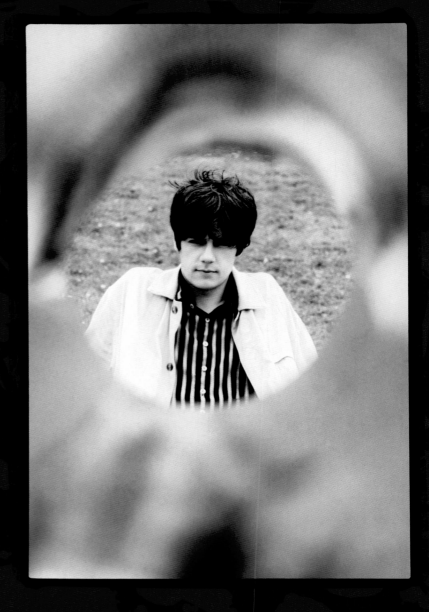

However, The Stone Roses had a notorious reputation for being monosyllabic and awkward during interviews, to which some journalists took offence. Belcher soon found himself facing this problem. However, since Tilton had forewarned him over the phone the previous day, Dave remained patient with the band. After a seemingly unsuccessful interview, he was about to turn off the tape recorder. Perhaps they'd been testing his mettle, but now, at the end, they'd decided to talk. Ian remembers: "The interview continued in a strange and awkward way, with a smattering of their laconic and sometimes flippant sense of humour – but at least they were talking. It was slightly surreal and I wondered just how Dave would write this one up for *Cut*."

It was now Tilton's turn, but there was still no sign of Reni. Ian continues the story. "I wasn't sure what to do then. It was obvious he wasn't gonna turn up and no one knew why, so I turned to Dave and said, 'You could be in the shots. You could be Reni. We could put a hat on you and turn you the other way so we can't see your face and it will still look like a four piece. Wanna do it?' Dave thought I was joking. 'You're serious aren't you?' he finally asked. "Yes," I replied, "I've done it before. It will work. You could put a hat on and turn your back to the camera so the lens can't see your face.' The band were amused. Awkwardly, Dave declined, although he has recently told me he wished he'd done it. So I made the best of it and photographed them as a three-piece.

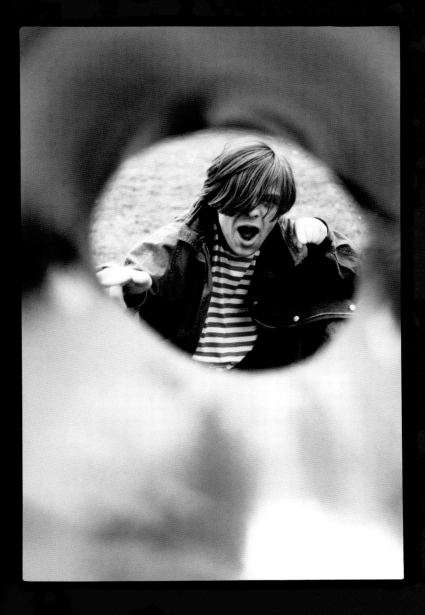

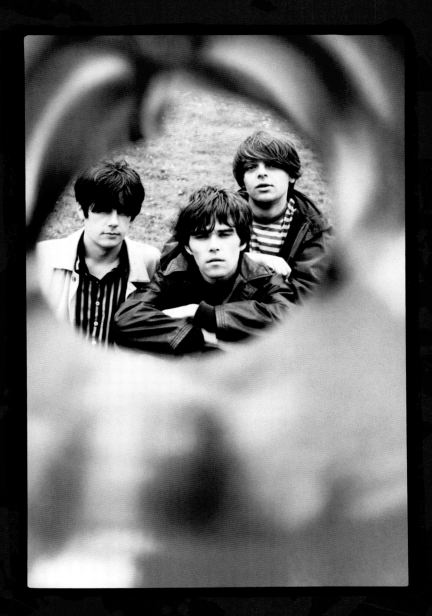

"The combination of the infrared and the reflections from
the inside of the metallic pipe was interesting and surreal.
Rather like the interview really."

"I posed the band on a grass bank near some stone steps adjacent to Victoria Station and photographed them through a metallic tube, taking some pictures in black & white and some in infrared colour.

"Infrared colour film produces an eerie quality; skin looks waxy, pale and blue/green. Grass turns red or magenta, and the whole thing looks unreal. Add this to the metallic reflective pipe I photographed them through and the effect is time warpish, like Doctor Who going down a time-warp tunnel with the Roses at the end of it. All except Reni, of course. Maybe he was in a parallel universe, or perhaps he was still in bed. I never did find out.

"As we were about to say goodbye to Dave, who was catching the train back up to Scotland, he wryly remarked to Ian Brown: 'Ian, I am the Son of the Devil.' Hellishly funny and devilishly dry, that Dave Belcher."

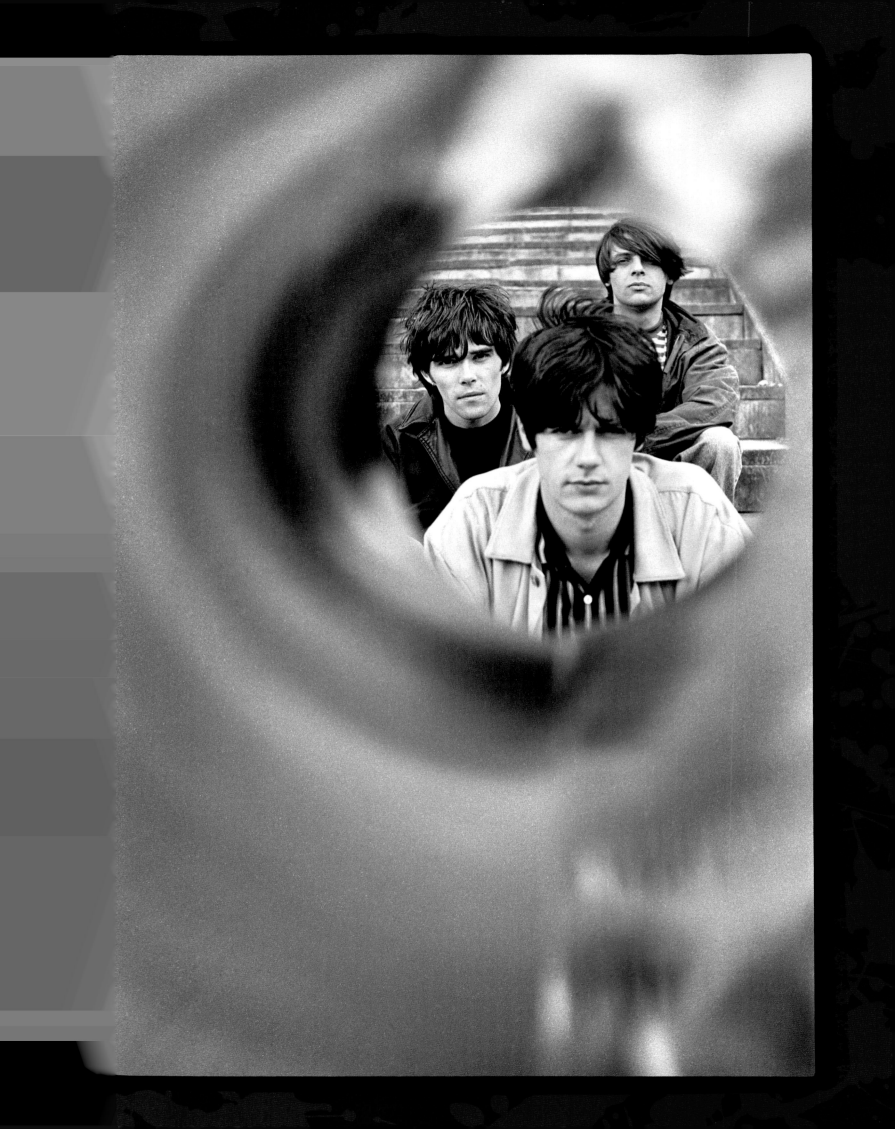

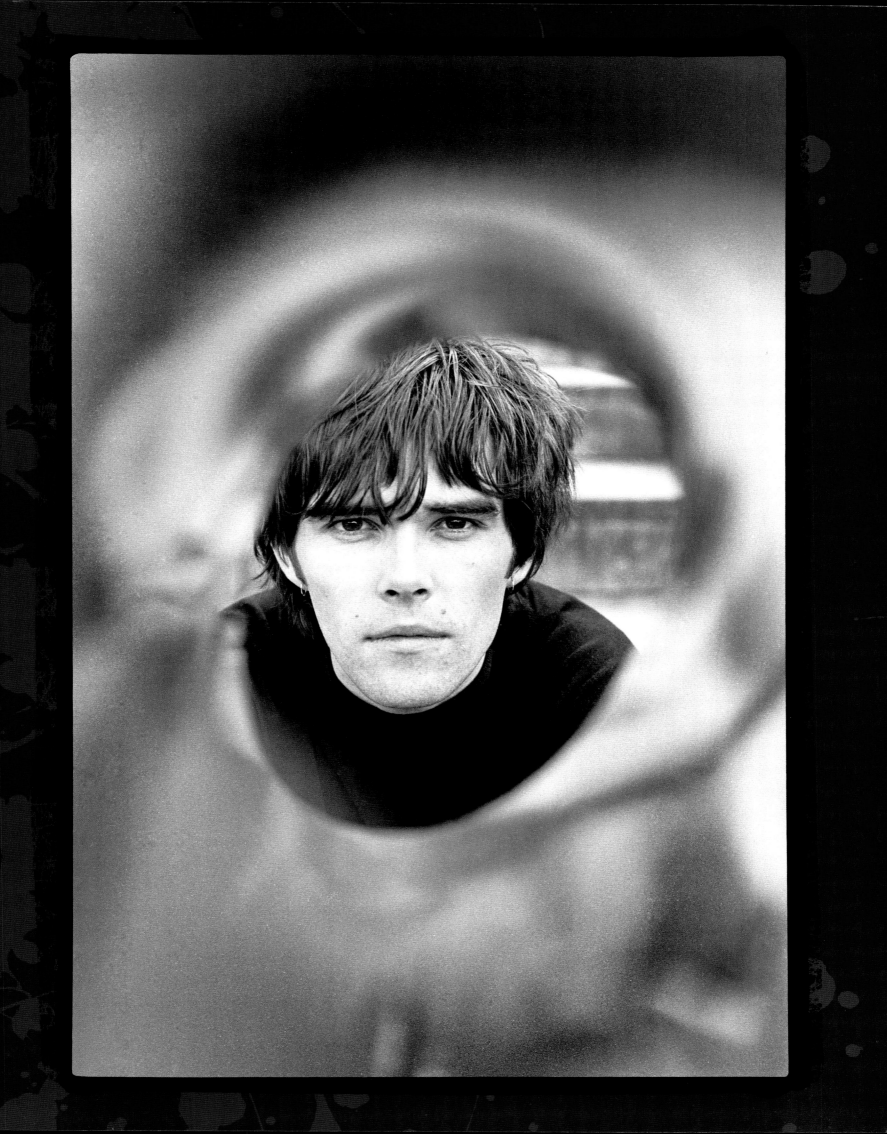

"They're really funny photos, quite manic.
His eyes are just mad! Mani in the background is trying to
bring some life to the pictures as well.
He's kinda shaking his head and his hair around in a couple of them.
Good on ya' Mani, for giving it a go, for joining in!
When Ian pulled the first monkey face John's smiling in the photograph.
It amused him as well."

CHAPTER 10
THE START OF ALL THAT MONKEY BUSINESS

"Brown put his hand in the air and started waving his fist around.
And that was it, the iconic monkey face — I got him to do it!"

Tilton was commissioned to shoot The Stone Roses on July 20, 1989 for the front cover of Sounds. *The Blackpool Empress Ballroom Gig was only three summer-soaked weeks away.*

When the Roses arrived at Tilton's house Ian Brown showed off his 'Money' T-shirt for the first time. He knew it looked good and Tilton agreed, adding it would be brilliant for the cover. Being a front cover shoot, Ian had to set the shot up to accommodate bold text, leaving space at the top for the magazine logo and spaces at the bottom and sides for any text the designer wanted to include.

86 "One of the rules for a front cover was always to have the subject's eyes looking directly at the camera. This would ensure they made contact with any potential buyer who was browsing the newsagent's shelves. So the rule was never photograph anyone looking out into the distance, looking away or with his or her eyes shut."

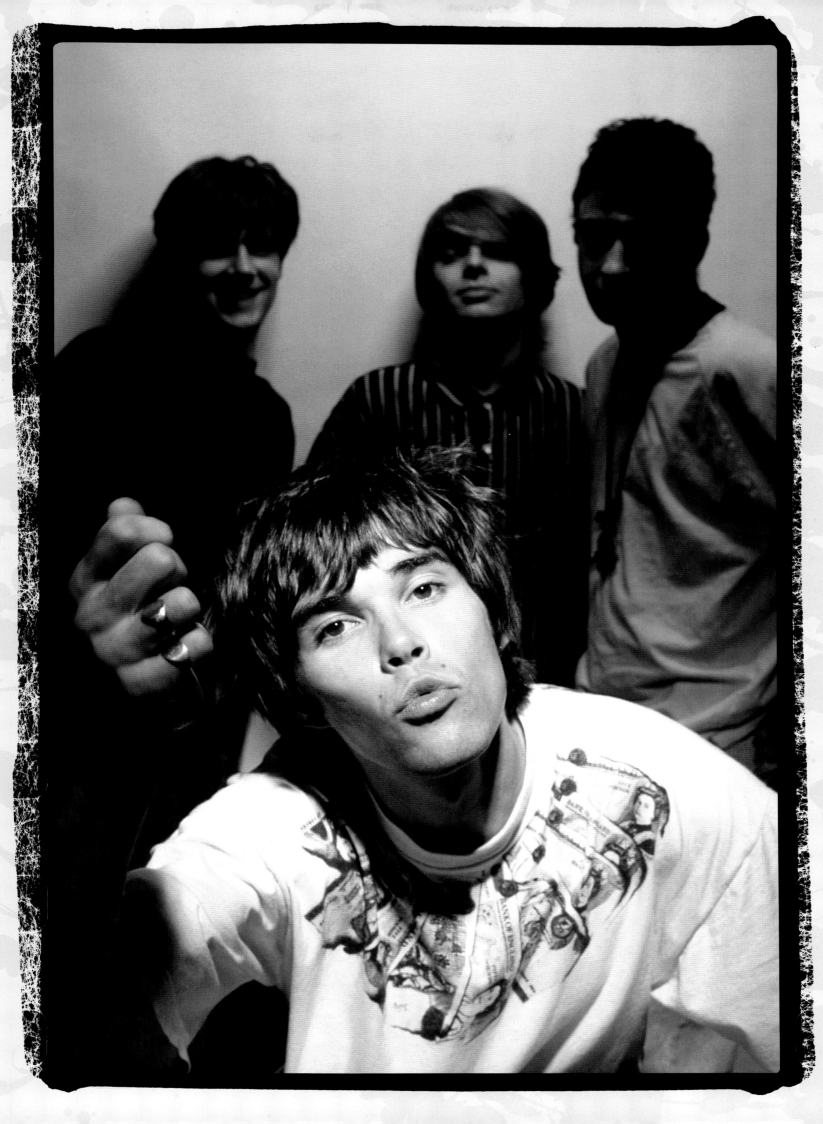

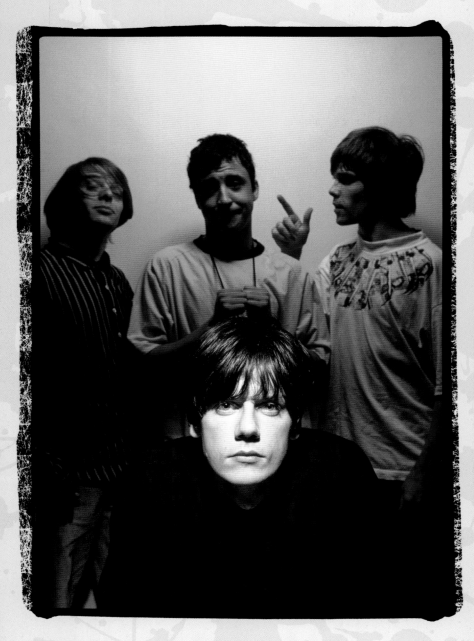

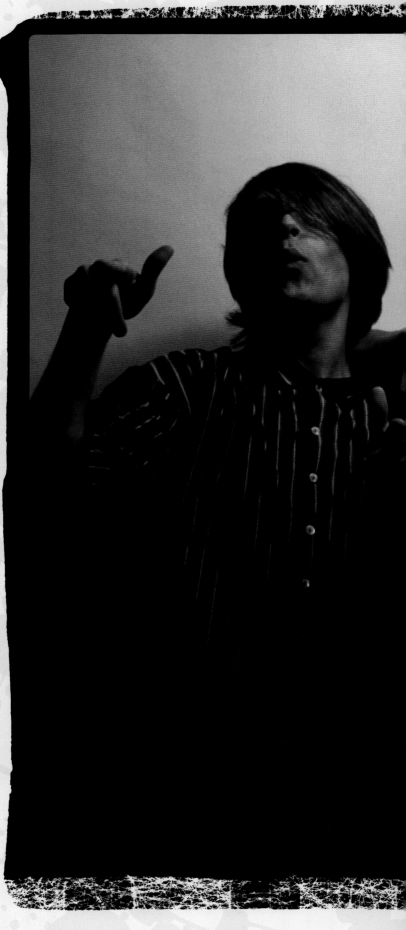

"John looks pretty serious and the band in the background look really manic. They're really going for it, larking about and having a great time, whilst John is just looking at me, subdued and cool."

Tilton started this photo shoot in a simple fashion. "You need a few ideas, a focus, somewhere to start, so I thought I'll light it with rose-coloured lighting. I'm really pleased with the lighting on this session, as I think it worked out well. I often scribble my first ideas as drawings and words onto paper. The first few photos were quite straightforward. I was encouraging Ian to do slight variations on his poses and thought, 'Right, we really need to bring this to life now.' So I said, 'Come on Ian, liven it up!' At which point he pulled the monkey face...

I immediately thought, 'Oh, that was good!' It was fun, and then he dropped it, but I said, 'No, you gotta keep that going.' In my mind I was thinking that it might've been a pretty goofy thing to do, but it worked. I'm so proud of that. But the other images from this session I've never used until now.

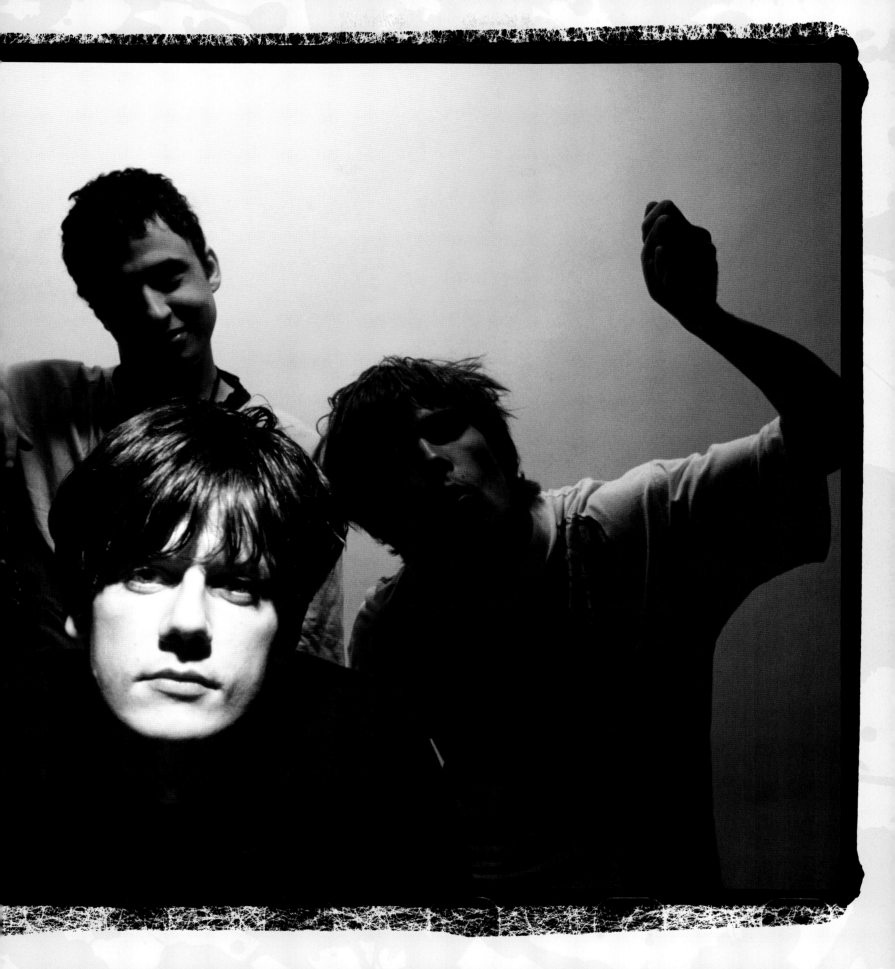

"Whenever I had to do a magazine front cover, which was nearly always in colour, I'd have to shoot on black & white for the inside pages as well. Now with today's digital cameras you shoot on colour and can easily convert it to black & white, but back then I had to use two cameras; one camera using a colour film and the other with black & white.

"The magazines wanted black & white simply because it was cheaper to reproduce a black & white page than colour. On *Sounds* the front, back and centre pages were in colour, but the rest was black & white to keep the production costs down. That's why photographers had to shoot both."

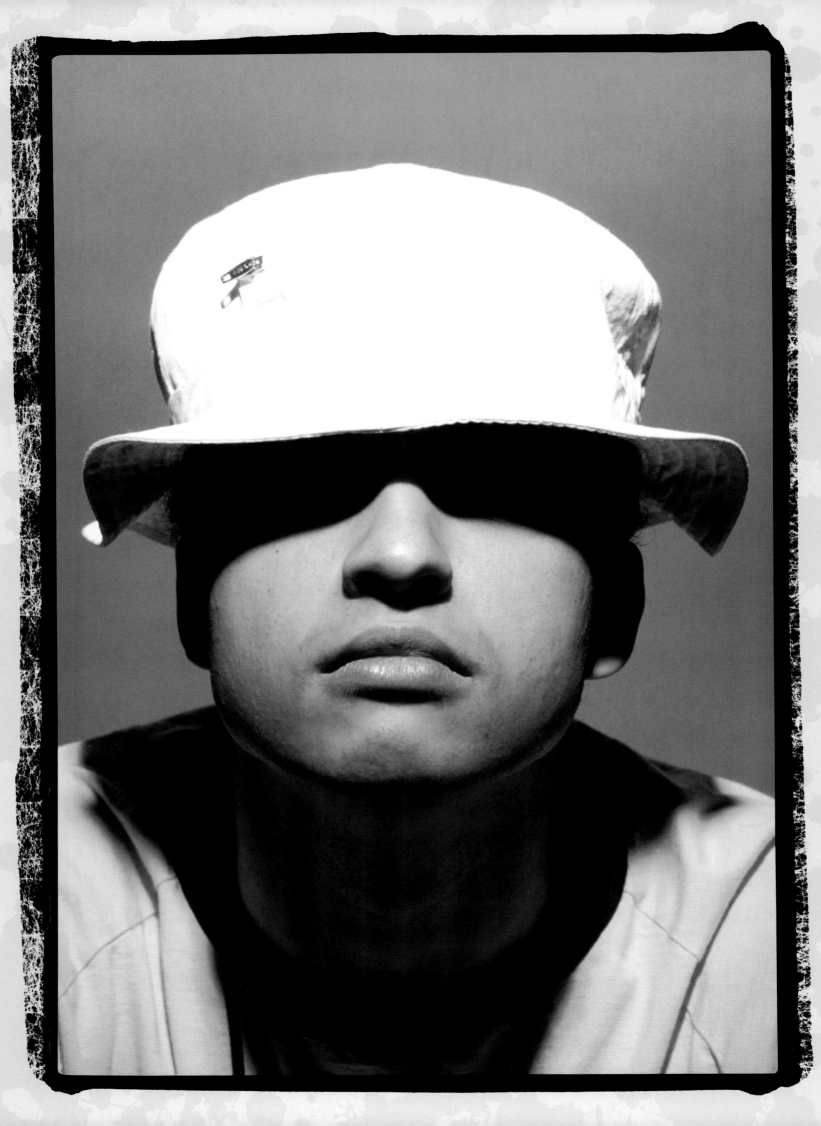

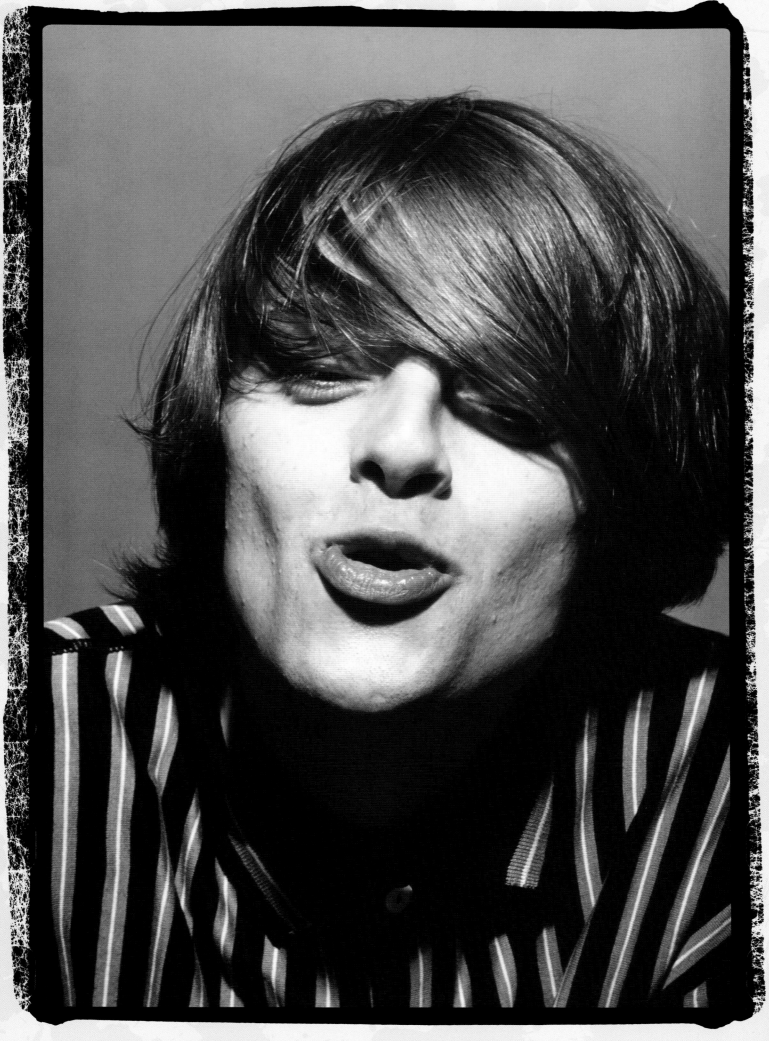

"Mani wanted to have a good time. It was interesting to
see how much he'd evolved as an artist and become part of the band."

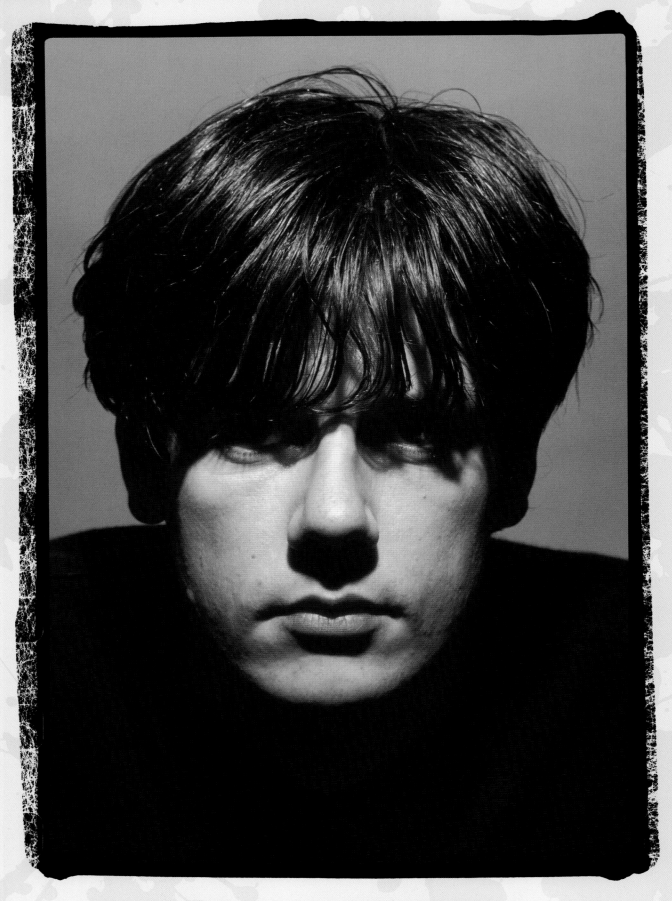

"When I took John's portrait he was easy to photograph.
He sat quite straight and took the whole thing seriously."

Tilton also photographed the band individually that day, against the rose-coloured background. "When Reni put his hat on, his eyes were hidden under his hat and I liked that. I couldn't see his eyes. But when I sent the editor all the prints, I thought he'd choose a great band image for the cover. Instead he chose four individual shots. He montaged the four of them on the cover and it was really effective. Personally, though, I think the group shots were better.

"I also took some photos with John Squire at the front and put Ian, Reni and Mani in the background. Only one shot from this sequence has ever been used, I think because everyone wanted the iconic picture of Ian with his monkey face. John looks good here, but Ian looks amazing. He just grabs your attention and holds it.

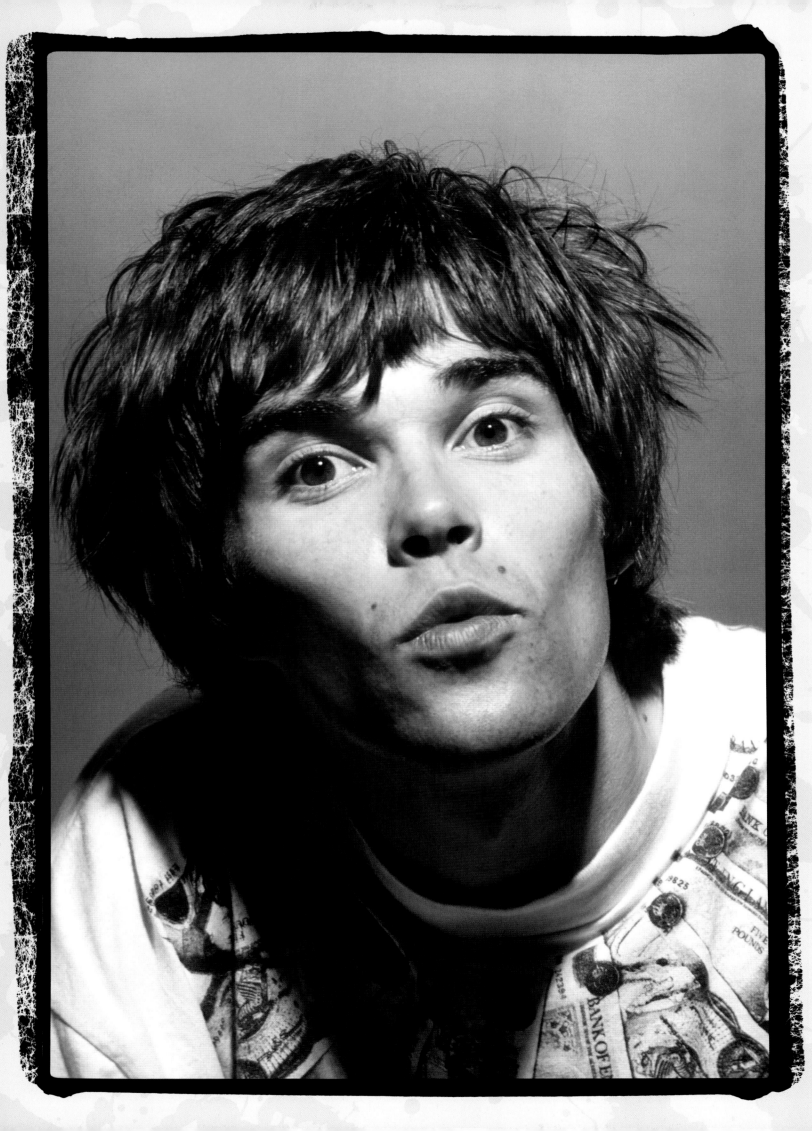

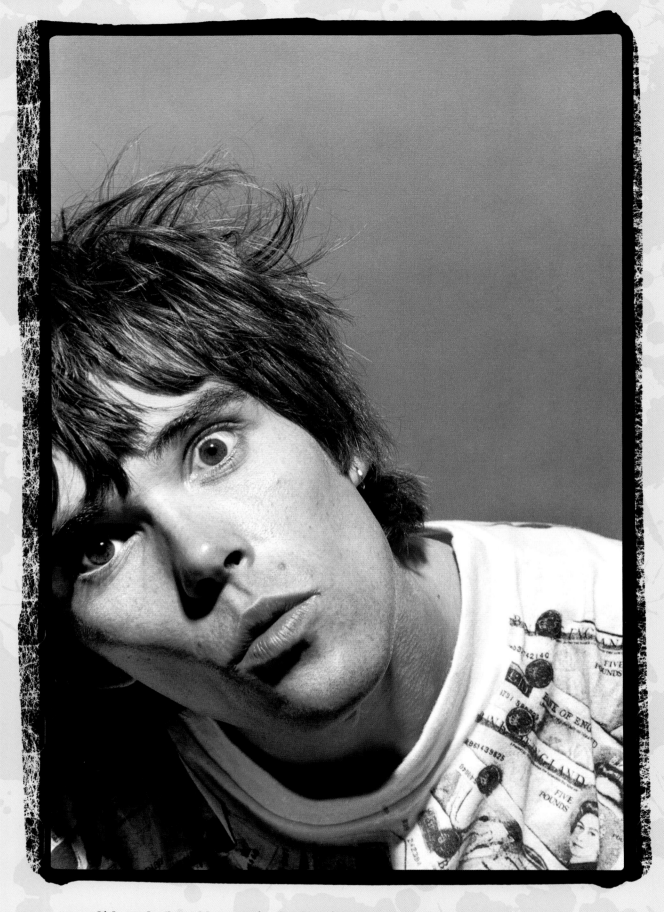

"Ian didn't look well, particularly with the lighting I'd used on him.
He'd lost a bit of weight in his face and there was something really skull-like,
almost skeletal, about his portrait."

"When the pictures came back from the photo lab, I was quite shocked to see how thin and drawn Ian Brown looked. And Reni, it transpired later, wasn't keen on the individual photographs I'd taken of him with his eyes hidden under his hat. John didn't feel like larking around, unlike Mani. I got some great ones of Mani trying out the monkey face too! I enjoyed seeing how each of their individual characters came across and what they were willing to give to the photo shoot. The pictures are full of character, dryly comical and arresting. The band had to trust that what I was doing would yield a good result. Nowadays, with digital the band can be more involved, have immediate access to the images and give you instant feedback."

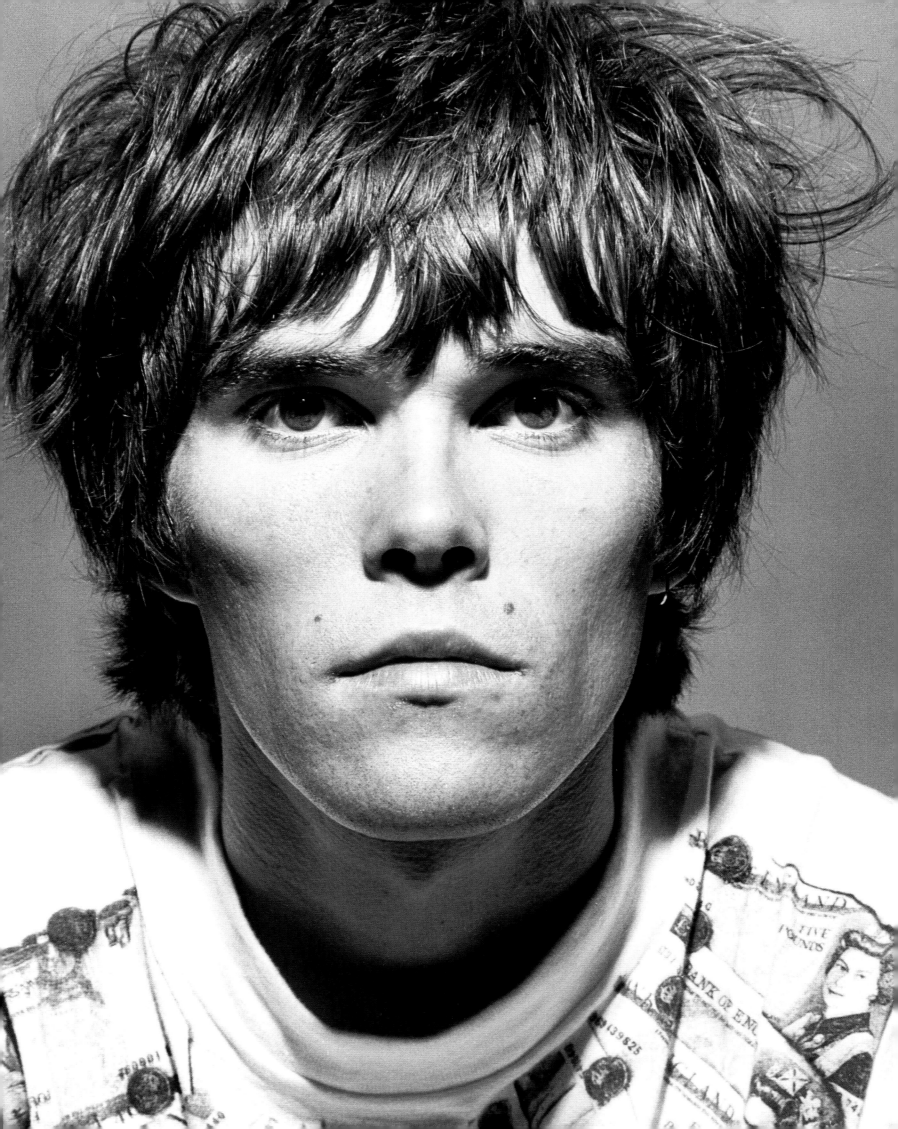

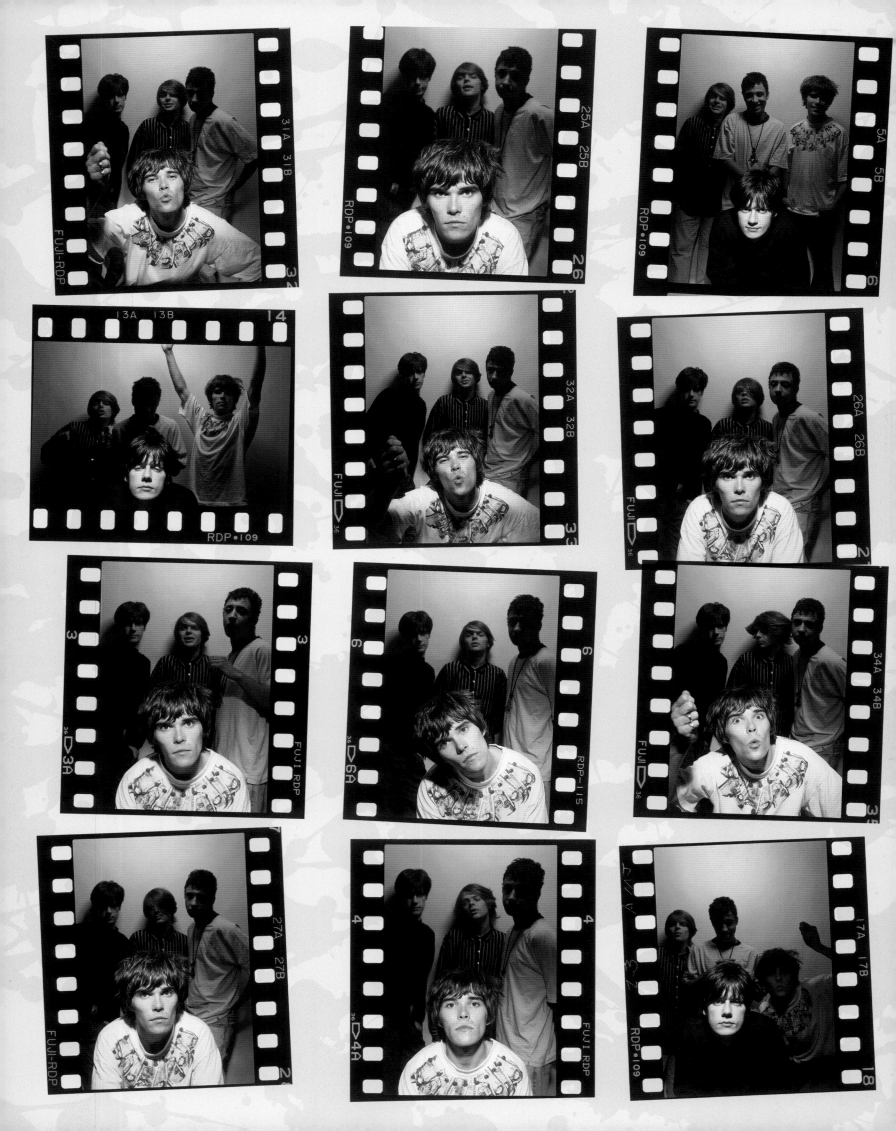

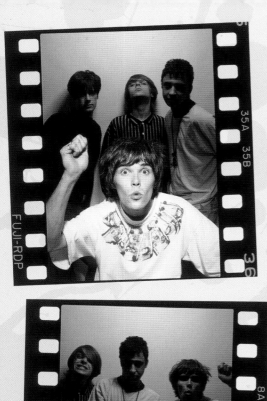
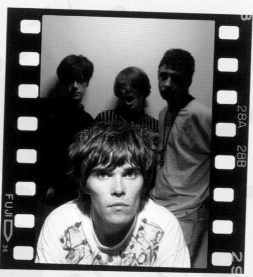
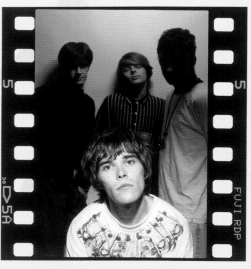
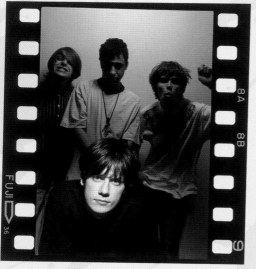
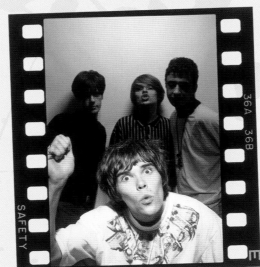
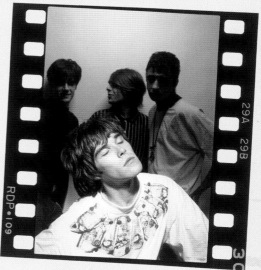
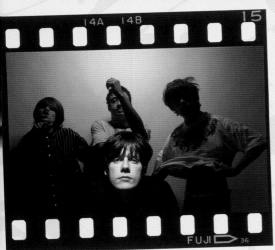
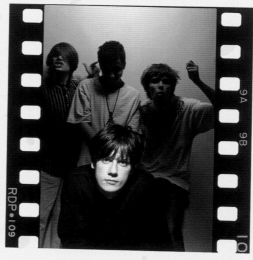
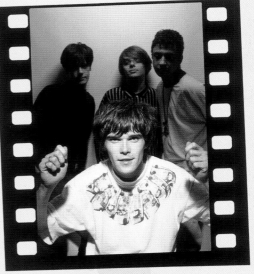
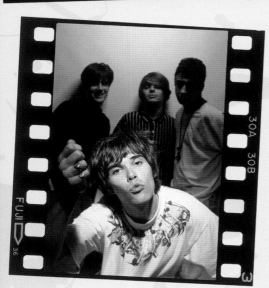
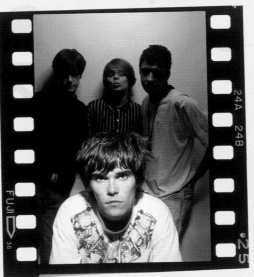
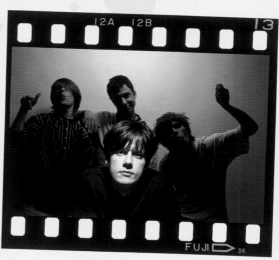

CHAPTER 11
BIG CAMERA... ACTION!

"Ian was doing his monkey face again and I remember asking Reni to surf.
I said, 'Look like you're surfing' and it gave him something to focus on.
He looked great and was at the front.
At this point Mani had gelled so well with the band that in the photos he's doing his own thing.
He's confident and he's got a great look, with his hair grown over his eyes."

"This photo was taken on the same day as the rose-coloured background session. The big camera in the photograph had been a birthday present from Carolyn Hine, a friend from Blackpool. She knew someone who worked in TV as a prop maker and had this beautiful, squashy camera made. John Squire took a shine to it. He picked it up and wanted to use it in the photo session. My idea was to have the band looking active in the picture and to superimpose paint splashes over the top of them. Because there was no such thing as Photoshop in those days I had to create any photo effects as I was taking them, or later when I printed them up in the darkroom. Photographers could do double exposures by 'sandwiching' two negatives together at the printing stage. I did these shots on colour transparency (slide film), using a high-quality, medium-format camera that was capable of making double exposures.

"I took a photograph of the band and then on the same piece of film took a photograph of one of John's paintings so that it appeared overlaid on top of the band looking ghostly. I shot a Polaroid first to check the double exposure was correctly aligned and to make sure the exposures were right. Once I was confident about the technical details, I then shot the film. I didn't know exactly where the blobs were gonna go over their faces, so I took a few in the hope that one of them would be the perfect image. It was a time-consuming process, requiring the band to be very patient. I went from band to painting, back again to the band, then to the painting, and so on. That's kind of difficult for a band, but they helped me, had patience and wanted to help get the picture right.

98

"I took a small number of photos at this shoot but all of them turned out well and the one that is featured here is the favourite. However, I honestly can't remember what the shoot was for."

CHAPTER 12
BALLROOM BLITZ

"So Ian taps me on the shoulder from behind and says, 'Here, have a look at this!'
He spontaneously shoves a whole jaffa orange in his mouth, so I quickly just grabbed the shot.
Just one shot and that was it.
And that orange in the mouth became one of his most famous images,
despite being such an extremely fleeting moment."

Blackpool Empress Ballroom on the balmy summer's evening of August 12, 1989 was an epic gig. The Stone Roses wanted to give their fans a top day out to celebrate in style. They were all on a pilgrimage to the tacky but glorious Mecca that is Blackpool. This wasn't a spiritual journey on the hippy trail but a north-western convoy to the fabulous Lancashire coast, previuosly host to such music hall comedy greats as Les Dawson, Mike Yarwood and George Formby.

Blackpool is only 50 miles from Manchester and so was an important part of the northern independent music scene. The young Ian Tilton had seen some great local indie bands in Blackpool, such as Zyklon B, Section 25 (on Manchester's famous Factory label), powerful punksters The Fits and One Way System, Sign Language, The Ken Turner Set, anarcho punk band A-VOID, sixth-form electro-style Pure Pink Paraffin,
The Frets, Vee VV, The Zanti Misfits and personal rockabilly favourites, The Riverside Trio. Ian's brother Mark Tilton and his friend, music journalist John Robb, were members of The Membranes, a post-punk group who had pogo-ed their way out of the tawdry Blackpool kiss me quick culture and into cult punk stardom via the creative streets of Manchester.

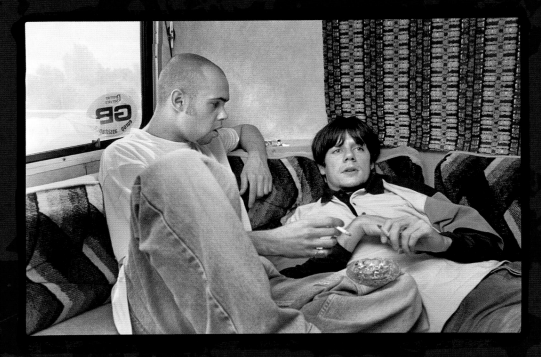
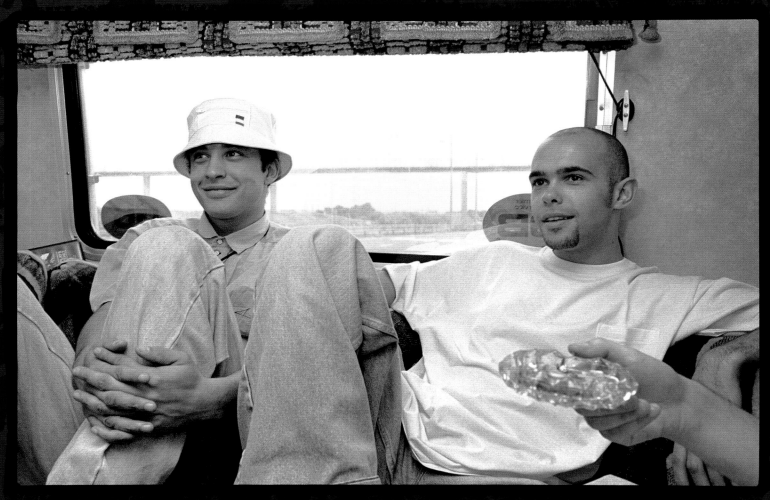

When Tilton heard that the Roses were playing the Empress Ballroom, he asked to join them on the tour bus, hoping to capture the band both en route to the gig and backstage. Ian remembers: "I felt that there was something legendary happening here. I said, 'I just want to photograph all of it. I wanna hang out backstage and I want to take some good live pictures.' The band's début album had been released just four months previously and was steadily climbing the charts. They seemed to be achieving a word-of-mouth success. The press was now on to them and the Blackpool gig was a stroke of genius. In just one gig, it elevated them from playing to 100 people at venues outside Manchester to 4,000 fans."

102 It was obvious to Ian that the Manchester thing was taking off. He had seen past movements disappear quickly, so was determined to experience this moment while it lasted. There was a magical atmosphere about the whole day. The band, and their fans, were ready for a good time. Ian recalls everyone on the tour bus being very relaxed.

"After I'd had words with Reni, I remembered I'd wandered up to
the front of the tour bus to talk to the driver and Adge.
Whilst I was there the Roses had, like naughty schoolboys, taken my camera out of
the bag and photographed themselves with their chins sticking right out,
like a gang of scally Jimmy Hills!
Then they put the camera back in my bag without telling me about it."

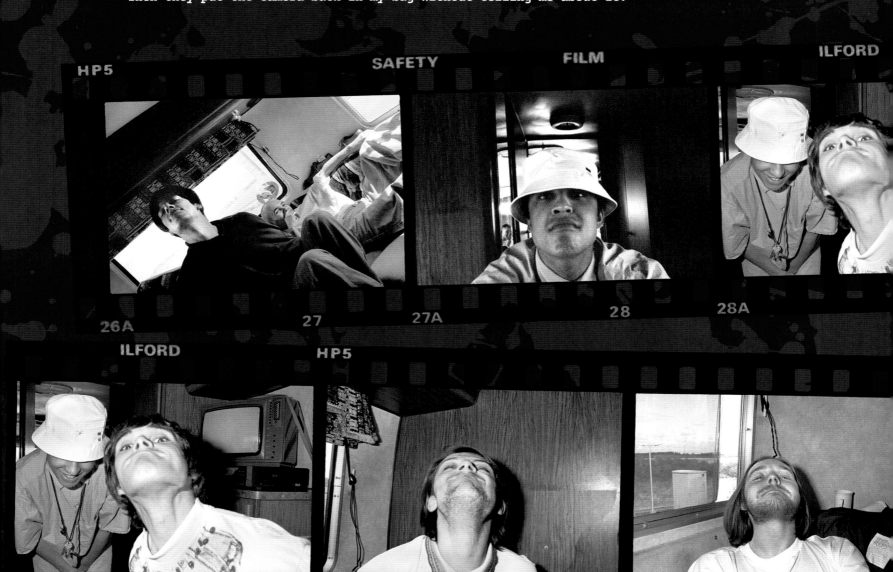

The 'Monkey Face' photographs had been printed on the cover of Sounds just a few days prior to the Blackpool gig. Reni hadn't taken much of a shine to the shots of him that had been chosen for the cover. He asked Tilton, "Why did you use that one? It's just a great big chin sticking out from under my hat!" Ian replied, "Well I liked it, but you're right, it doesn't look like you're the most handsome bloke in the world. But it's a really striking picture despite your big chin. I think you look cool." But Reni still wasn't happy about it.

Ian laughs as he recalls what happened next. Fast forward a few days to Ian's darkroom in Chorlton. He remembers: "When I got back to my gaff to develop all the pictures I noticed that there were some that looked under-exposed. You know, thin, washy and out of focus. I thought, 'I don't remember taking them. What are they?' They were under-exposed and I wouldn't do that! I thought maybe I'd made a mistake. So I looked at them through the magnifying glass and they were close-ups of faces, all in negative, with big chins sticking out. And then I twigged… The childish bastards had nicked my camera and taken shots of themselves when I wasn't looking! The photo of Reni with his chin jutting out was impossible to print because it was too under-exposed; it was only the advent of digital photography that allowed me to do these pictures some justice."

These unseen comedic images were used for The Stone Roses *20th anniversary box set and provide an insight into how playful the lads were that day. Ian remembers: "There's one of Al Smith the roadie sticking his chin out too. It made me snigger. I knew it was a test of my mettle. Their mischievous Manc sense of humour was shining through in these piss-take self-portraits."*

103

When the tour bus arrived at the Empress Ballroom, there were already loads of fans waiting to have their T-shirts signed. Also waiting was the crew of a film company from Newcastle, commissioned to capture footage of the live gig. Tilton knew them from years before having worked with them on Channel 4's hip, live music programme The Tube, during filming of a Blackpool special. Whilst runners were being built for cameras, Squire and Brown were roguishly pushing each other around the ballroom on the camera trolley. Tilton managed to capture the moment, which wonderfully illustrates the sense of fun and enjoyment they had at the time.

"All aboard the Blackpool Trolley!
First stop: the soundcheck at
the Empress Ballroom.
Then 'ave your photos taken on the prom.
A splendid time is guaranteed for all!"

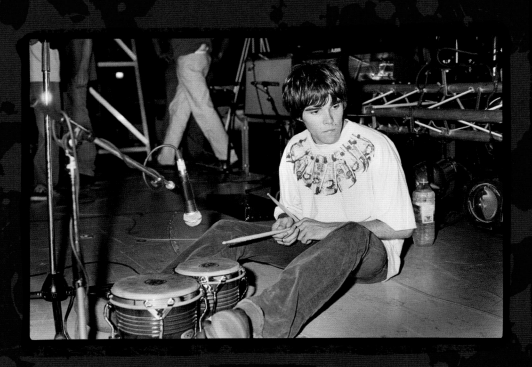

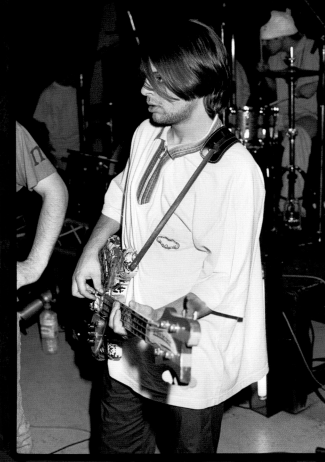

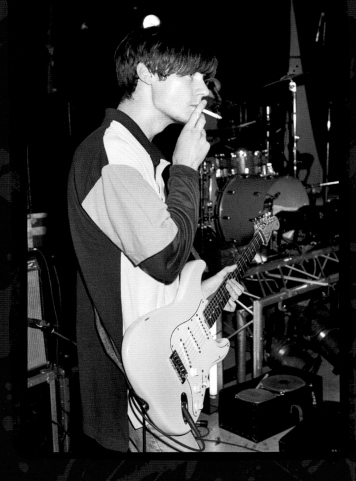

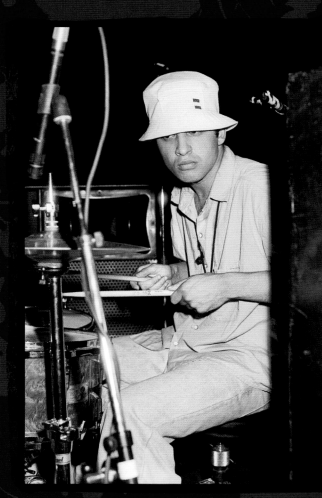

"Onstage for a pre-gig soundcheck."

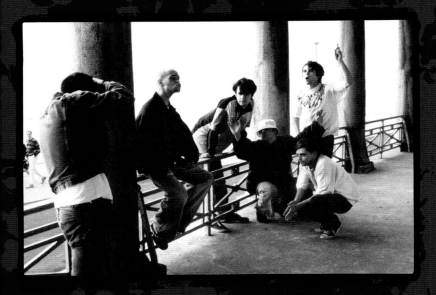

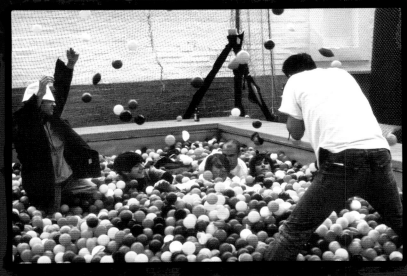

"Chris Clunn was generous in letting me document his photo session and
my photos capture the process, showing how the band were having a good time.
It reminded me of how they'd worked with me in my studio sessions."

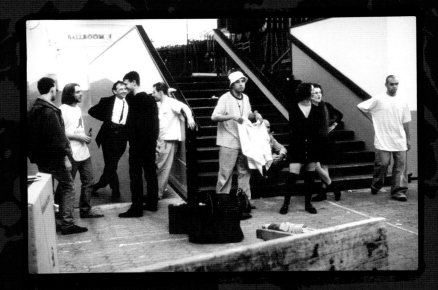

The NME *was also there, as Helen Meade (journalist) and Chris Clunn (photographer) had travelled up from London for the show.*
Ian documented Chris through an extensive photo session which started on the promenade: "Surprisingly, I had never watched another
photographer doing a photo session with a band before. The Roses really worked at their sessions. And fortunately, I didn't cramp
Chris' style." *Tilton then returned to the ballroom, where he hung out with the band backstage and took his iconic image of Ian Brown with
an orange in his mouth.*

Ian also remembers how unified the Roses seemed that day. "One thing that really struck me was the close relationship between Ian Brown and Steve Cressa. They did exercises together and had a great bond.

"I felt comfortable around Cressa; he was shy, humble and open. He had a real kindness about him and looked out for people. He seemed genuinely pleased to be there, to be a part of the party. He looked fantastic when he was dancing about on the stage. I think he also helped out John with his sound pedals by occasionally twiddling an electronic gizmo-type thing (maybe a graphic equalizer). Cressa looked good and he danced really well. He was really loose. He added a myriad of colour and spirit to the band.

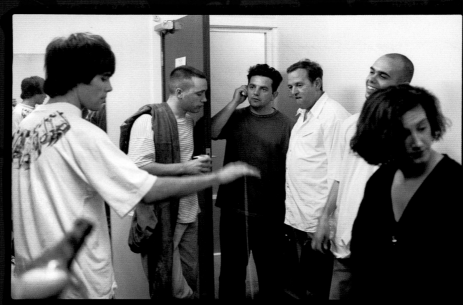

"Cressa and Ian touched heads a lot. Cressa was more than just a fifth member of the band. Everyone describes him as being the Bez of the Roses, but to me his character was completely different."

"They touched heads with one another when they spoke, which was really unusual to see. I had an exhibition at Urbis, Manchester in 2009 and Ian Brown was at the premiere. He gave me a great big hug and we chatted. In fact we chatted and touched heads in the same manner as the Brown and Cressa photograph! It can be quite unnerving if you're not aware he sometimes does this. It's a very in the moment thing to do."

Come show time, Brown sauntered onstage with a yo-yo, looking cool as fuck to massive cheers, wearing his Money T-shirt. The opening chords of 'I Wanna Be Adored' filled the ballroom and the atmosphere in the Victorian dancehall was mesmerising. The band threw ice pops out into the audience to help cool them down. Tilton was also on the stage with the Roses and can be seen on the TV footage, crouching in the right-hand corner, between the amps and speakers in his paisley shirt.

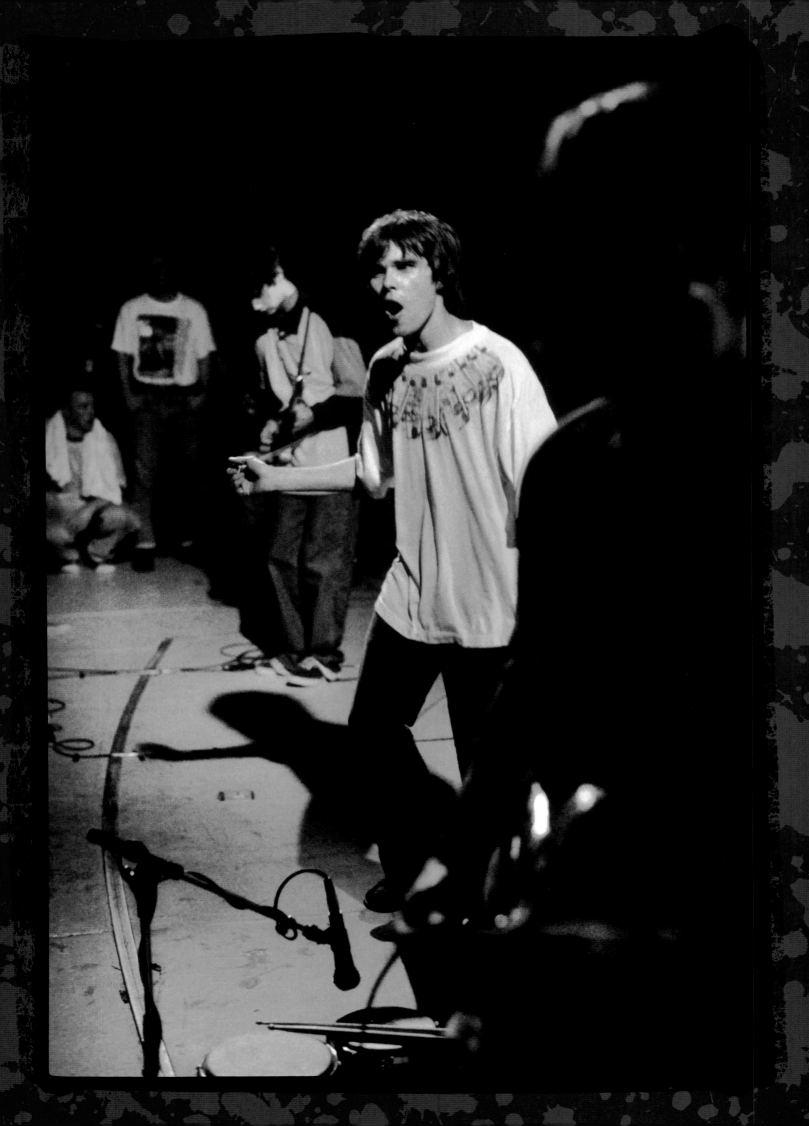

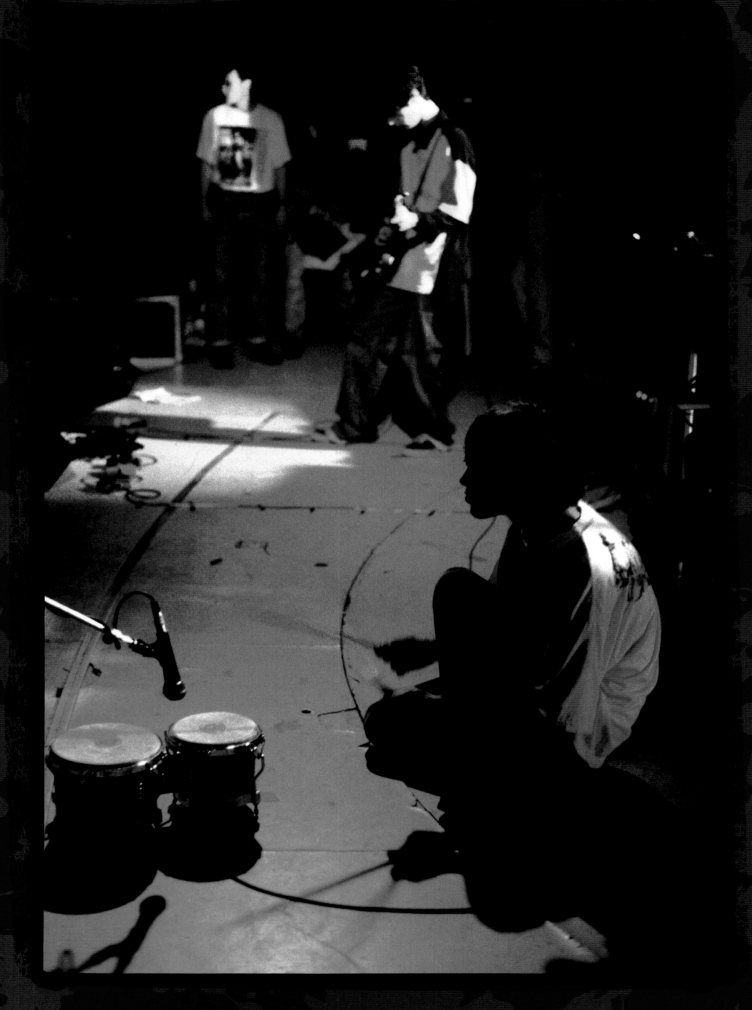

116 "Admittedly it wasn't the best photo session I've done live, as the block reds and greens made the process difficult. Musically, however, the Empress Ballroom was a great venue. There was a big semi-circular balcony looking down on the main action and amazing chandeliers hanging from a beautiful ornate roof. It really felt very intimate for a 4,000 strong audience."

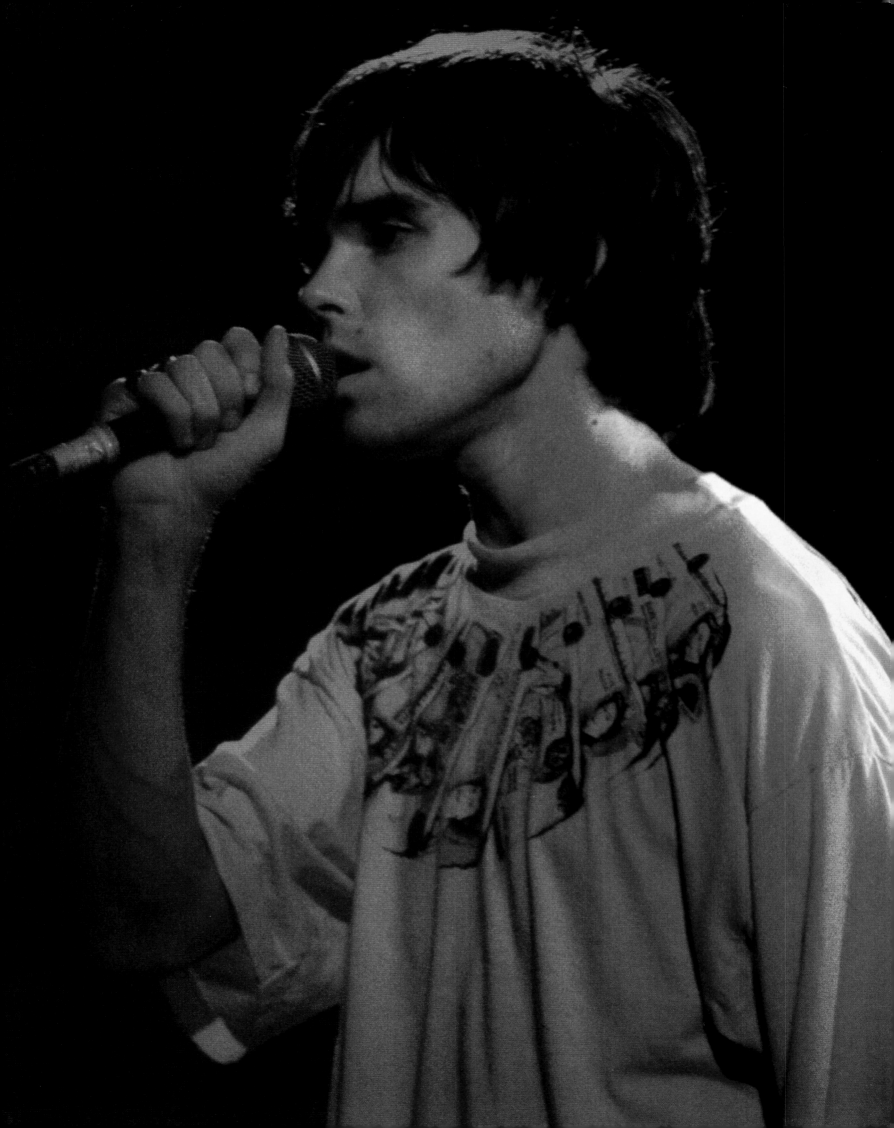

"It was the height of the summer and at last it felt like the sun was shining on the people once more. Ecstasy, speed and LSD were readily available and became the classic forbidden fruits that young people wished to experiment with.

"The drugs brought people together and fans enjoyed losing themselves in psychedelic-soaked dreams. And in the Roses they found a band they could relate to and who provided the perfect soundtrack for their hedonistic generation."

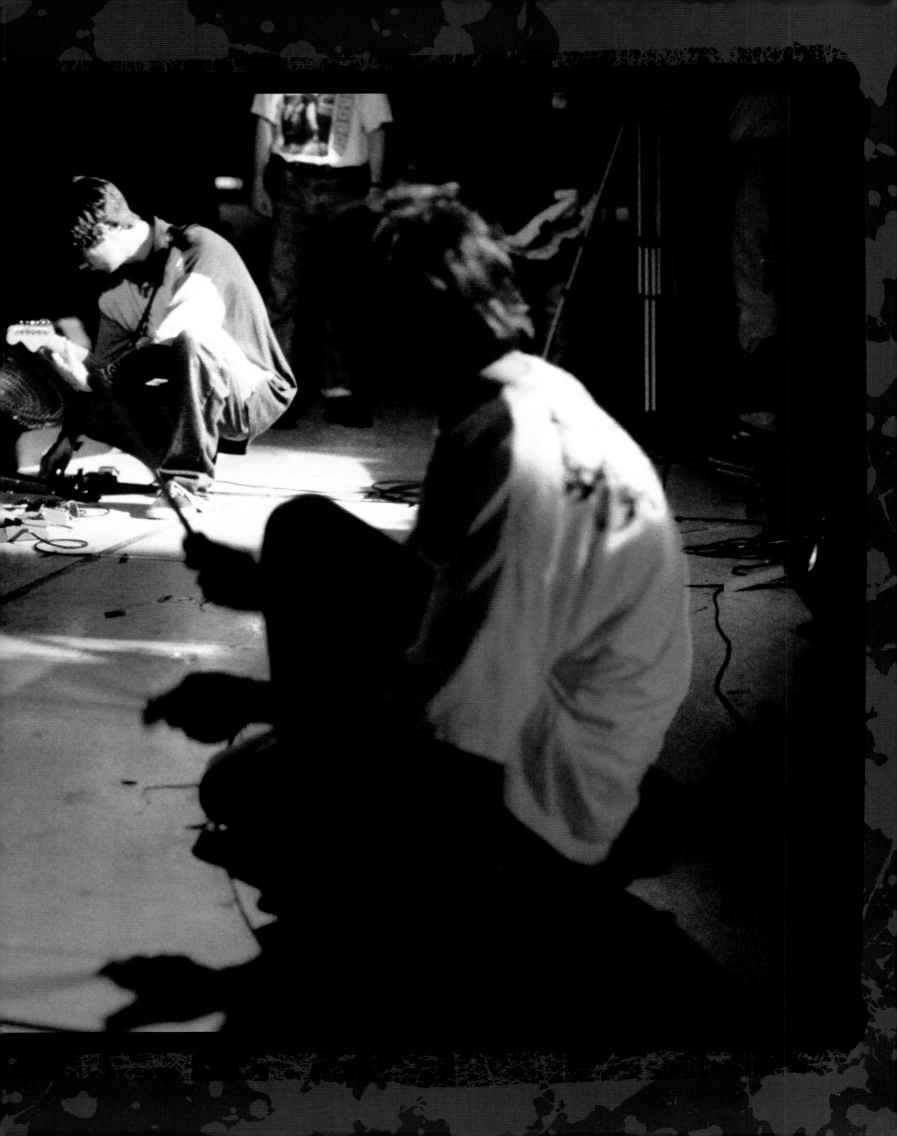

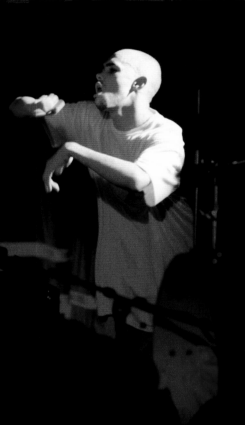

"Steve Cressa, chief groover,
throws another top manoeuvre."

After the gig concluded with 'I Am The Resurrection', Tilton went backstage with the band.

"Those after-gig photos show how hard the Roses worked. They were sweating profusely when they arrived backstage. Reni was shaking the sweat from his hands and fingers. In the photos you can see it dripping off his fingers and eyelids on to the floor. He must've lost a lot of weight that night! Mani was shaking sweat from his hair. Ian was stripped down to his boxer shorts and John looked sad. There's not a smile amongst them. There was a certain energy in the room, but it's definitely a different atmosphere after a gig. It was almost as if they had given their energy away to the crowd and in doing so had sapped themselves. And now, here they were backstage, in their own space but also in each other's company. What a contrast to how the whole day had been.

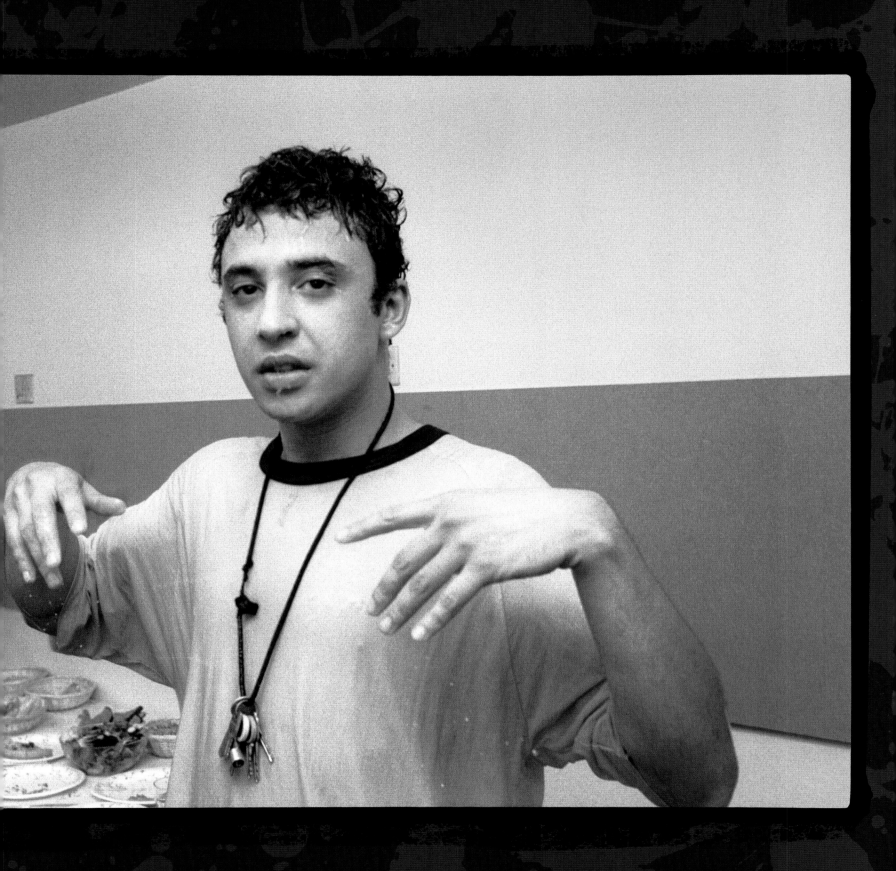

"When you're doing documentary photography of people, first they're really aware that you're there with a camera and become really self-aware. But after a while, your presence becomes the norm and here the Roses have really accepted me. They're not reacting to me taking photos at all. I've become part of the furniture and that's what I was aiming at.

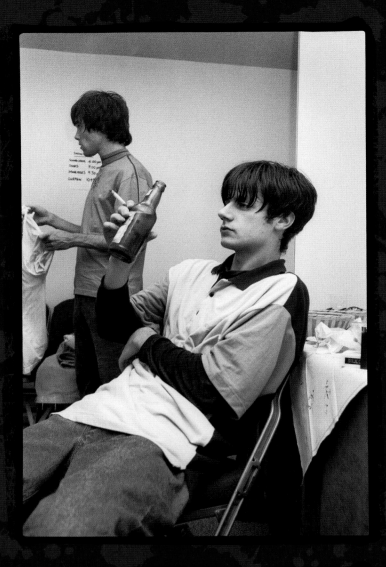

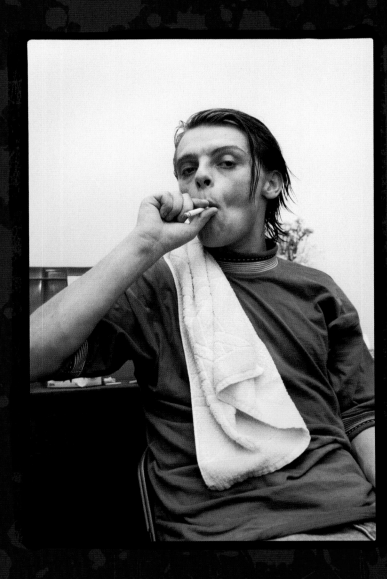

"It looked like they were deflating in front of my eyes. I also felt
that there was a kind of sadness there and the pictures show this.

124 Shoulders hunched, eyelids drooped, mouths open. Bodies that
had been psyched for performance moments before now flopped
heavily. This was the comedown."

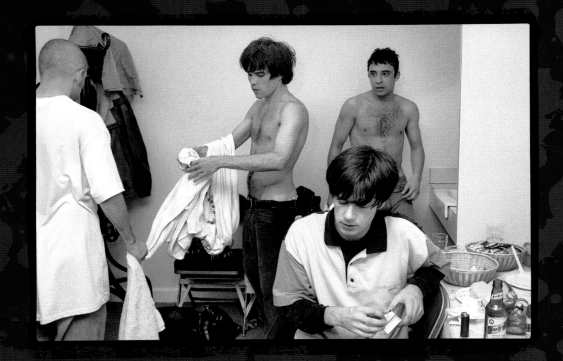

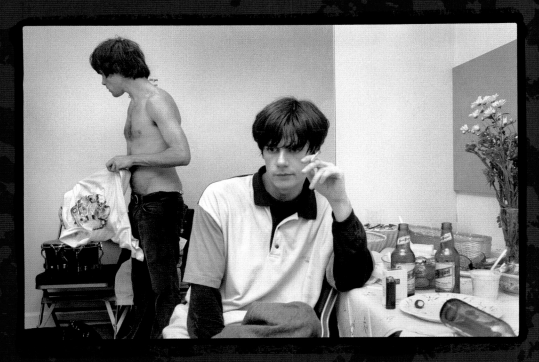

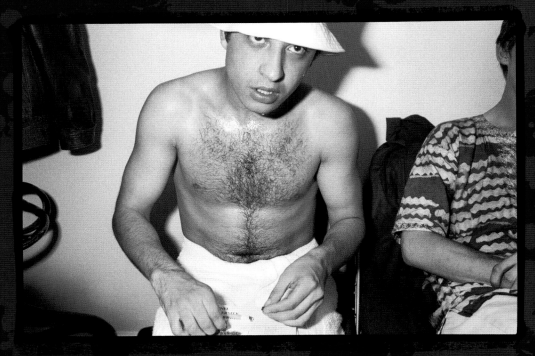

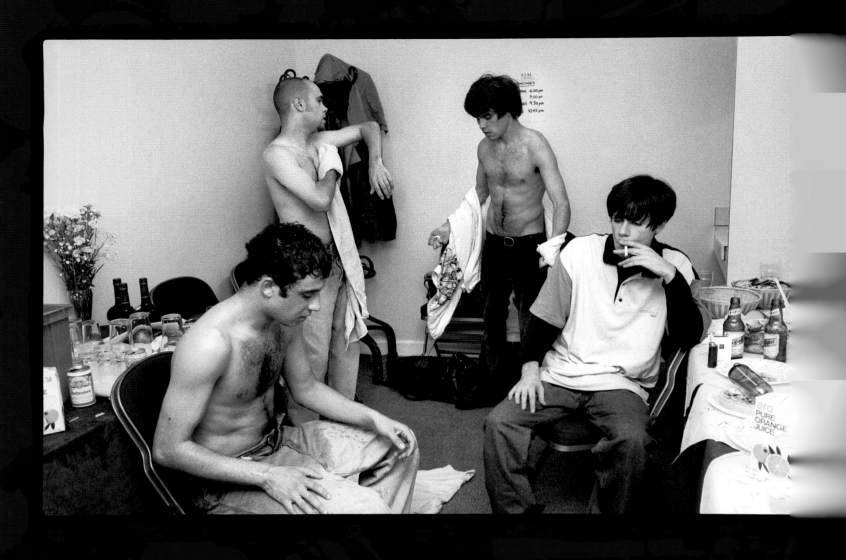

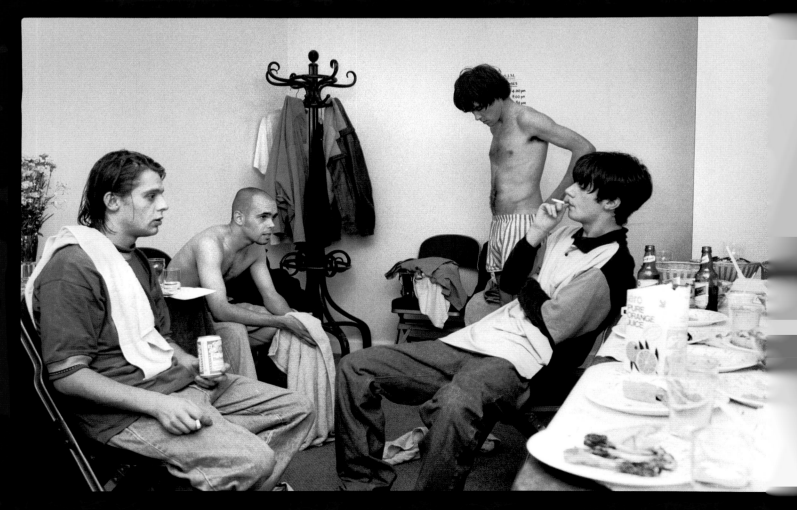

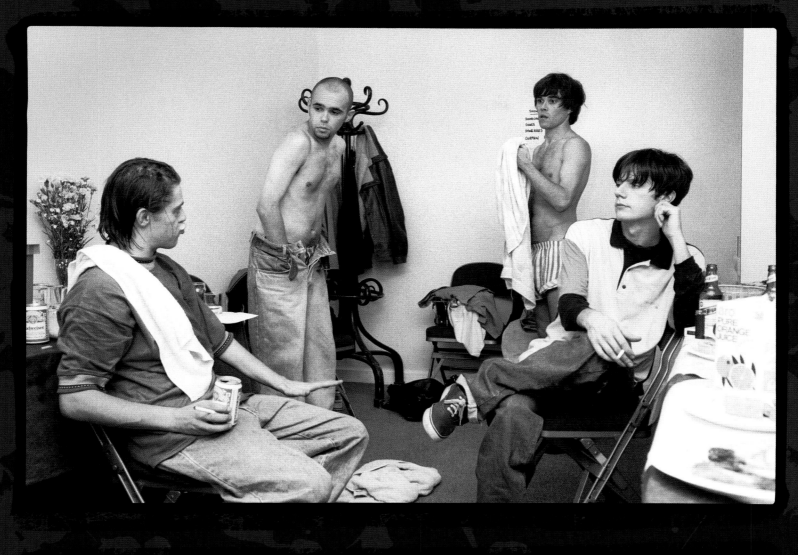

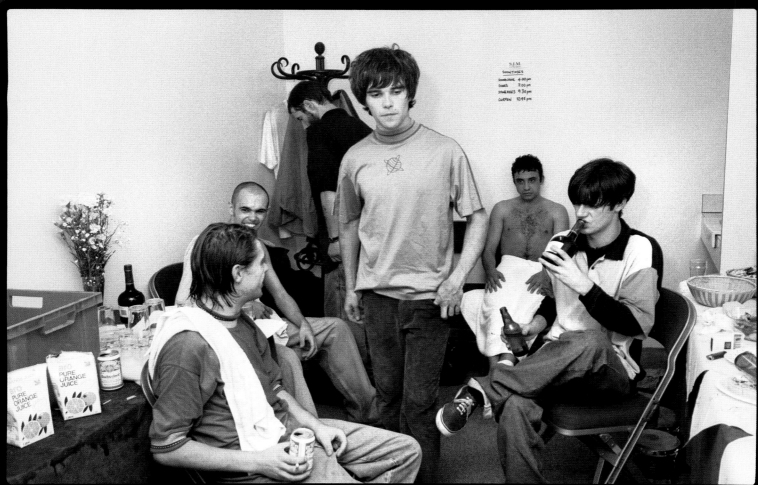

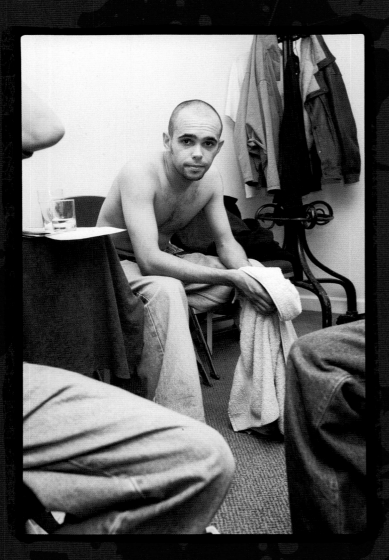
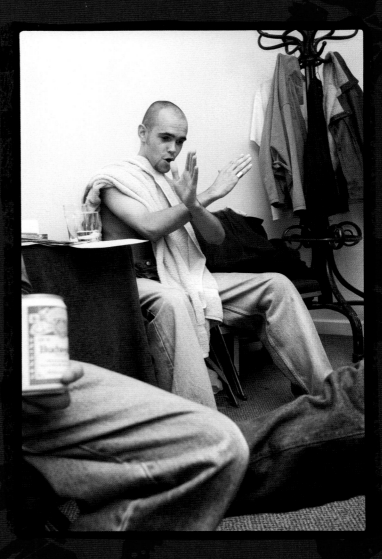

"Cressa started throwing some kung fu moves and I took some great photos of
him sat with John, relaxed with their arms around each other.
It seemed to me that Cressa was the glue that kept the band together."

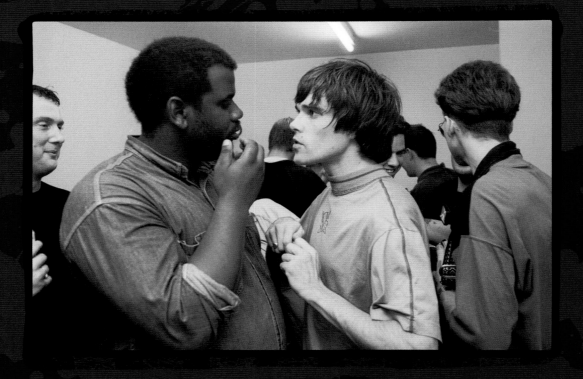

Slowly, as they got their energy back, the photographs began to change. Ian cracked a smile and Mani responded by pulling funny faces.

Graham Killough walked in with the rest of the Manchester crew and the band began to lighten up. Andy Rourke from The Smiths and other Manchester scenesters like Martin 'Sugar' Merchant appeared. Reni who moments before had appeared absolutely zombified was now enjoying his Courvoisier and Coke and the laddish banter.

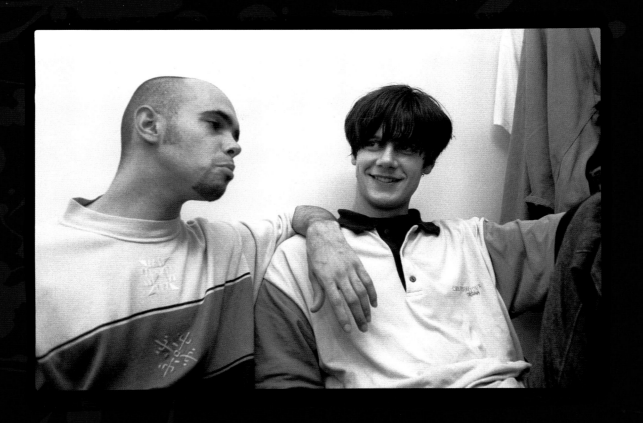

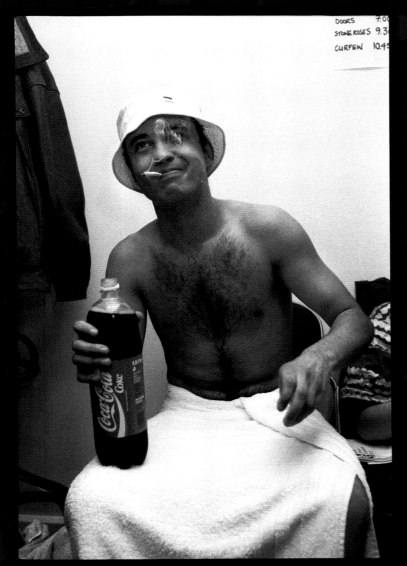

Ian called it a day and left the Roses to enjoy their time away from the camera lens. He went to see his mates who were up from London and then caught a tram on the prom to visit his parents who lived five miles up the road in Anchorsholme. The band and loads of their friends went back to the nearby Carlton Hotel to celebrate and stayed up drinking and partying until dawn.

CHAPTER 13
WHAT THE WORLD'S PRESS WAS WAITING FOR

On May 26, 1990 a press conference was held upstairs at the Piccadilly Hotel, in the same building as Piccadilly Radio in central Manchester, for The Stone Roses to answer questions about their 30,000 capacity gig near Widnes the following day. Spike Island was a peculiar place to host a gig, since it was an old industrial chemical processing site and had gained notoriety as the most polluted ICI site in Europe. When new legislation on pollution made the old factories obsolete, the chemical industry on Spike Island went into decline.

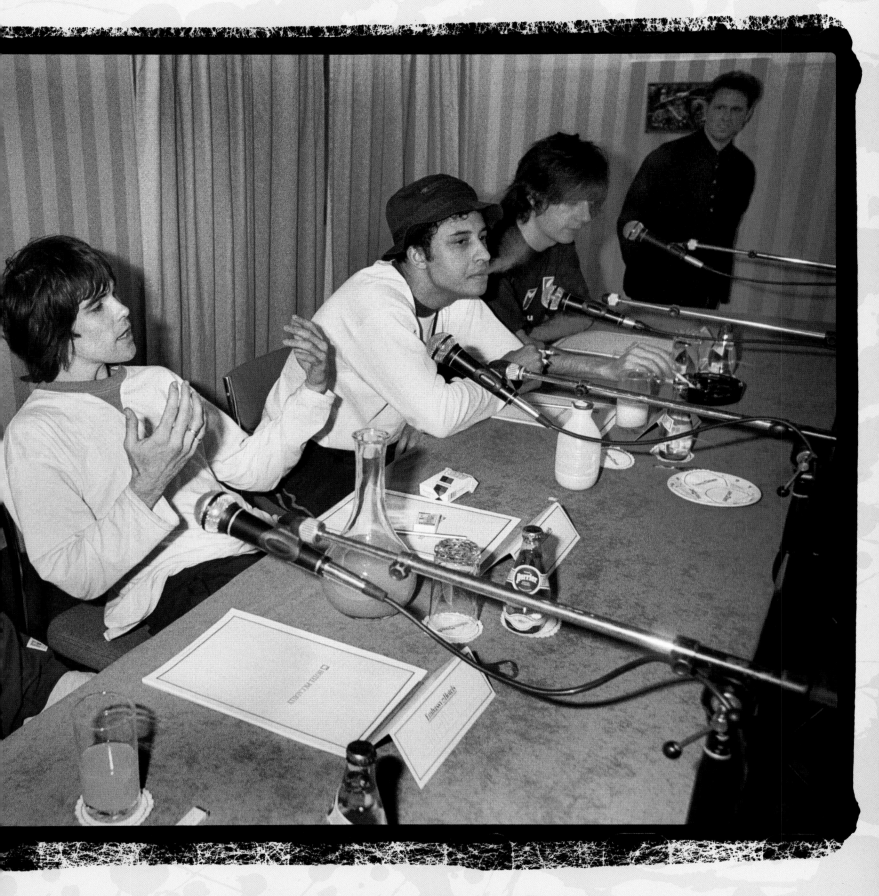

"Mani, Ian, Reni, John and the Stone Roses' press agent/publicist Philip Hall (of Hall or Nothing).
Rarely fazed by anyone or anything, Philip Hall looks amused by
Ian Brown's confident counter attack to the press' interrogations.
The band were notoriously awkward and reticent to respond to journalists' questions with a straight answer."

Tilton remembers: "The press conference was unusual because I'd never seen one for a band in Manchester before. For an indie band to do that made a big statement! I was also asking myself if this conference was going to be a disaster, because the Roses were notoriously reticent when answering questions. Were they going to alienate the world's press? Would top journalists walk out feeling that the Roses' evasive answers and trademark long silences had wasted everyone's time?"

"The press conference looked like it was in a tent and the table
looked like a barrier between the Roses and the press.
The atmosphere was quite stifling and the low ceiling which bore down
on proceedings hardly helped, creating a feeling of tension."

Spike Island was within striking distance for nearly everyone in the north-west. However, the media were less familiar with it. "At a guess
there weren't many people at the press conference who knew where Spike Island was, or that it was an industrial wasteland surrounded by
canals and cooling towers. They probably thought it was gonna be a complete disaster as no one had used it for a gig before. They'd also
heard that there were no shops or pubs on the island!"

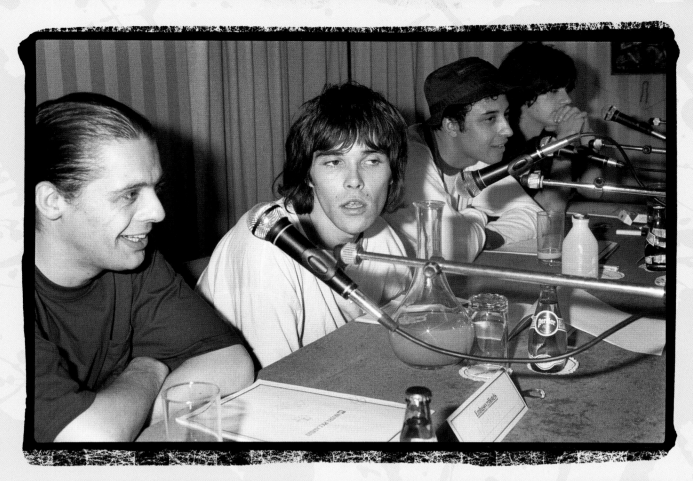

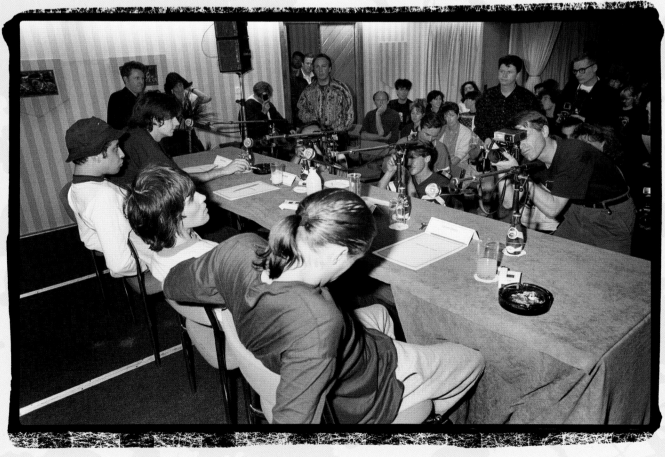

Amongst the press that day were some of the Manchester media who had followed the band from the early days. There was journalist Sarah Champion, who at 17 was Pop Editor of City Life and was collaborating with Ian Tilton on a book about Manchester music and youth culture entitled And God Created Manchester; music journalist and punk musician John Robb, who has since written many successful music books and is a familiar media presence; Bob Stanley, who wrote for Melody Maker and was also in the band Saint Etienne; Stephen Kingston, editor of a free Manchester listings paper; journalist Jon Ronson, who later wrote regular columns for The Guardian and many best-selling books including The Psychopath Test; James Brown, deputy editor of the NME, who later conceived the influential lads' mag Loaded; Pennie Smith, the ace photographer and one of Tilton's heroes; Tom Sheehan, chief photographer of Melody Maker; and Alison Bell, radio presenter and director of Red Alert PR agency.

133

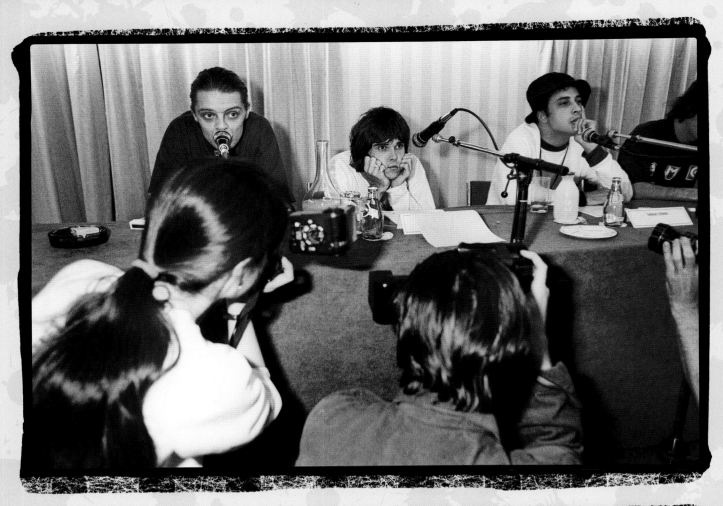

"Ian Brown had a run-in with a journalist from *The Daily Star* when she asked, 'Where will you be in five years?' Brown replied, 'What kind of stupid question is that?' I think this was part of the image that they were portraying, being cool, aloof and almost rude. If you're not from Manchester then the sense of humour can appear dry and is easy to misunderstand. I remember one male journalist getting arsey when the Roses didn't respond very well. I managed to shoot him in full rant. However, some other questions and answers managed to produce a lot of laughs."

"Journalist Frank Owen blows a fuse at the increasing tension."

"It was already a circus before the show had started, with the Roses the
puppet masters pulling the strings and the press mere puppets.
A journalist called them boring and selfish and accused them of wasting the hacks' time,
but the Roses didn't give a shit what he thought."

As the circus continued Ian Brown was now taking the role of ring master. "Caroline Aherne stood up in the audience and as we all knew her and her bizarre routines from the Manchester comedy circuit, I thought 'She's not a journalist! What's happening here?' Because they knew who she was, the Roses were smirking mischievously. In a very serious and deadpan manner, Caroline announced, 'All these wonderful press people from around the world have been asking you some very serious and intelligent questions but what I'm really wanting to know is… pause… pause… what is your favourite colour?' Those of us in the know were stifling our laughter and looking around to see the reaction of the world's press. There was a long silence and a few embarrassed giggles, and then one of the band mumbled 'black'. This just added to the surrealism of it all. People walked away not knowing what that comment was about."

137

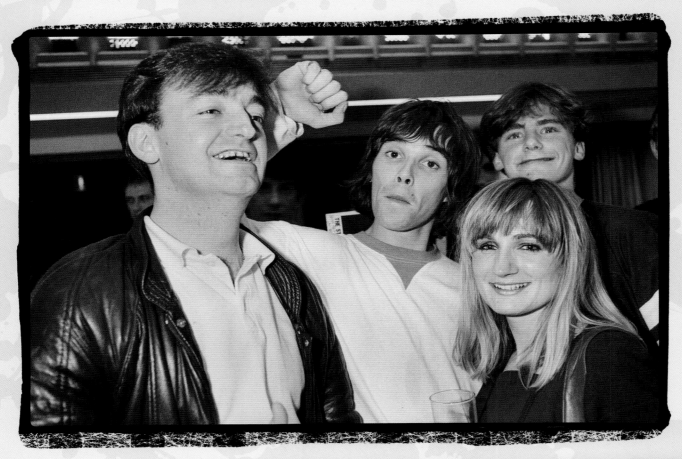

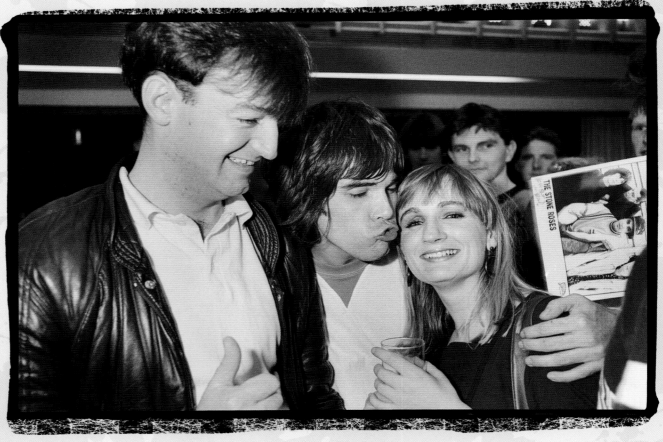

"After the conference I took a photo of Caroline Aherne with Ian and Craig Cash.
She was brilliant and had an act where she dressed as a nun called Sister Mary Immaculate.
Caroline also had a spoof band called The Mitzi Goldberg Experience where she pretended to
be a country singer in the style of Tammy Wynette/Dolly Parton.
They were great characters."

After the press conference Ian Brown said hello to Caroline and her buddy Craig Cash. Craig had his own live radio show at KFM Stockport, on which Caroline also worked and Tilton had recently been interviewed about his photography. Ian Brown started monkeying around with Caroline and Craig for Tilton's camera and Ian snapped some playful shots of them together.

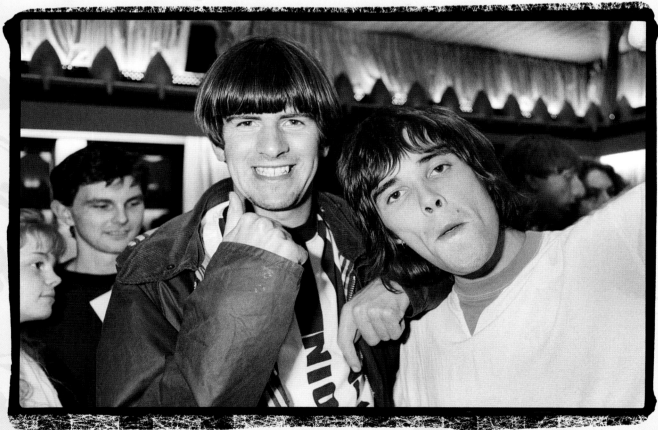

"Music journalist Bob Stanley gave the thumbs up, while Ian Brown larked around
and whistled loudly at Tilton and his camera.
Bob was also well known as the keyboard player
and co-writer in the pop band Saint Etienne."

"Another side of the band I recognised that day was how they looked out for their fans. I noticed that there were some lads at the conference who weren't journalists. They were just genuine fans and the band had made sure they got in. They popped up at Spike Island the next day, too, wearing T-shirts signed by the band from when they'd played Oslo. That degree of loyalty and enthusiasm got them exclusive access to the legendary press conference, which I thought was a nice touch."

CHAPTER 14
SPIKE ISLAND

On May 27, 1990, on a bleak, industrial wasteland in Widnes, one of the key music events of the decade took place. Spike Island is a nature reserve jutting out into the River Mersey, sandwiched halfway between Manchester and Liverpool. No palm trees or clear blue sea surrounding this island, though. Spike Island had been the birthplace of the British chemical industry in the early 1900s. And it was here in the summer of chemicals in 1990 that The Stone Roses played to 30,000 exhausted, sun-kissed fans beneath a bright blue sky, with an imposing, industrial backdrop of smoking cooling towers and power stations.

The choice of venue was intriguing to say the least. In fact, the Roses' manager Gareth Evans and promoter Phil Jones had hoped that the band could use the gig to make a political stance against pollution.

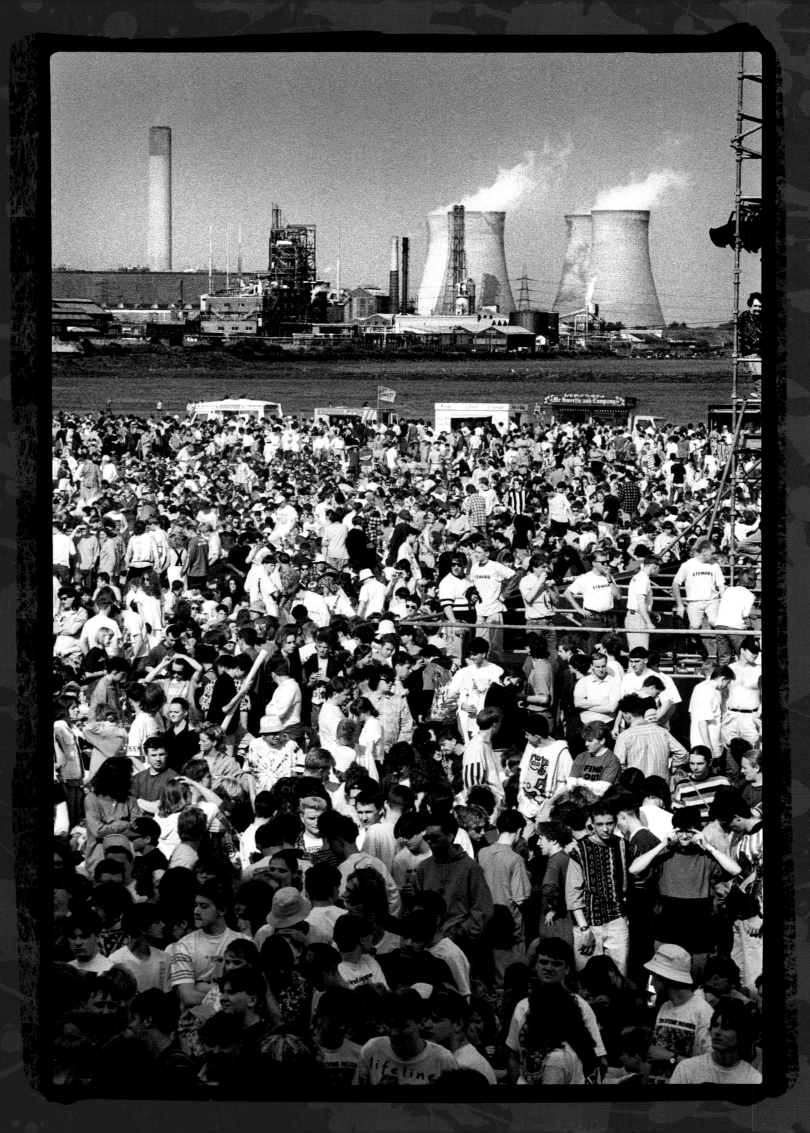

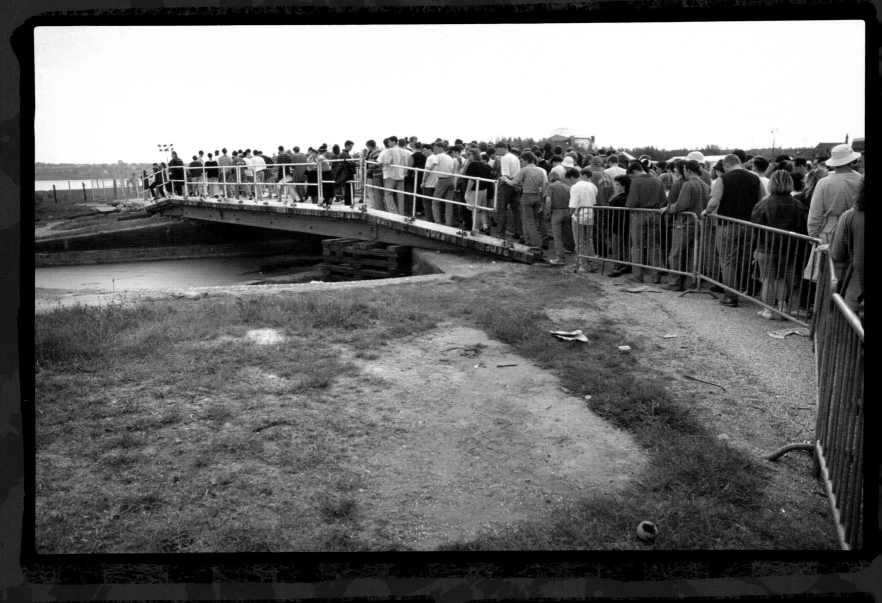

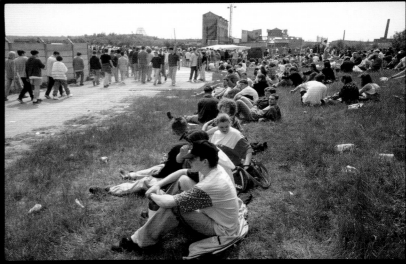

"I captured some really interesting documentary shots as the fans stood on
the ramshackle bridge that crossed the stagnant canal on the way in to the gig.
This next photo shows some lads trying to blag their way in by sneaking along the canal
and then being sent away by the zealous security staff.
I wonder if they eventually made it in!"

142 *Tilton drove over to Widnes, feeling both disbelief and excitement as he first saw the cooling towers loom into view. He still shakes his head with amusement at the memories of that day. "There were 30,000 people and just four beer taps for everyone, with a few burger and ice cream vans dotted around."*

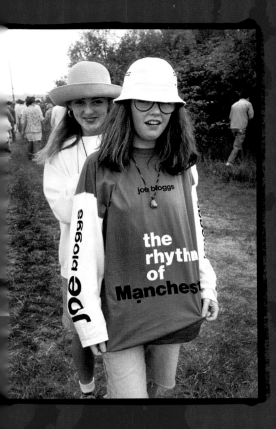

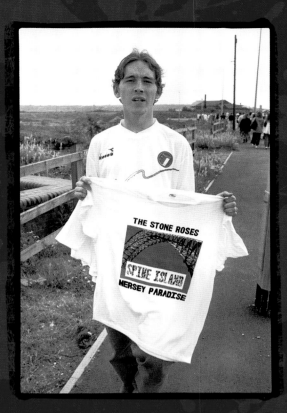

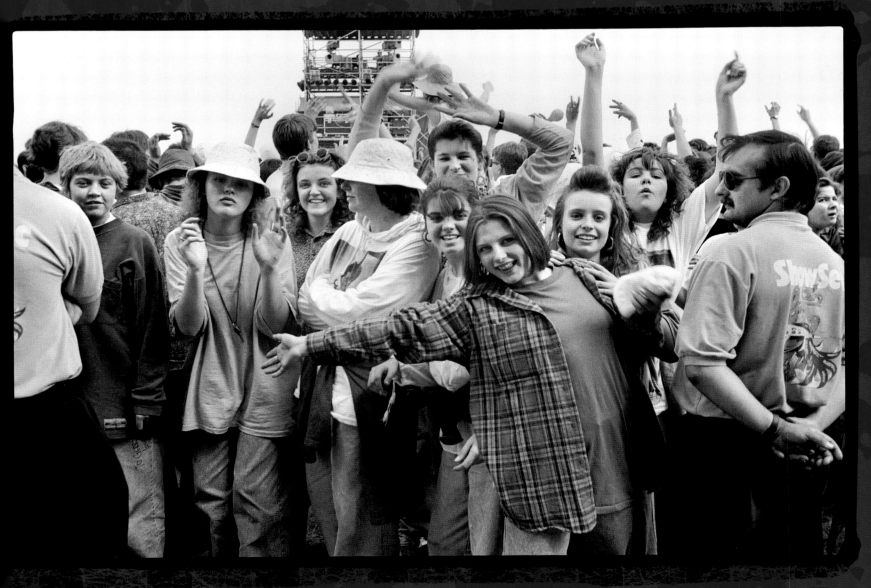

There was also a sea of Reni hats bobbing about in the crowd. The hats were unofficial merchandise and allegedly Reni was pissed off that someone else was pocketing money by aping his style.

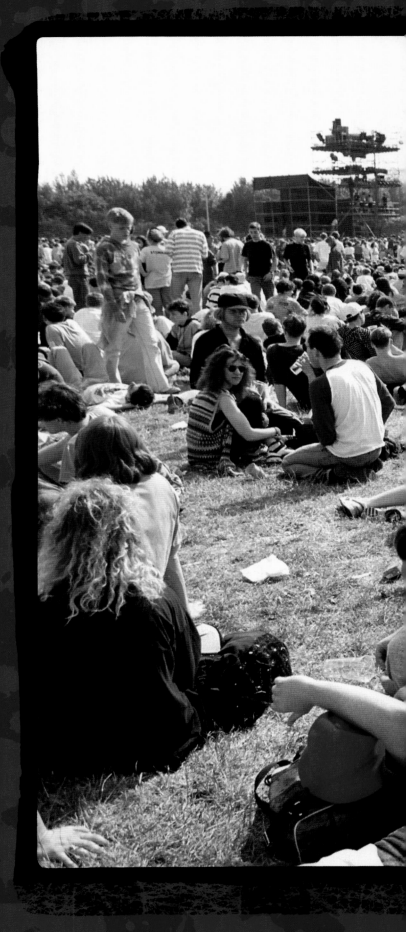

Ⓐ Gary Clail. Ⓑ DJ Dave Haslam points out he's now officially an 'artist'.
Ⓒ Thomas Mapfumo, 'The Lion of Zimbabwe', and his orchestra.

The sunshine, lack of beer, massive queues and lousy catering brought the fans down to their knees and forced a mass chill out. Thankfully there was no more pollution here, just the nearby Widnes cooling towers pluming out pretty white clouds of water vapour. Tilton's photo makes it look like the Second Psychedelic Summer of Love, an updated Woodstock, but on a smaller scale and in the middle of the English countryside.

"Thank God the line-up was a good one. Gary Clail, Thomas Mapfumo and DJs Dave Booth, Dave Halsam and the Jam MCs all played, warming the fans up nicely."

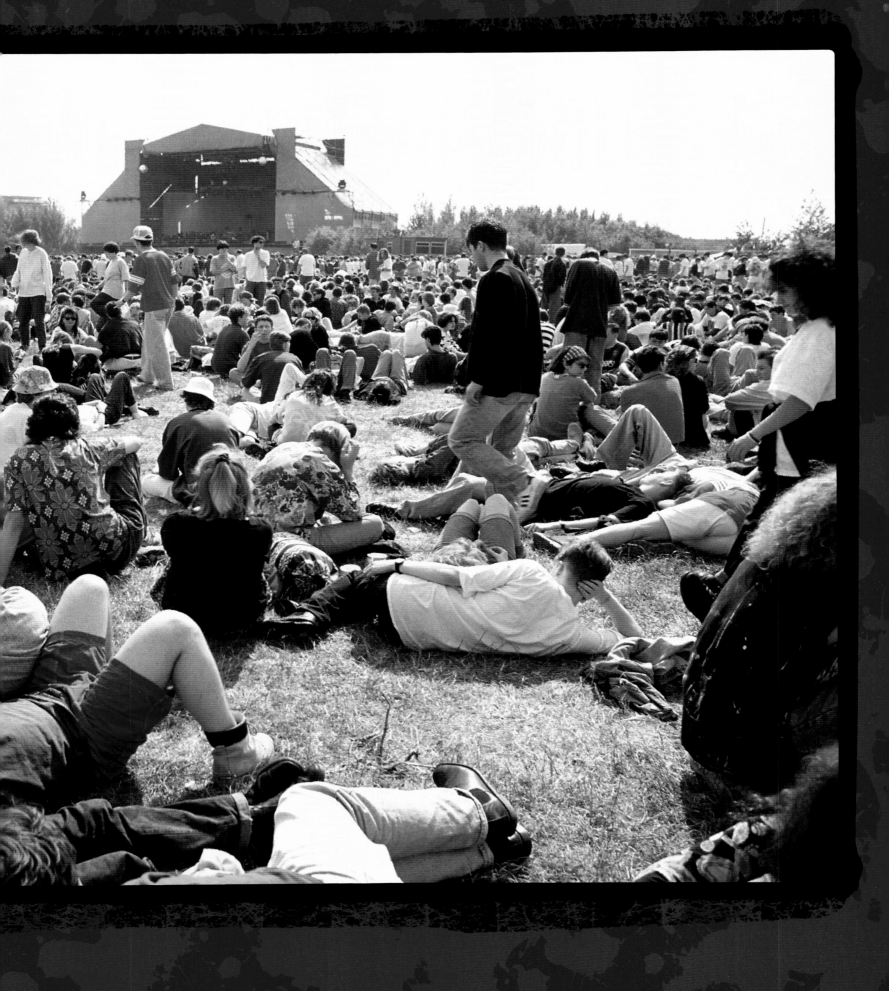

Tilton's photographs capture the baggy fashions of 1990 in all their acid-coloured glory: baggy jeans, paisley shirts, batik-style hooded tops, Stone Roses T-shirts, bright cycling tops, dungarees, Kickers and multi-coloured Head bags. Perhaps due to hallucinogenic drugs, there seemed to be a major fascination with psychedelic patterns at the time.

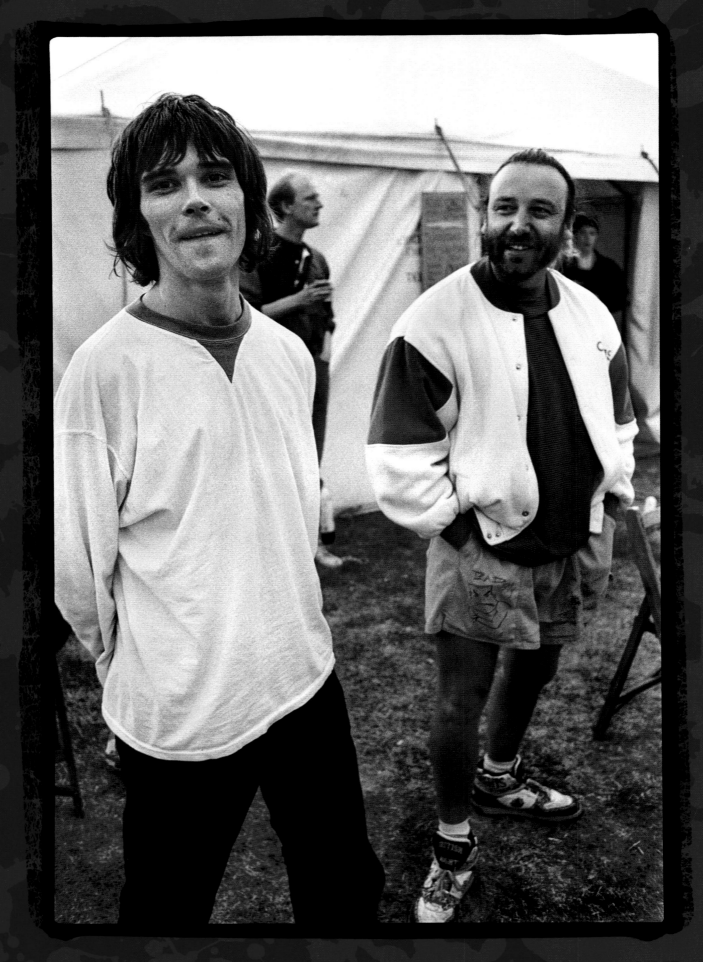

"Ian Brown and 'Hooky' (bass player from legendary Manchester bands Joy Division and New Order)."

Backstage in the VIP and press area the atmosphere was chilled out, aided by the summer sunshine. Ian Brown and Reni were hanging out and chatting to friends, including Hooky of New Order and his girlfriend Jane. There was Bez and the Mondays' manager Nathan McGough, Bobby Gillespie from Primal Scream, Graham Massey, Martin and Andy from 808 State, Gareth Evans with Basil from Yargo, plus The Bodines and Liverpool band The Christians. Tilton chatted to fellow photographers and journalists Peter Walsh and AJ Wilkinson, Jon Ronson, James Brown, John Robb, Mandi James and others.

146

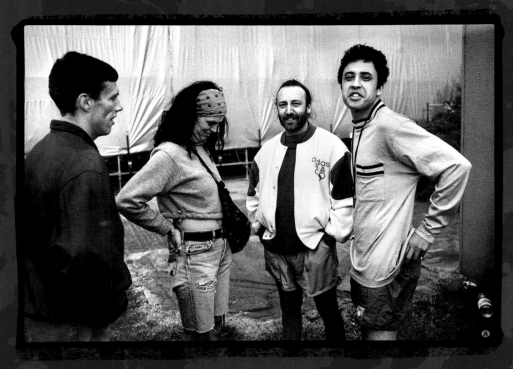

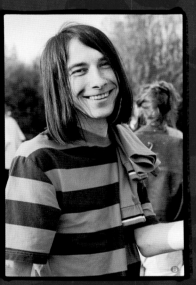

147

Ⓐ Mark 'Bez' Berry (dancer with the Happy Mondays), Jane Roberts and her partner Peter 'Hooky' Hook from New Order, and Reni. Ⓑ Bobby Gillespie from Primal Scream.
Ⓒ Left to right: Happy Mondays manager Nathan McGough flicking the Vs, Lorraine Hayward, Debbie Turner, editor of the *NME* James Brown, and Steve Massey from *Boys Own Fanzine*.
Ⓓ Manchester Vibes In The Area! Make some noise!! MVITA's Alfonso Buller.
Ⓔ Basil Clarke's daughter Ayesha, Gareth Evans (Stone Roses manager), and Basil Clarke from the Manchester jazz funk band Yargo.

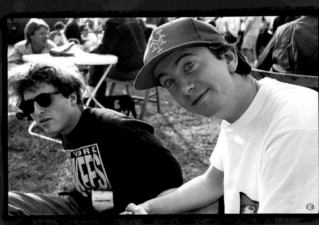

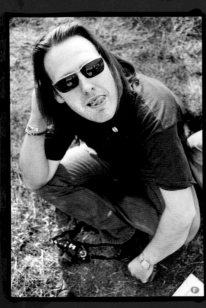

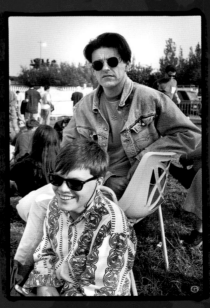

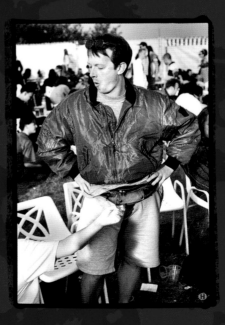

148 **A** Rachelle, Keith Curtis and John Robb (journalist and singer in The Membranes and Goldblade). **B** Brothers (and friends of Mani) Steve and Mark Davies with their friend Clare –
Steve and Mark went to Spike Island the week before and spray-painted their nicknames all over the place to be part of the backdrop: 'Dickie and Bobble of Failsworth'. **C** Cressa.
D Peter 'Hooky' Hook (New Order) and Shaun Ryder (Happy Mondays). **E** Jon Ronson (journalist, author, band manager and TV presenter), Peter Walsh (*NME* photographer and filmmaker).
F Photographer A J Wilkinson. **G** Martin Price and Andy Barker (808 State and DJ with the Spinmasters). **H** Mandi James' hand, Graham Massey (808 State and Biting Tongues).
Facing Page: Olly (Ian Charles Oliver) and Ian George Brown.

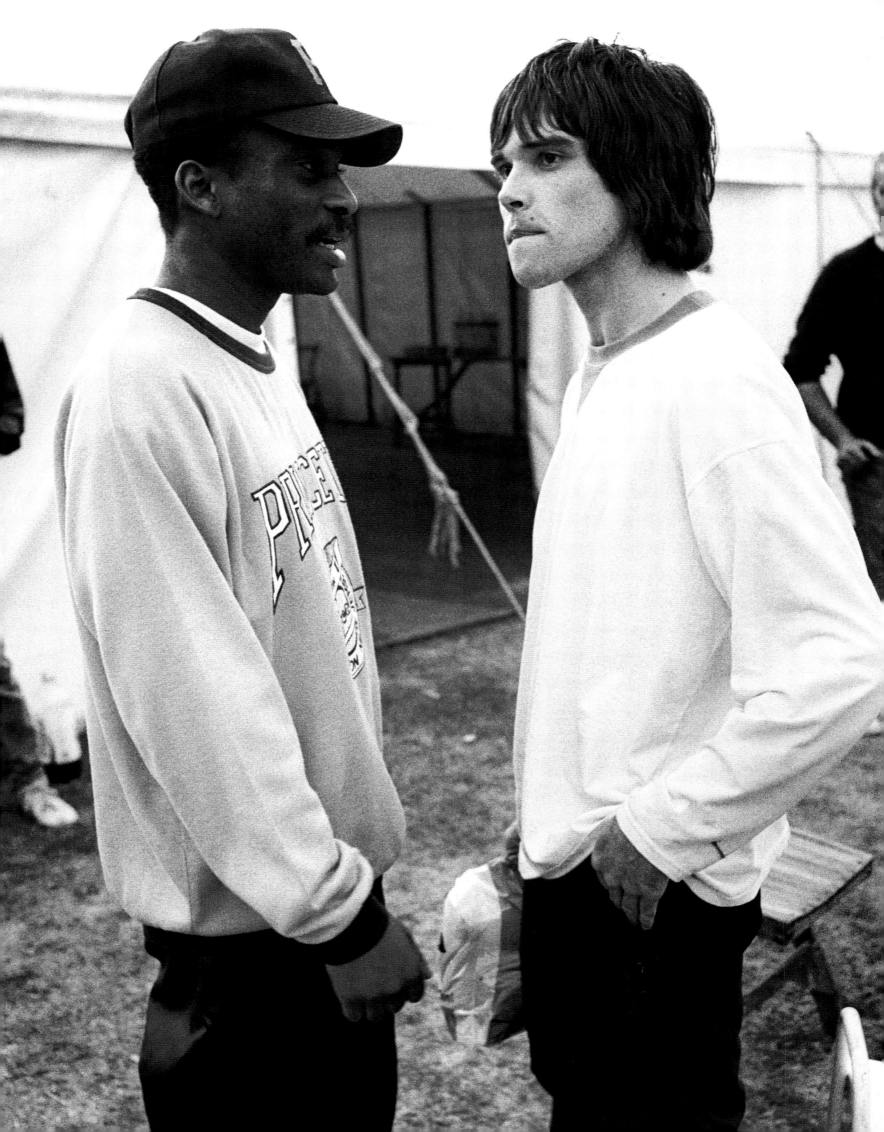

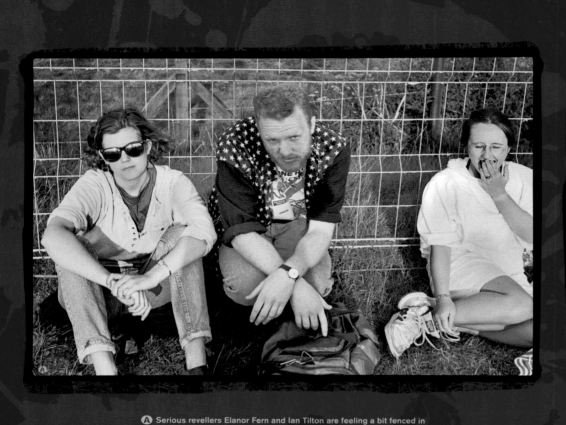

A Serious revellers Elanor Fern and Ian Tilton are feeling a bit fenced in
waiting for the band to appear onstage.
Little Jane yawns while she gets her legs suntanned.

It soon became apparent that there was going to be a long wait before The Stone Roses appeared. Tilton remembers: "The band didn't come on for hours. It was a long, hot day. The photos show that people were having fun, but also that they are really weary and tired.

"People who went to Spike Island said they'd enjoyed it but it was a long wait. The fact that there were only about four beer taps meant that the fans couldn't really get drinks, or certainly had to endure long queues for a beer. There were problems with the sound and some people at the back couldn't hear. I'm pretty glad I was at the front on the photographer's stage. I didn't fancy being in with the crowd on such a hot day. That was a great perk of the job, although I too remember feeling pissed off that they took so long to appear!

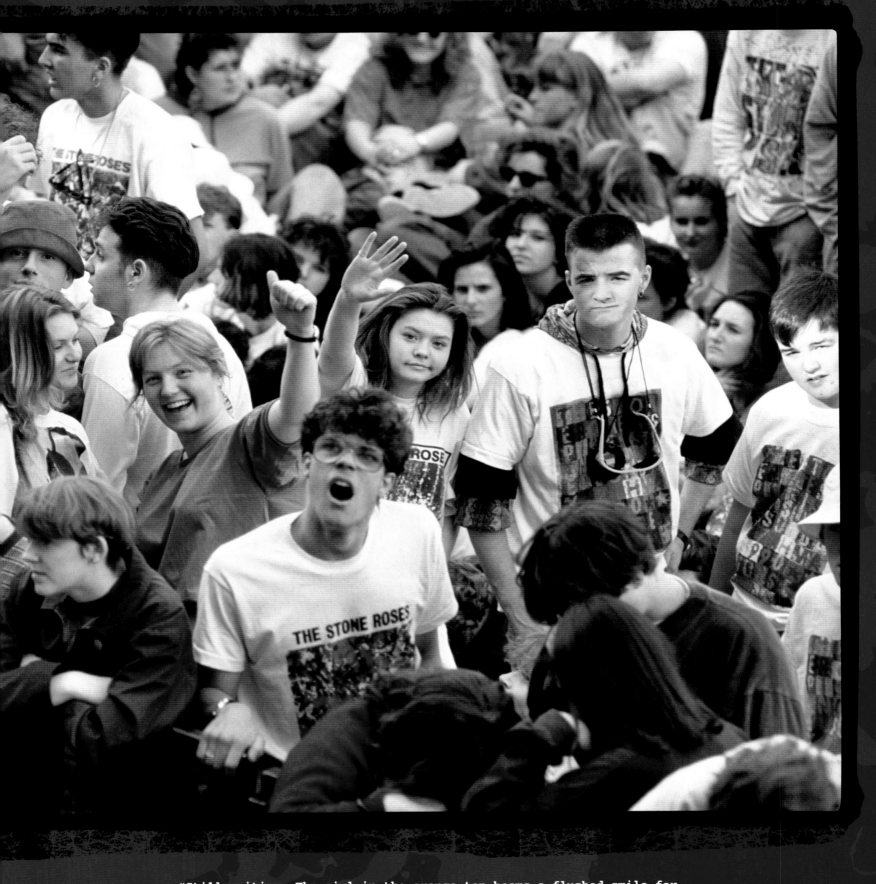

"Still waiting. The girl in the orange top beams a flushed smile for
the camera but the tired gestures and body language of
everyone else speak loud and clear, giving away their true feelings.
I can't quite make out what the lad in the blue top and red hat is saying though, can you?"

"People weren't really partying. They were pacing themselves. It was slightly subdued because we knew the band wouldn't be on
until around 9pm. People were complaining that they couldn't get drinks or food. Well they could, but the queues for the inadequate
catering facilities were massive and frustratingly slow. Mixed in with the heat of the summer afternoon, it all became very lethargic.

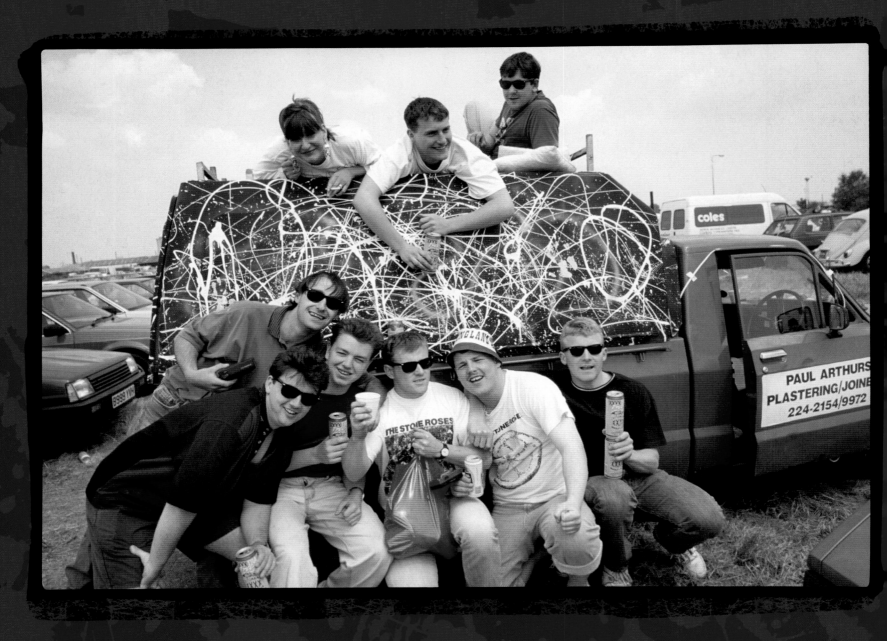

"The van was splattered with a champagne supernova of paint,
just like one of John Squire's canvases.
It provided the perfect oasis for this gleeful gang of raved-up revellers
and their liquid picnic."

"I was taking some colour photos of the brightly adorned fans whilst wandering around the edge of Spike Island. There were some people having picnics they'd brought with them, and I spotted a bunch of happy lads at the car park who were partying next to their brightly coloured van. They posed for me holding their cans of Aussie beer, in front of their work van of which they were very proud.

"A few years later I got a call from the picture editor at *Select*. He was running a feature on Spike Island, so I'd sent him all my pictures from that day. He said, 'We really love that picture of Bonehead and Guigsy from Oasis you took.' To which I replied, 'What picture? I never photographed Oasis then! Oasis weren't even a band back then.' The editor then said, 'Remember that van you snapped and the people who were with it? That was Bonehead's van and he's in your shot with Guigsy!' I had to laugh; I had no idea they were in the shots."

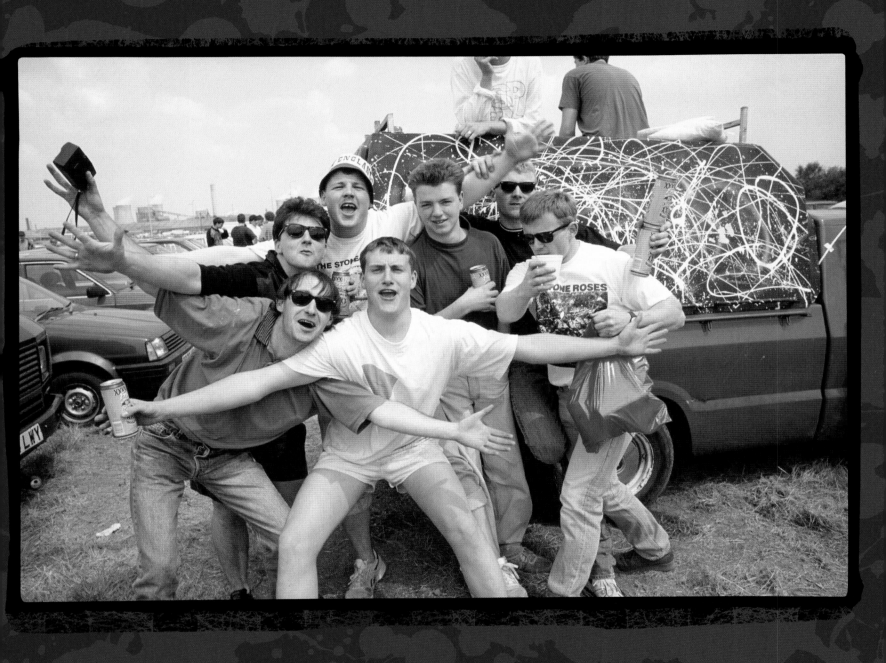

How many people have been energised by The Stone Roses to go out and form their own band? Nearly a decade and a half before Spike Island, punk bands had sent out a clear message – get on stage and just do it! It was a message heard by Ian Brown and John Squire. The Roses were clearly the inspiration for Liam Gallagher, Paul 'Bonehead' Arthurs, Paul 'Guigsy' McGuigan and Tony McCarroll to form Oasis. Noel joined his little brother's band some time later, having worked as a guitar techie for fellow Manchester band the Inspiral Carpets.

Just three years after Spike Island, in September 1993, Ian Tilton photographed Oasis for the first time, when they played live to a small audience of around 30 at Manchester's Canal Bar, just a few doors along from The Haçienda. Their road manager was none other than Steve Adge, who'd performed the same role for The Stone Roses.

153

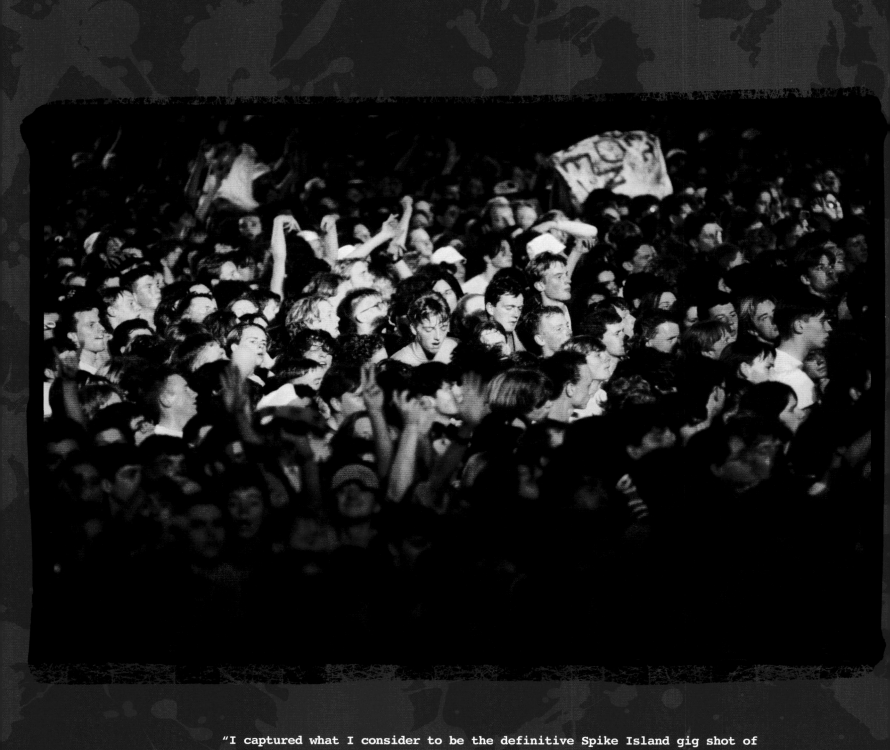

"I captured what I consider to be the definitive Spike Island gig shot of
Brown holding the inflatable world.
If you look closely at the photograph, he is actually licking the ball!
I got the right angle; I was in the right place at the right time."

"When the band eventually came on there were great cheers. Everyone instantly perked up as wonderful colours were projected across
the audience in vibrant waves. My photos show the density of the crowd, the vibe and the colourful atmosphere.

"I felt that the photographers were a bit too far away from the action, but I was ideally placed when the Roses brought a big inflatable globe
on stage. Ian had the whole world in his hands and it felt like this band was what the world had been waiting for."

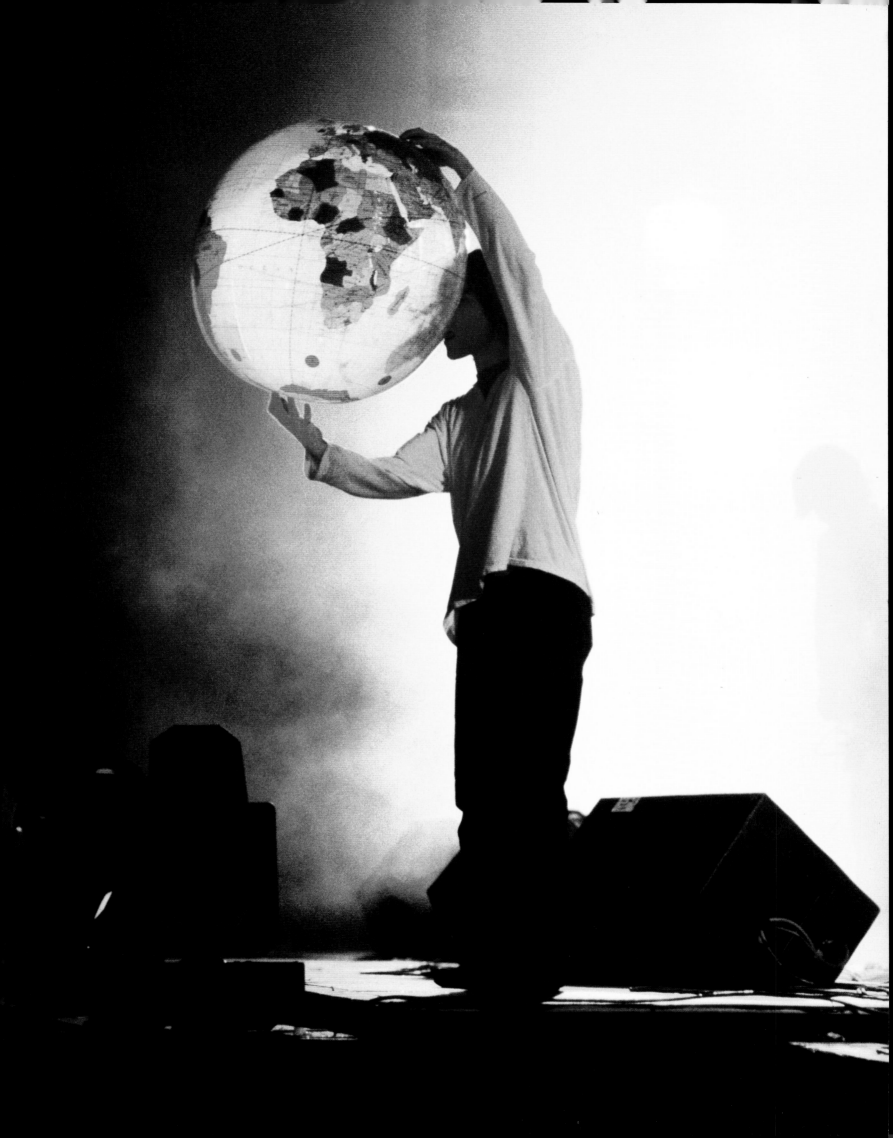

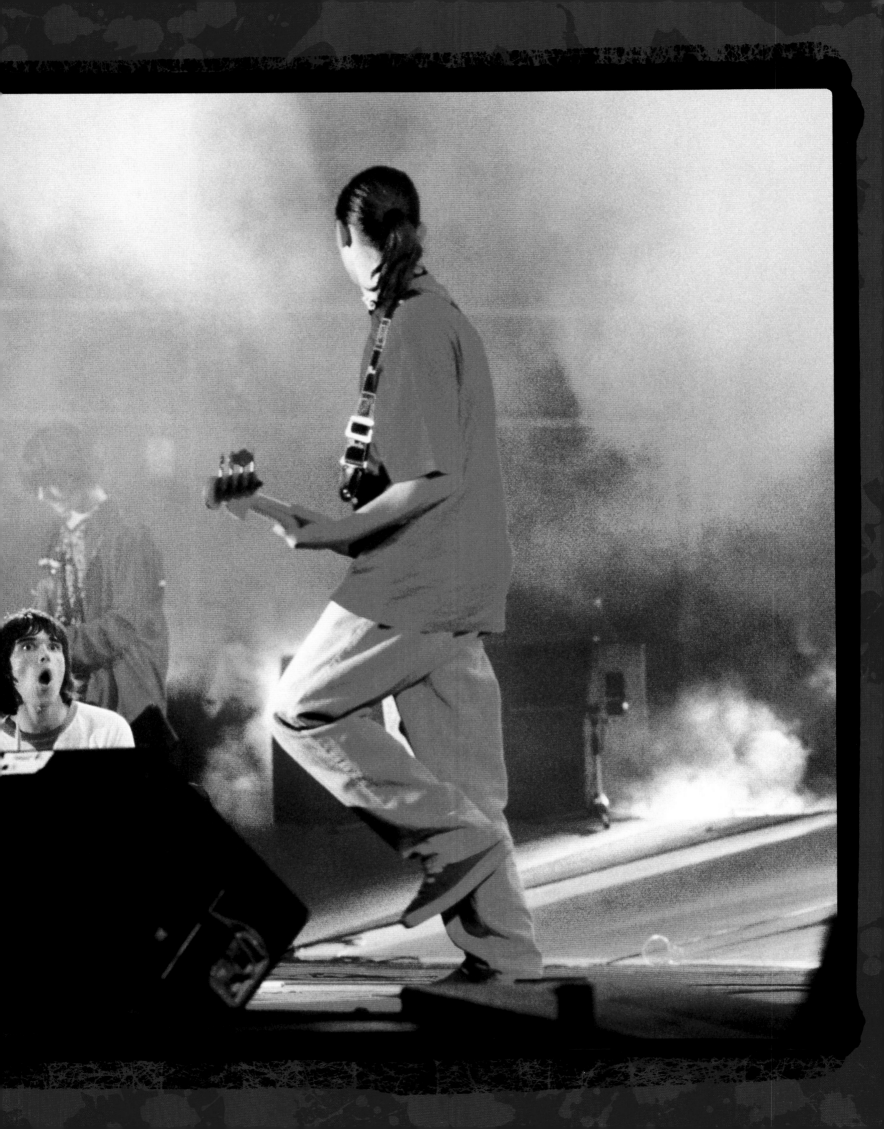

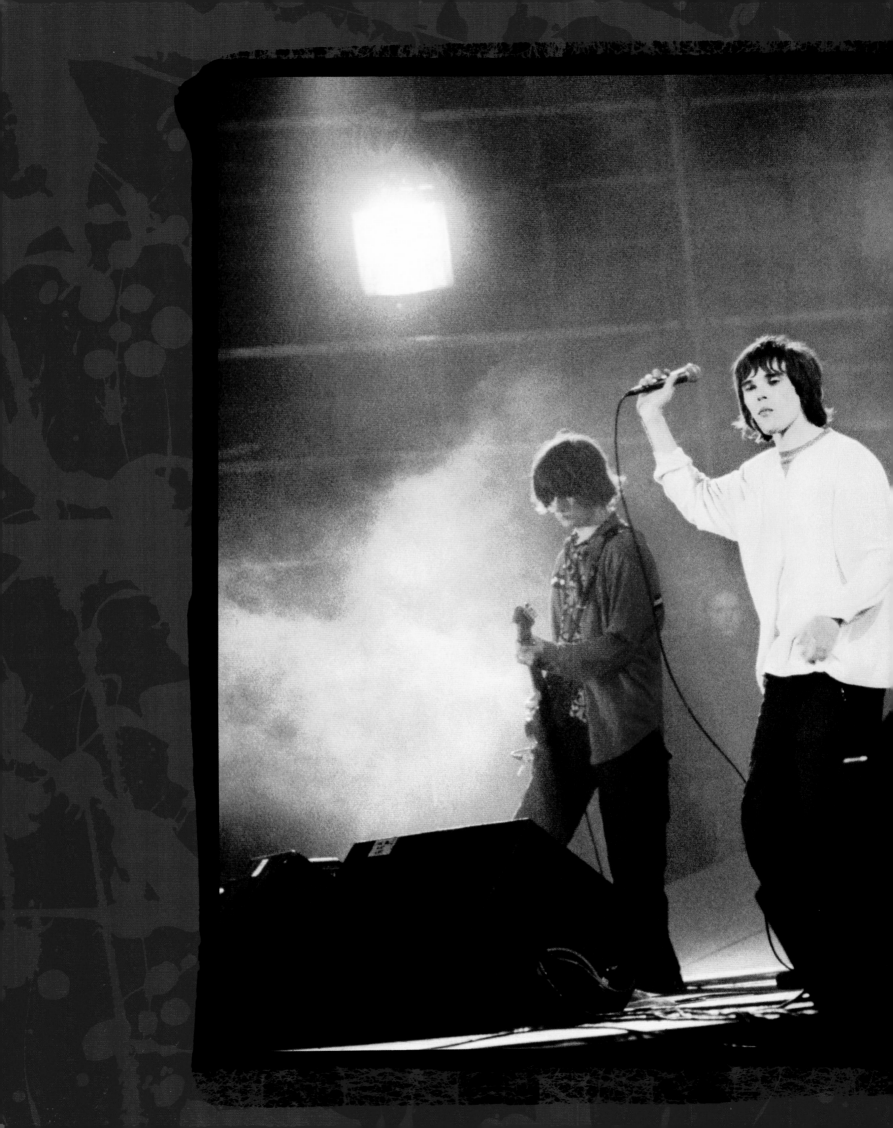

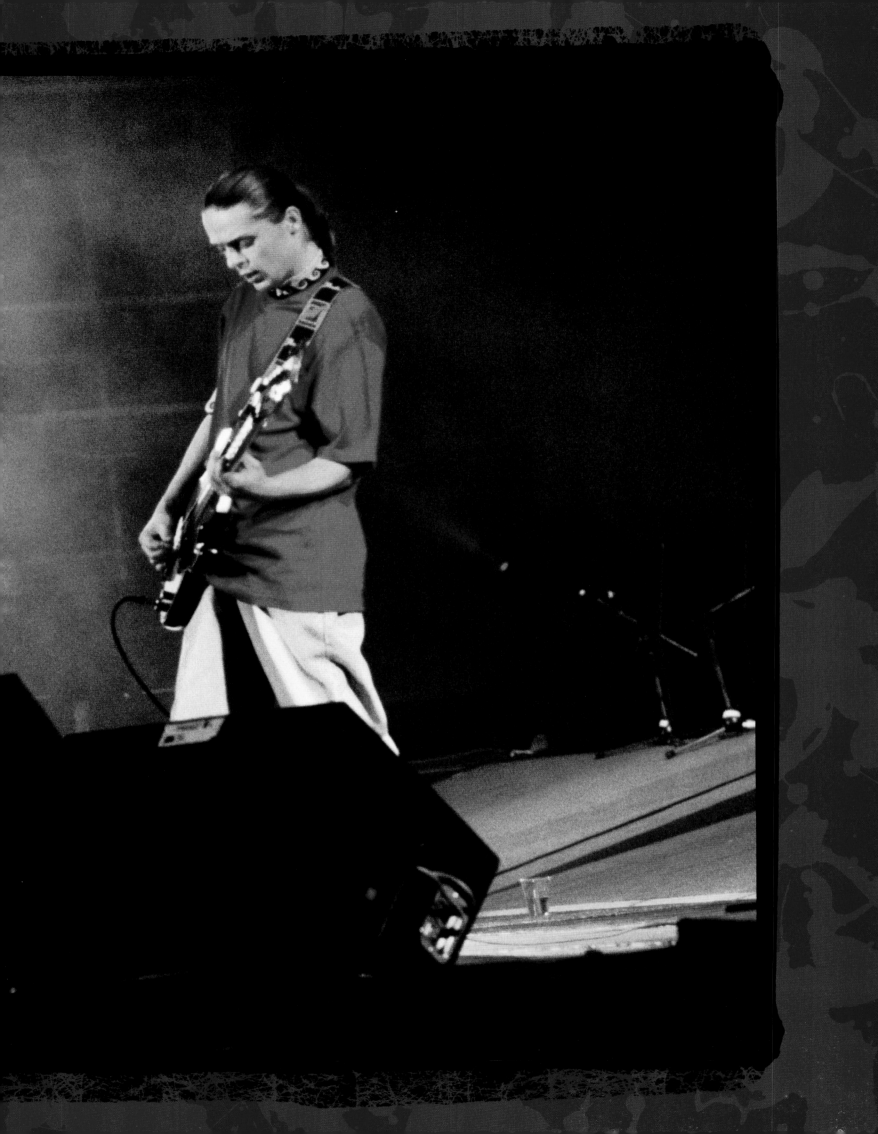

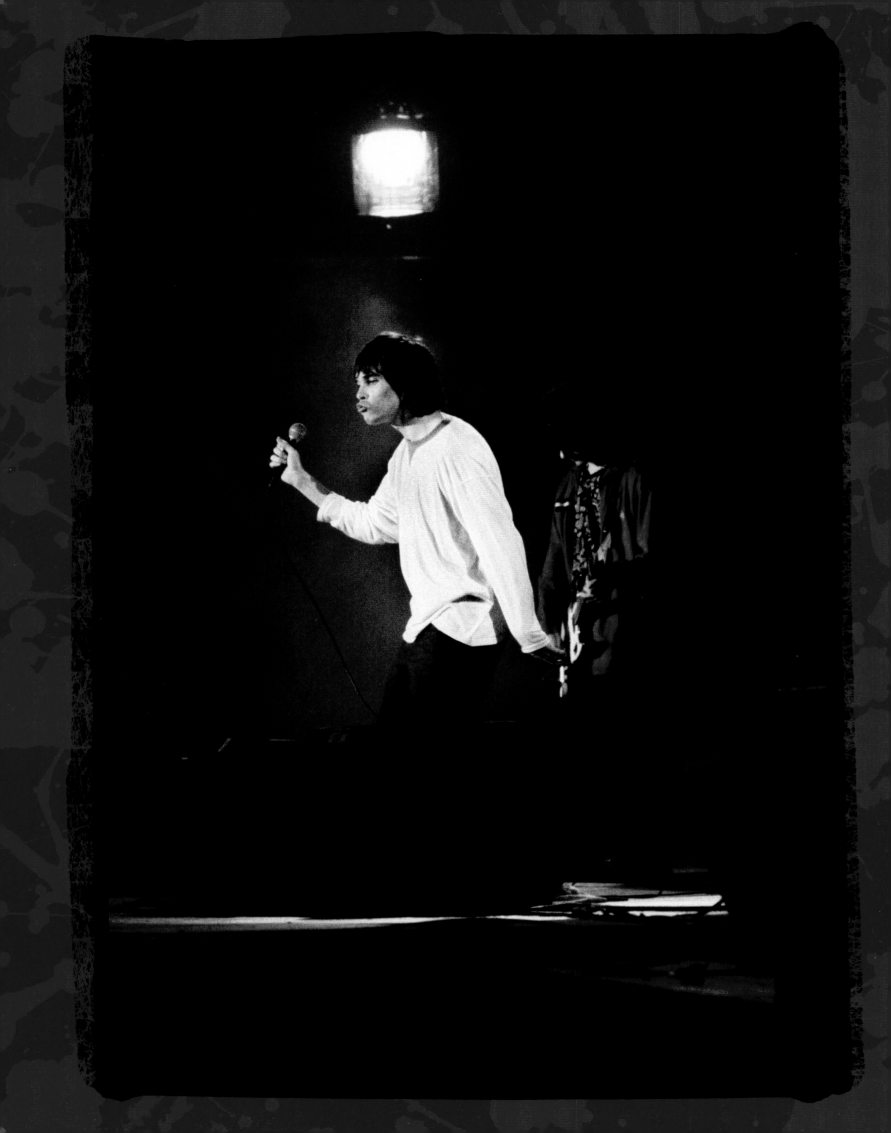

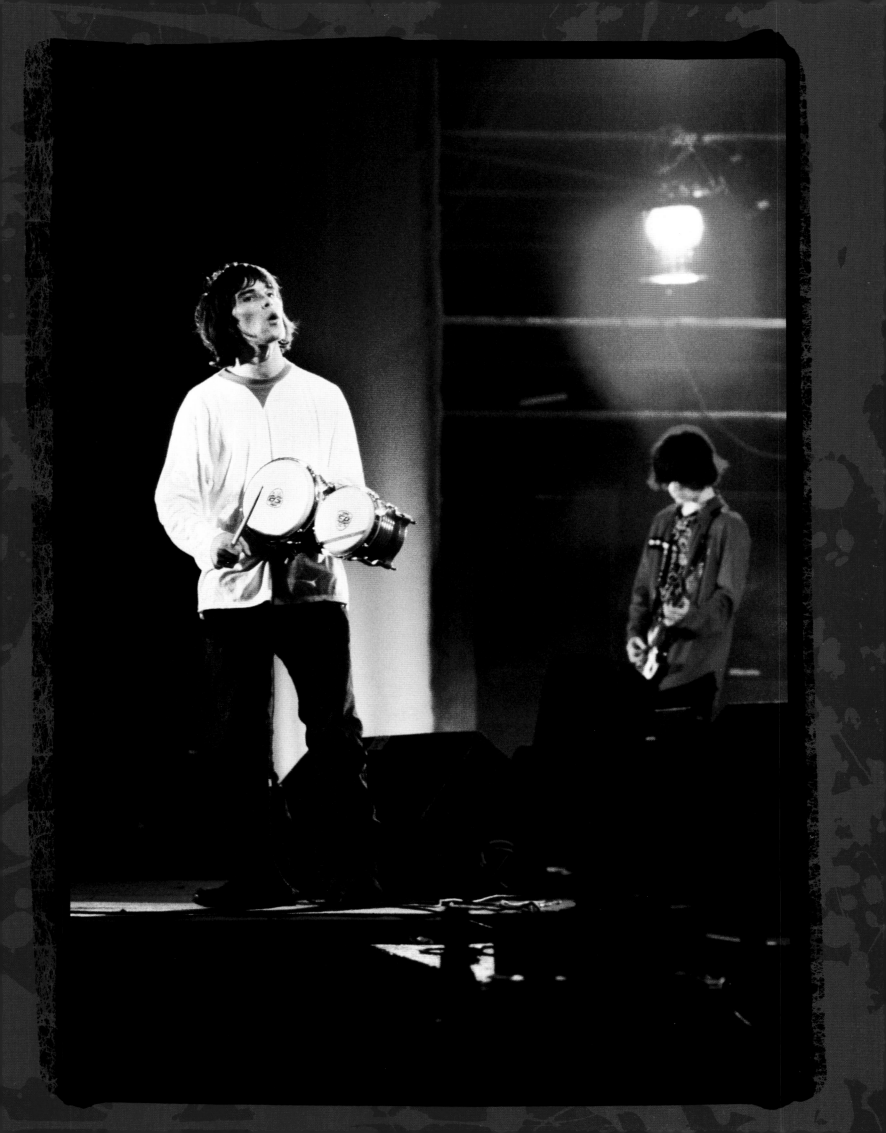

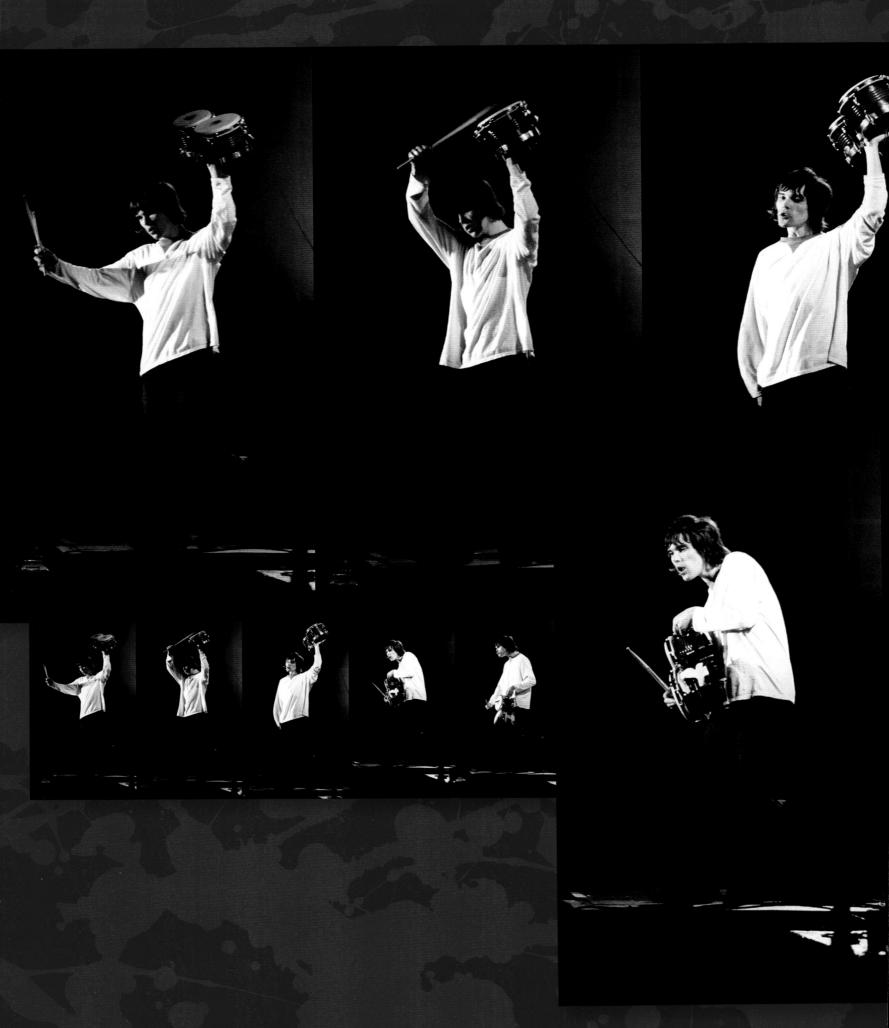

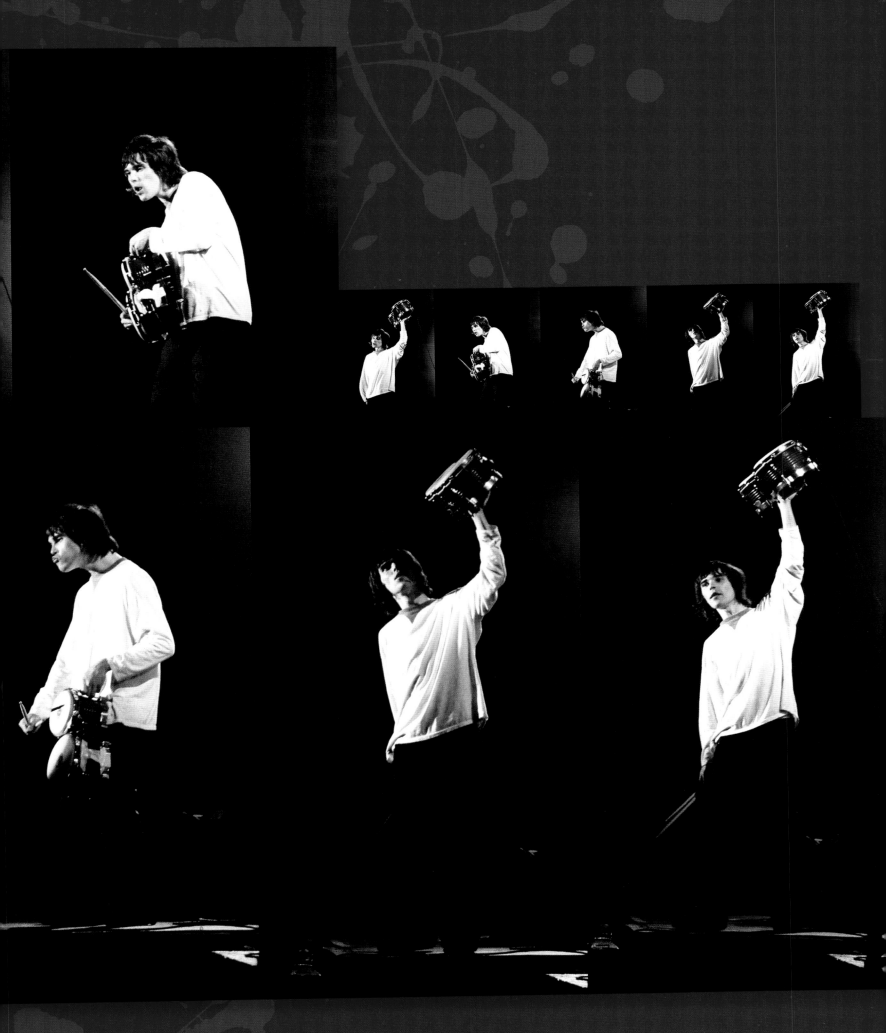

Tilton would have loved to stay on following the gig to enjoy the hedonistic vibe at the after party taking place at The International in Manchester. The band had delivered the goods and everyone was now ready to carry on through the night. However, Tilton had to call it a day and go home, since he was about to embark on a road trip with The Charlatans the very next day...

CHAPTER 15
SCOTLAND FOREVER!

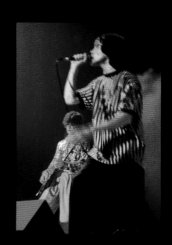
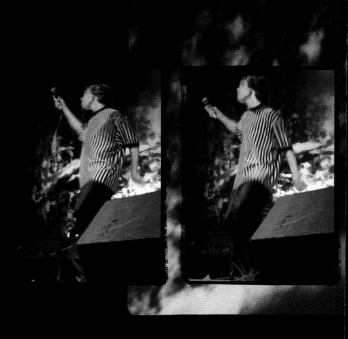

At Glasgow Green on Saturday June 9, 1990, barely a year after their groundbreaking gig at Blackpool Empress Ballroom, The Stone Roses played what would be their last gig for four years. This hardly seemed credible at the time. The Roses were riding high, looking forward to playing Glasgow and taking their psychedelic show up to Scotland. Both the band and their fans were blissfully unaware of the legal wrangles that would engulf the group and result in a reclusive four-year break.

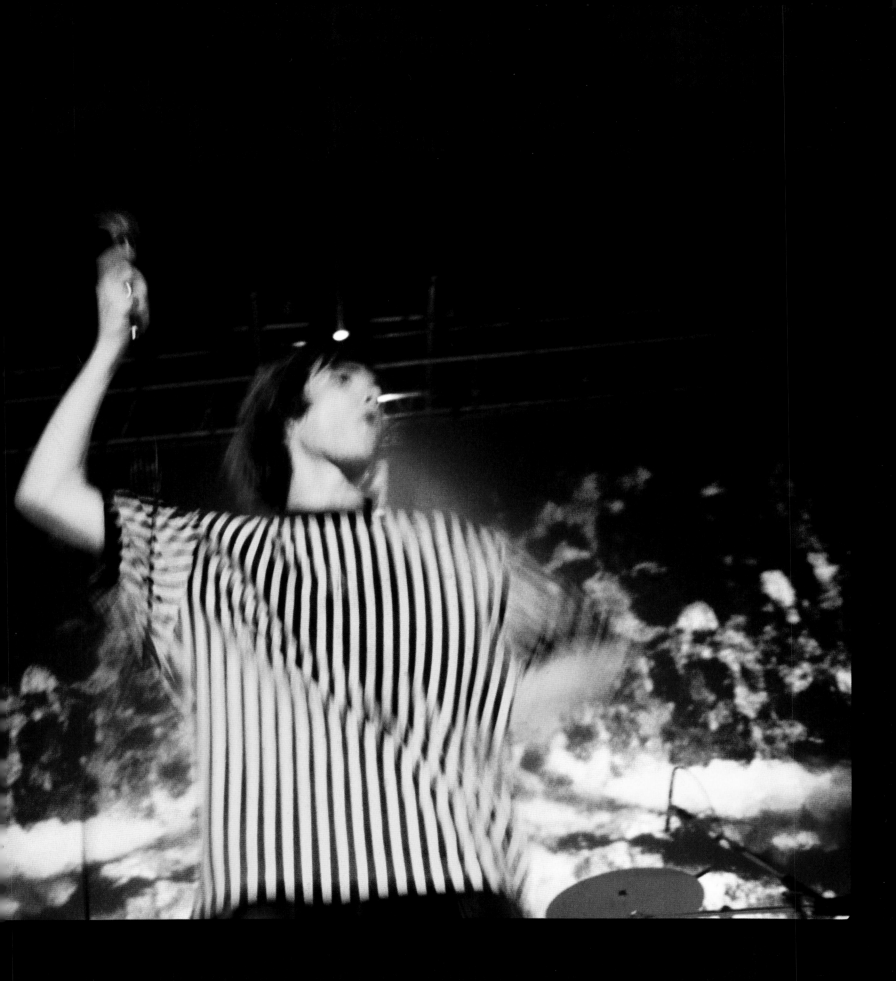

"It felt as hot as a tropical rainforest inside the tent,
with condensation and sweat dropping down on us in big blobs."

Tilton takes up the story: "We didn't realise that this would be the last Roses gig for years. They practically went into retirement. We all really thought that they would do more after this: more recordings, more gigs. It was an exhilarating time and we were buzzing! But then they just languished. It was really surprising that *Second Coming* took four years."

"I wasn't commissioned to take photographs of
 the Glasgow Green gig but drove up from Manchester with
then-girlfriend Marian Buckley and stayed over with
 friends Ian Baird, John Robb and Paul Bell.
We met up for a pre gig drink at the Horseshoe Bar in Glasgow."

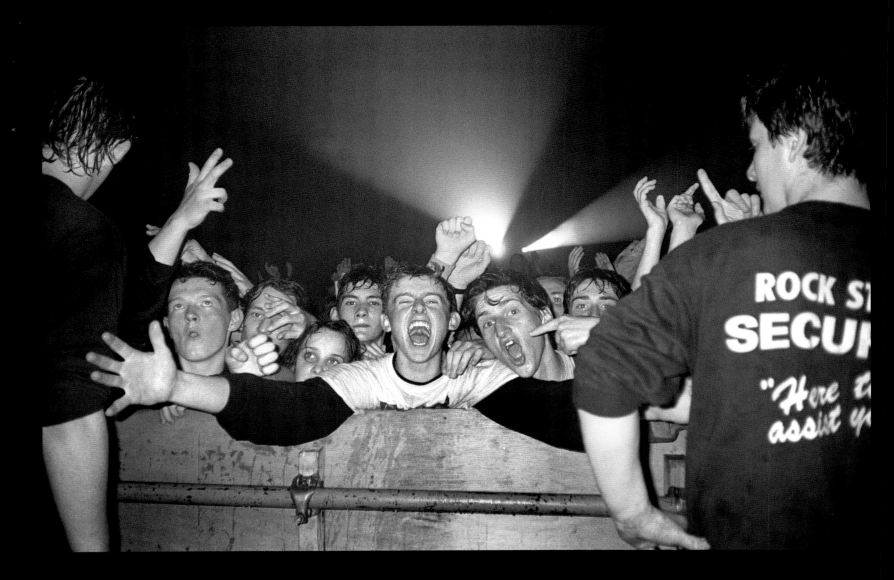

Tilton remembers: "This gig was different for me because I could let loose on it. I wasn't commissioned to take photos, so I didn't have to have my professional head on. This was a gig that, for the first time, I was going to enjoy as a punter. I didn't stay in a hotel and hang out with the band as I usually would. I just went to see the gig as a fan with mates.

"What's really nice now is there's a generation of young people who are really into The Stone Roses, who want to find out what it was all about. It's not like they look at their parents' record collection and go, 'Urgh, I'm not listening to that!' Which is kinda what I did when I was a kid, because I rebelled against my parents' music, artists like Jim Reeves, Frankie Vaughan, Vikki Carr and Julie London. I'm pleased that The Stone Roses are still a really cool band and the music has stood the test of time. Because the songs are great and the wonderful melodies still resonate with people.

"That's probably why I got so many good crowd shots, because I was buzzing off the atmosphere. And at Glasgow Green many of the

168 people were also on one, you can see it in their eyes. At first glance they can look really aggressive, but they're not because they are really feeling the love! Look at their eyes and you can see that their pupils are dilated, which makes them look like they are staring. It's definitely a picture of its time, capturing the chemistry of that era.

"People just enjoyed being together at this gig, something like
the festival experience today.
The drug going around at the time was ecstasy and since this wasn't
a professional commission, I decided to join in."

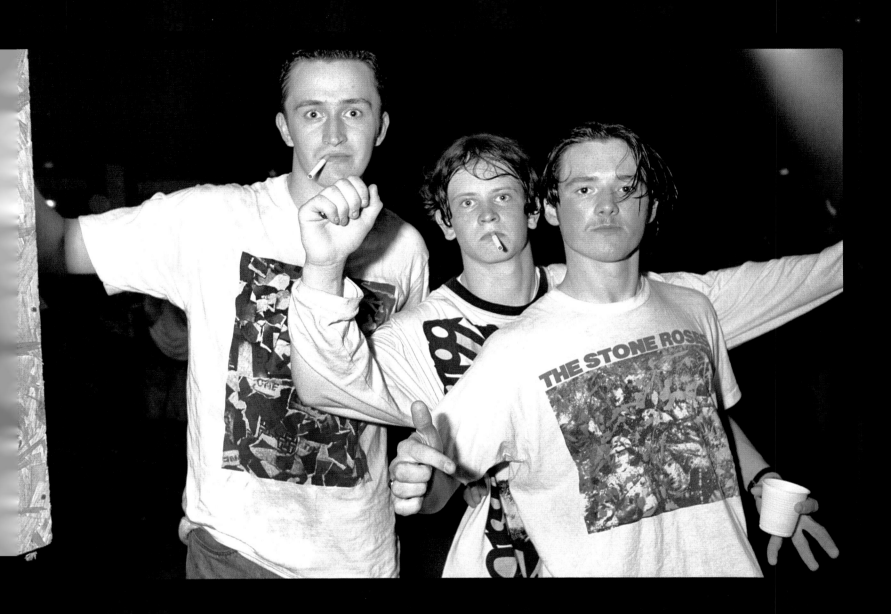

"When we got to the venue we found it was in a massive circus marquee, but bigger. It was the most enormous tent you could ever hope to see. It had stripes all over and a circus-like appearance, even though there were no clowns and jugglers! Looking back, it now seems very basic and there wasn't much razzamatazz or showmanship about the whole affair."

Ian explains that he recently discovered two rolls of black & white film that were previously unseen. "I have thousands of sheets of all the films I've taken over the years and earlier this year I took a look at the old negatives of The Stone Roses again. I discovered a couple of films that I'd long forgotten about. From the negatives I could make out loads of pictures of people wearing Reni hats and the Big Top circus tent at Glasgow Green. Well that felt really exciting and it turns out the photos are a fabulous document of fashions, Nineties style and youth culture. No one has been particularly interested in that side of things until now. Sure everyone has wanted to see my photos of the Stone Roses themselves but not particularly ones of the fans. These photos have now become a fascinating slice of cultural history. One thought that struck me is everyone was so young; there are some lads on there who look about 13 years old! Most people were in their

169

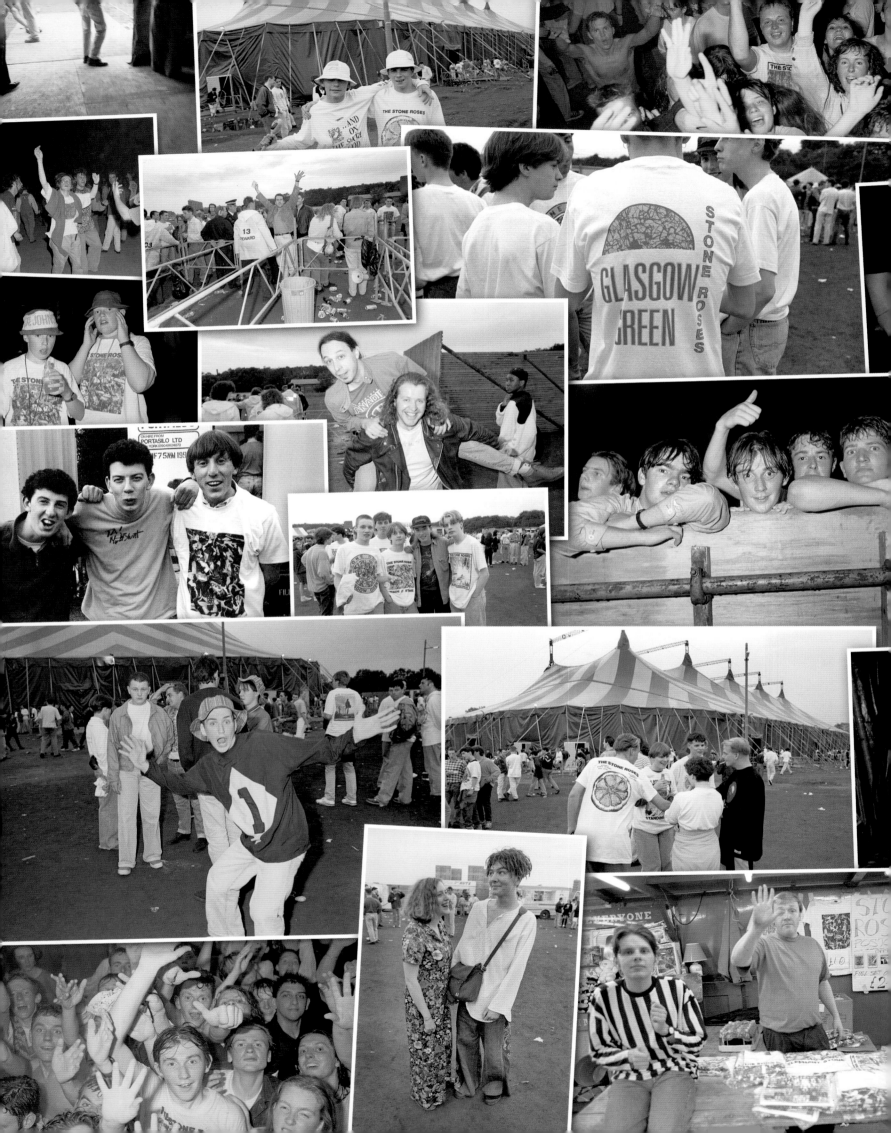

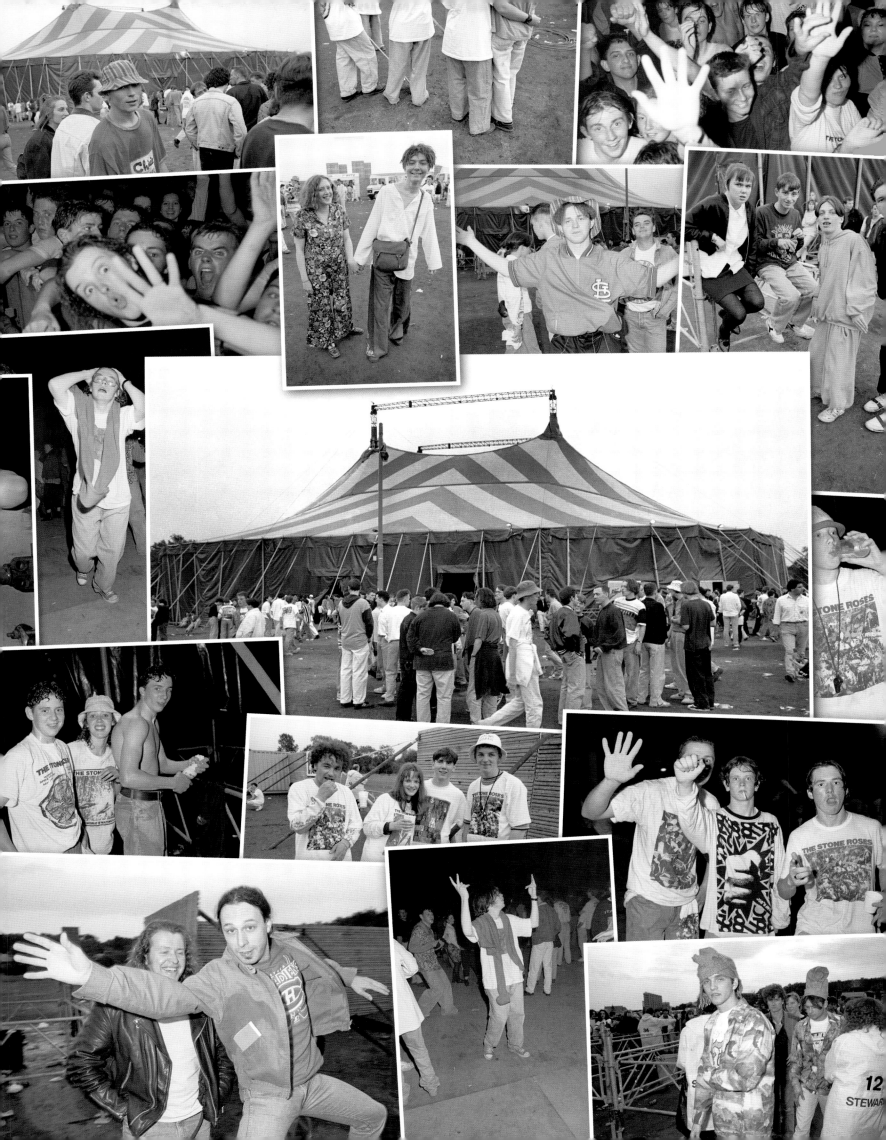

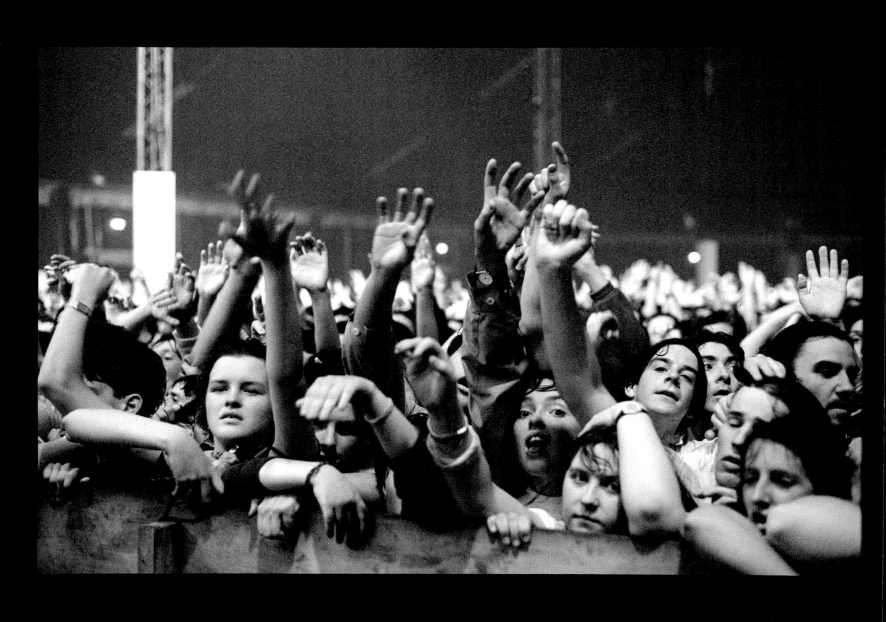

172 "I also got some great photographs inside the Big Top circus tent. I was down in the photographers' pit at the front. It was really unusual in those days to see the people in the crowd taking photographs at all. Nowadays everyone's got a digital camera or a camera on their phone and there are always dozens of arms stuck in the air shooting video or stills. But that was not the case in the Eighties and Nineties.

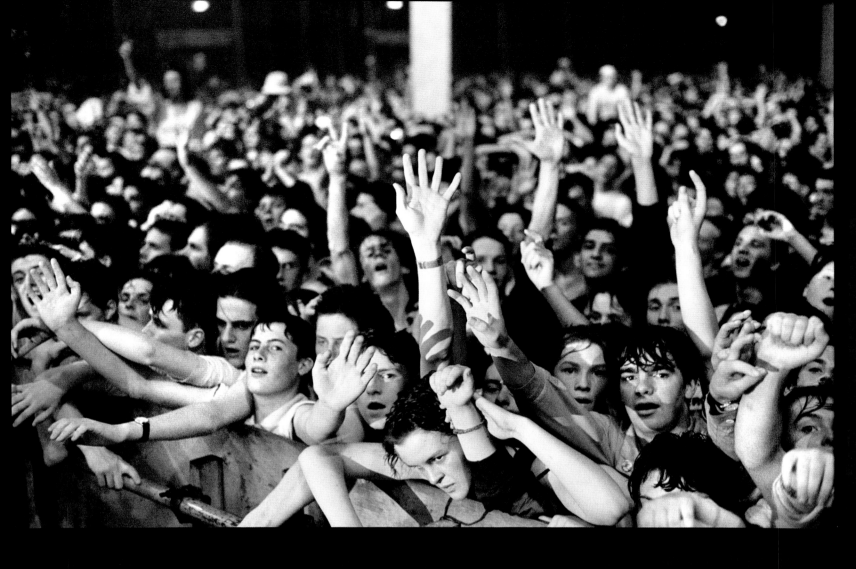

"Smile for the Sassenach! He wants a couthy grin!"

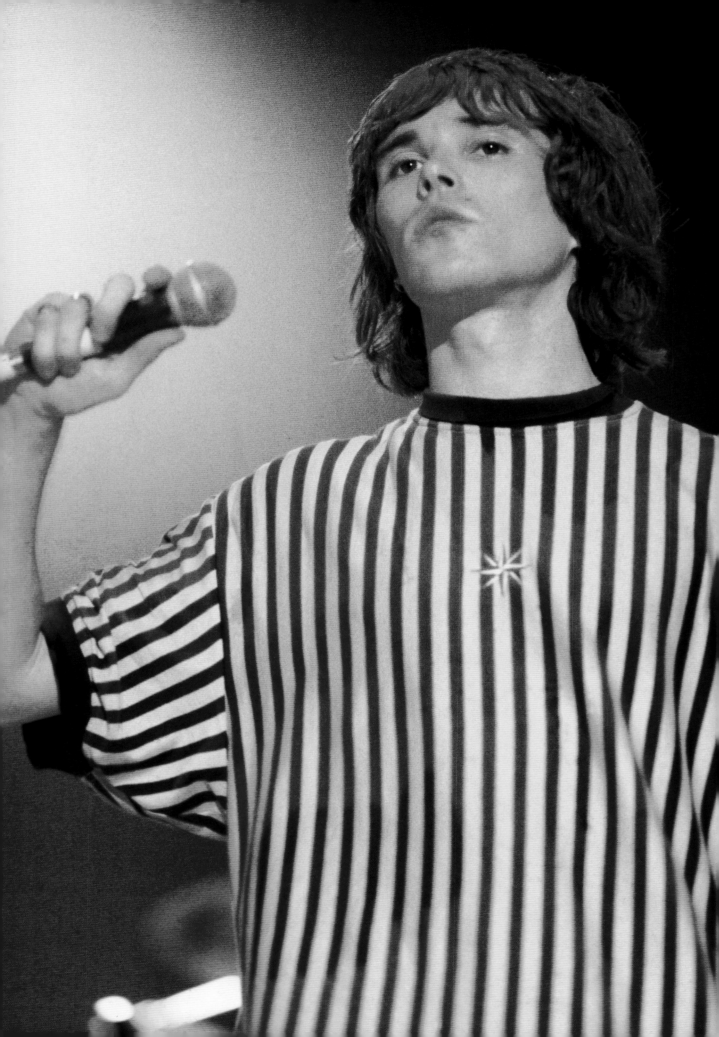

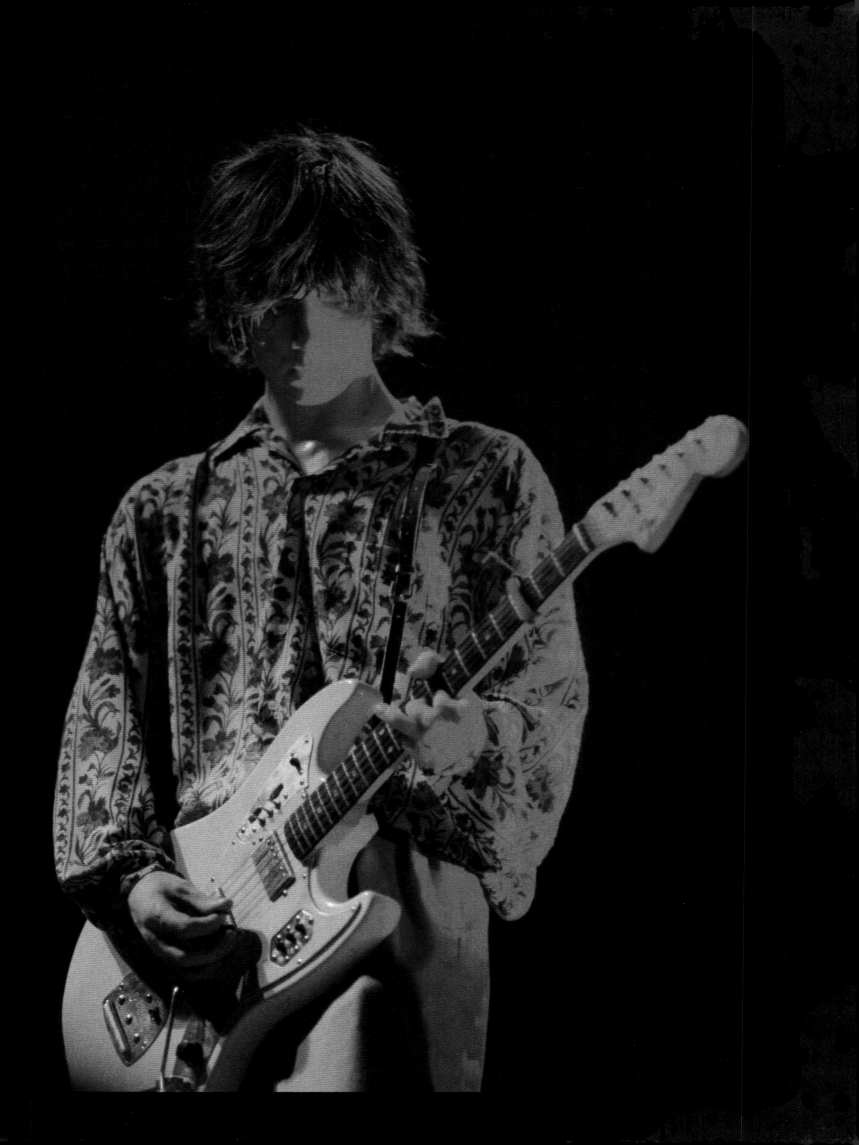

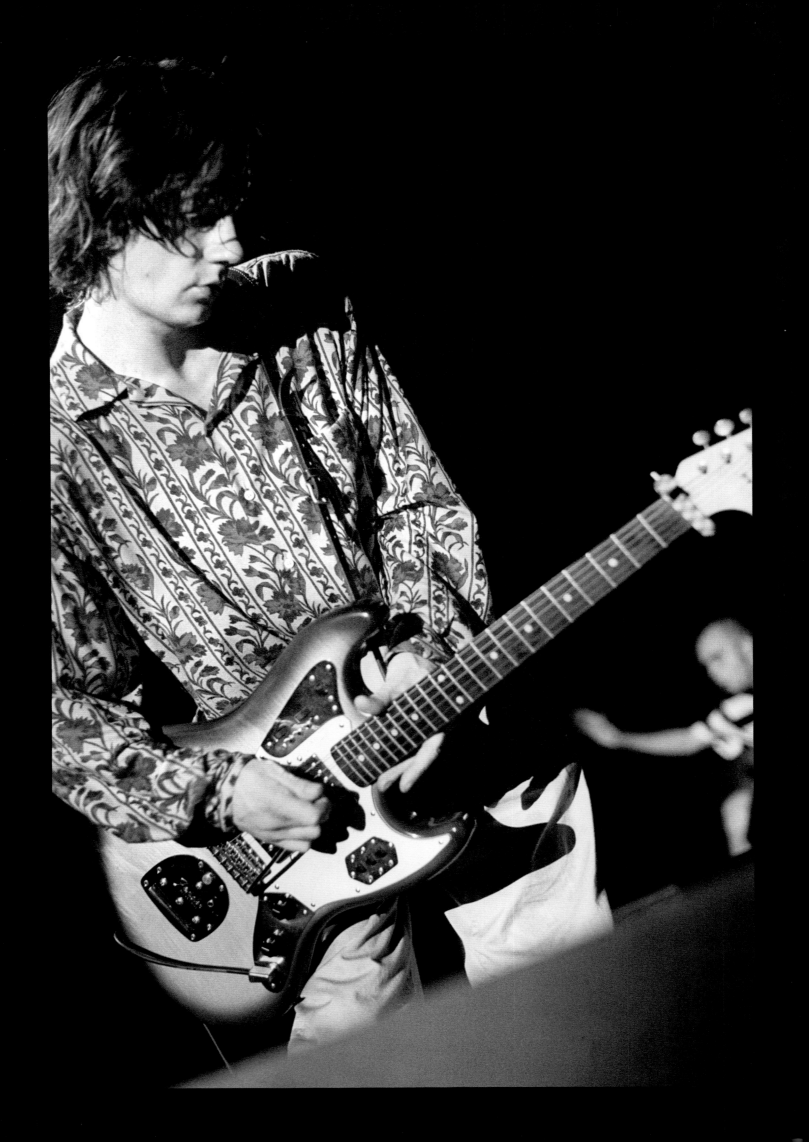

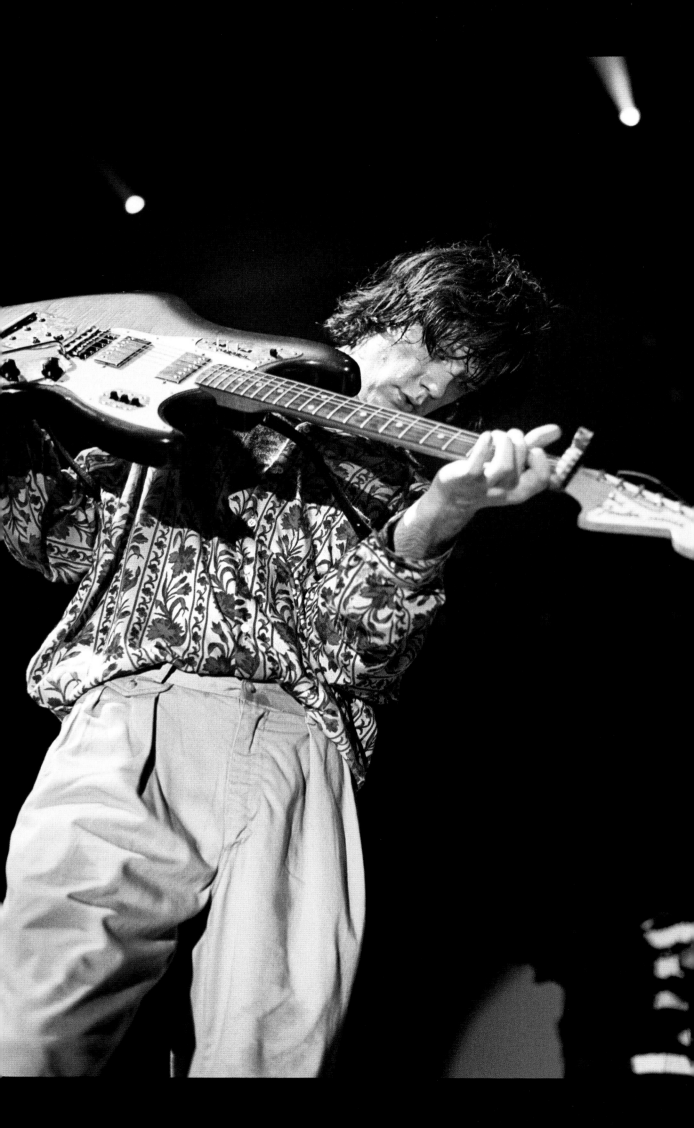

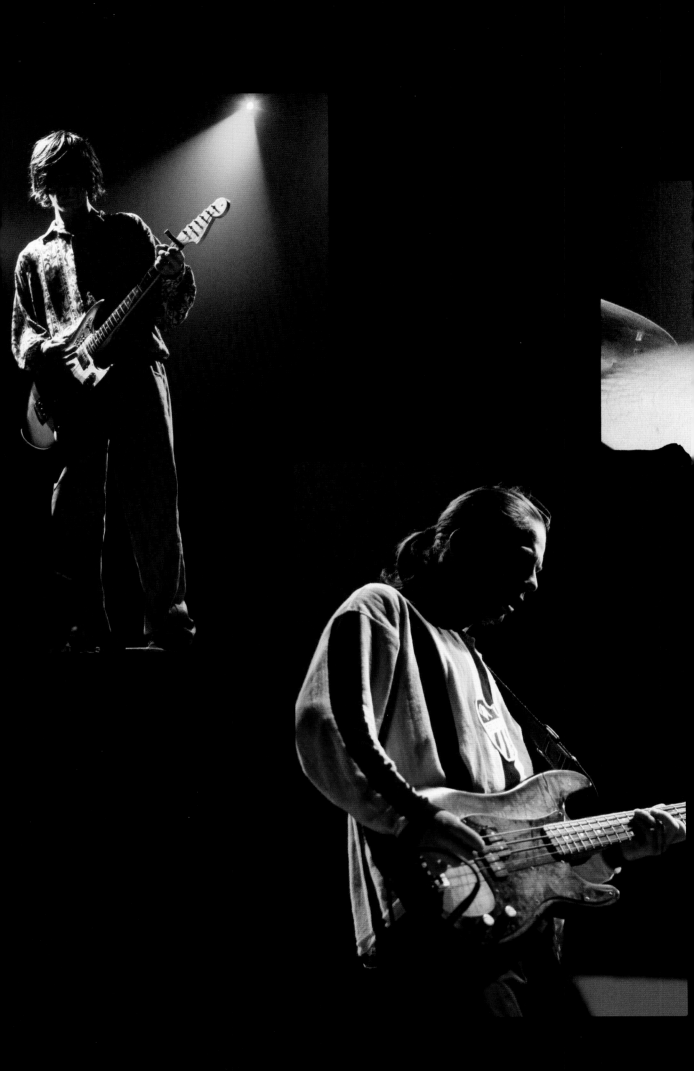

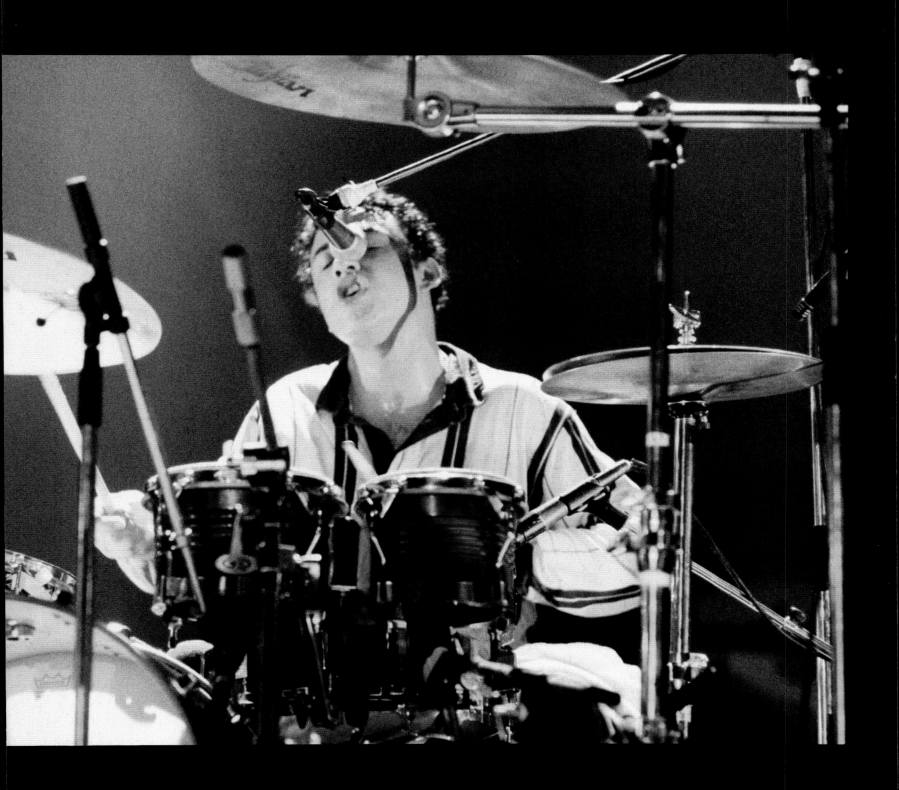

"Always entertaining and a joy to watch, Reni was a superb drummer.
Former Stone Rose Andy Couzens described him as being like 10 Keith Moons in one.
John Squire's poses are reminiscent of Jimmy Page, and his brilliant guitar on
the *Second Coming* album was a clear tip of the hat to Pagey's rock style.
But who could compare to the brilliant bassist Mani?"

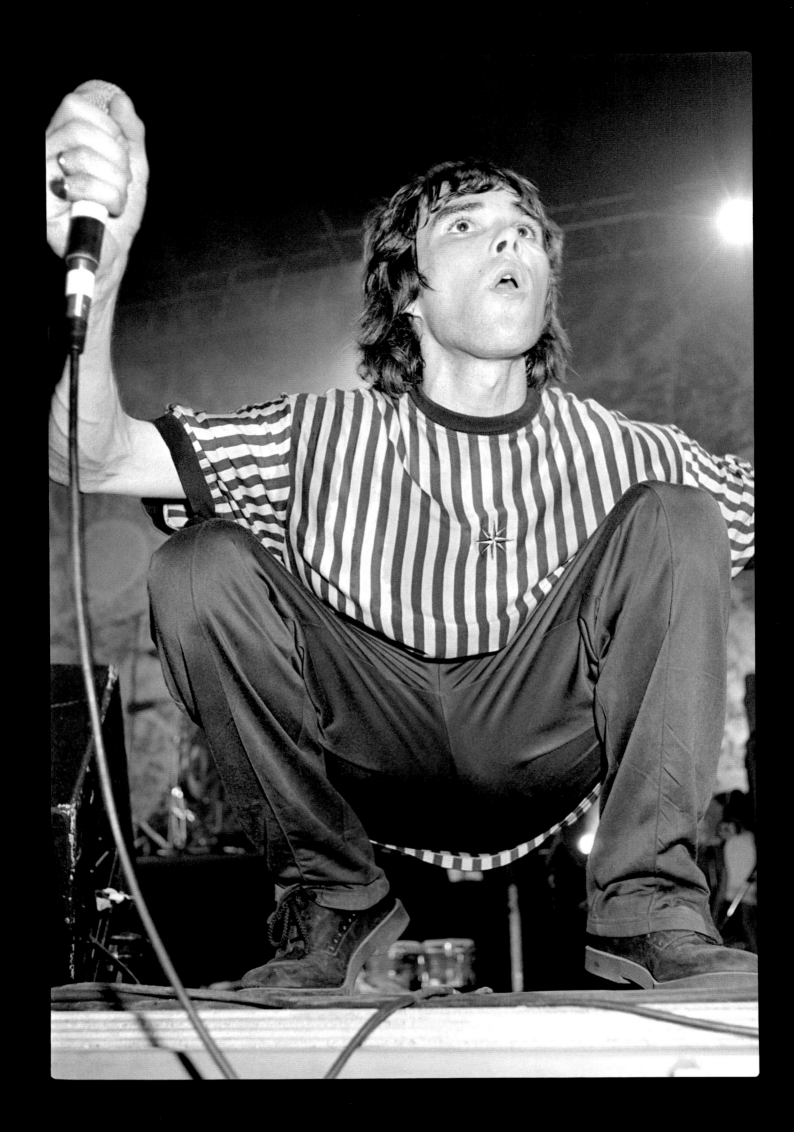

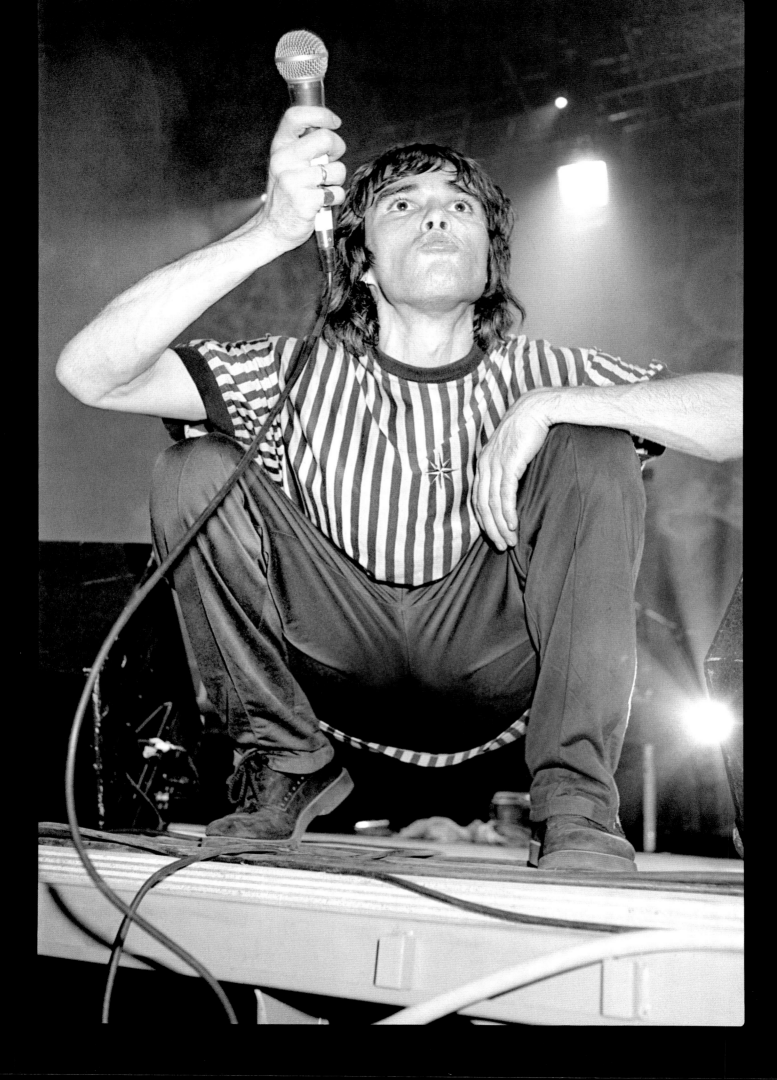

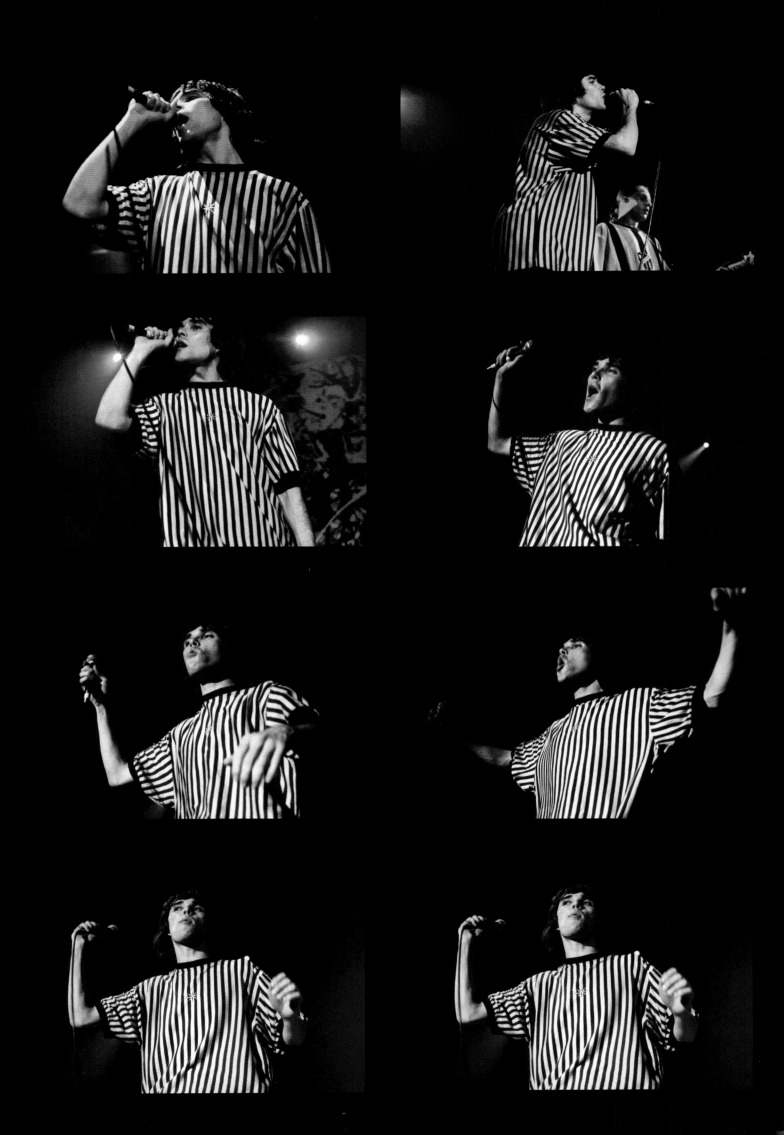

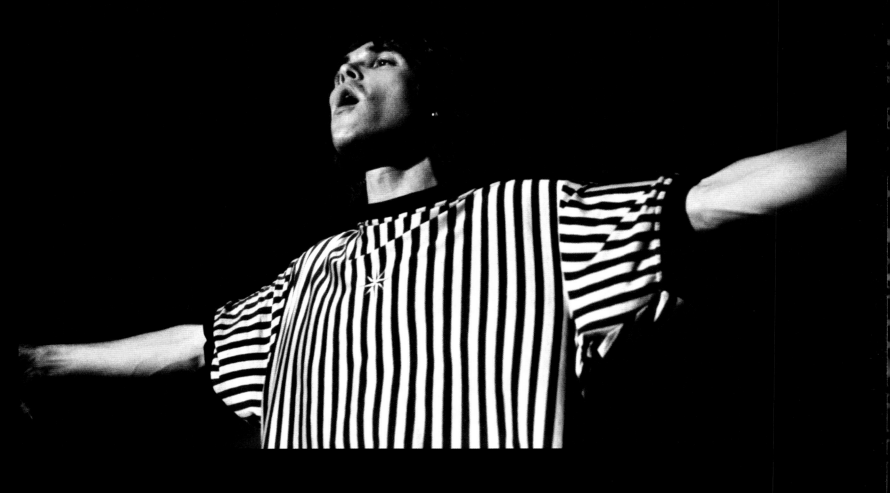

"Ian Brown: the resurrection and the light."

"After the gig the crowds melted away but we hung around to see what was happening. A group of us went to the Sub Club in Glasgow city centre, and Mani came too. I can't tell you how great the Roses played that night and I'd love to tell you how the Sub Club's after-party went, but I honestly can't remember. It's gone. A bit like the saying about the Sixties: 'If you can't remember it... you were there!'"

CHAPTER 16
THE SECOND COMING

"After years of inactivity everyone was excited when they learnt that the band were recording a new album. Ian Brown had been tracked down in Wales and his photograph appeared on the front page of the *NME*. It reminded me of Lennon's reclusive time in New York. Ian, like Lennon, had been enjoying the family life and time away from the cutthroat music world.

"Everyone, including me, speculated about their direction. Would it be more pop songs? Would it include some fantastic funky tunes? Or would it be radically different? And just why were they so secretive? Most people assumed that they'd simply been lazy and couldn't get their act together. They only granted one interview, to *The Big Issue*, and that article gave little away."

The plan for Second Coming's *launch was for HMV and Virgin on Market Street in Manchester to open their doors at midnight on the day of the album's release. It was even rumoured that one or two of the band would turn up.*

"So John Robb and myself, excited by the buzz and hoping that the band would be there, went, camera and notepad at the ready."

Hundreds of ardent fans queued up in the drizzling rain outside both shops. At midnight the doors opened and an excited crowd finally exchanged cash for their holy grail.

184 "Time moved on, it was one hour past midnight, and there was no show from the band. It reminded me of Reni not turning up at Victoria Station. The rumour wasn't true and the fans felt duped. The great ascension, the second coming, became something of an anti-climax. It felt like they'd missed an opportunity to give the fans something back."

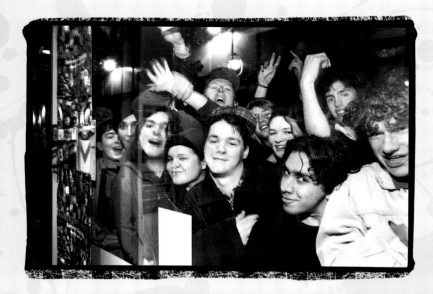

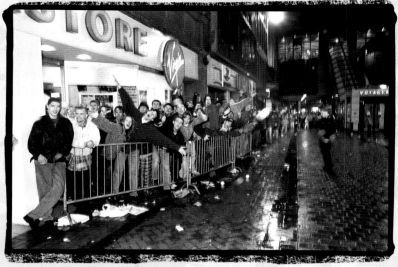

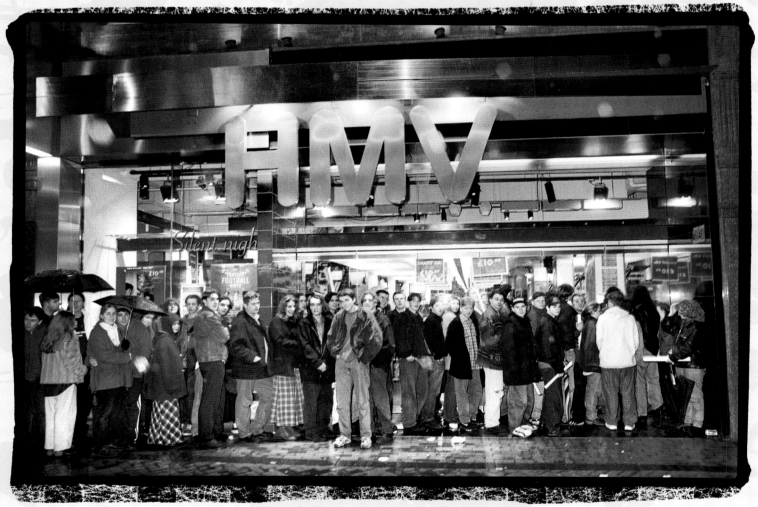

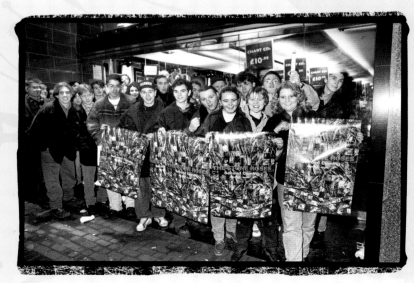

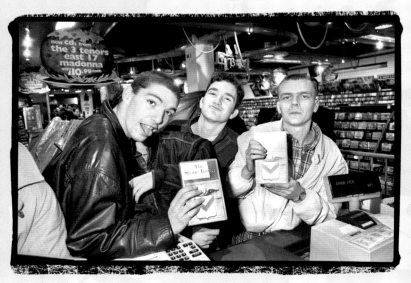

CHAPTER 17
THE Q SESSION

"Ian Brown took time out from rehearsals in
Stockport to be photographed by me for Q."

"This commission was for Q magazine. It was a one-page interview, with one picture needed. All pretty straightforward. I took colourama and lights to a big space where his band were rehearsing in Heaton Moor, Stockport, and set them up in a side room. Ian gave me a big hug, which I thought was nice after all these years. We chatted but didn't have too much time as he was working with the band. I remember thinking that Ian looked a little bit rough, but very happy. When he stepped in front of the camera I didn't have to prompt him. He just continued to be naturally chatty and cheeky. I took one roll of black & white and two rolls of colour film.

"I took the pictures pretty quickly at Ian Brown's request as he had to get back to rehearsals. A couple of days later I was watching the news and was shocked by the report that Ian had been arrested for air rage on a flight from Paris. There had been a few reports over the months of similar incidents and I immediately thought he'd been stitched up. I found it hard to believe he'd threaten someone in that way. He spent a few months in Strangeways for that.

"We met years later when a collection of my Haçienda photos were on show in an exhibition at Urbis Gallery in central Manchester, titled Haçienda 25 The Exhibition (FAC491). Again he greeted me with a hug and we touched heads just like he'd done with Cressa at Blackpool. Ian told me that he'd been set up. I could tell that the memory upset him, because he felt he'd been manipulated and made a scapegoat. Nevertheless, on the night of that exhibition Ian had been given some fantastic custom-made trainers by Adidas which had his name stitched in to them. He was really happy with them and walked off with a swagger and a smile..."

LET'S TALK TECHNICAL

For those of you who are interested in the process of photography we used to shoot on something called 'film.' You might remember it.

Back in the Eighties I would buy 35mm film in bulk rolls and load them into individual film cassettes, enough to take 36 'exposures' per roll.

I favoured Ilford HP5 for use in low light conditions, such as live gigs, and would set the film speed dial on my camera to 800 or 1600 ASA. For bright daylight photo shoots or when using flash studio lighting indoors, I would use Ilford FP4 or Pan F.

Still awake? Then please read on…

SHOOTING FROM THE HIP

For me the process of taking photographs and then making a photographic print was magical and mysterious. It's a fine balance between poetic interpretation and technical wizardry. I was always excited, even before the film was dry, to see what I had 'captured', despite all the contrary advice from photographic books telling me to be patient and wait until it has been washed. Once it was in the fixer, I just had to take a peek, partly to check the camera had been working properly and that I'd technically exposed it correctly. This was always an anxious moment for me; holding the spool of fixer-soaked film up to the light…

Once in a very blue moon something would go wrong – either from human error (never mine, of course) or a technical fault (or 'gremlin') – and then the emotions would be hard to cope with. It's fair to say I was often anxious as so many things could go wrong and the photographer was always required to come up with great pictures.

Mark E Smith of The Fall once called me "twitchy" because I was so nervous. The nerves weren't brought on by technical problems, but were entirely down to meeting one of my heroes. I'd followed him since the Seventies, before I'd even picked up a camera, and was consequently a nervous wreck.

I have happy memories of the great staff and freelancers at *Sounds* when Tony Stewart was editor. I was 23 when Tony gave me my first commission to work in America (my first time in an aeroplane even). He said, "Tilly, I don't want to put pressure on you, but if you come back from San Francisco and you've fucked this job up then we will have no front cover next week. There'll just be a blank page because we haven't got a back-up cover story. No pressure, mate." Yeah, no pressure eh, Tony?

Melody Maker commissioned a cover shoot from me in the mid-Nineties to celebrate Manchester DJs Mark and Lard (Mark Radcliffe and Marc Riley) securing the coveted primetime morning slot on BBC Radio 1. The gremlins were at work that day and the three films I shot turned out blank. A re-shoot was impossible, as they were on a flight to London and my deadline had ticked away. I was so anxious I puked, whilst the *Melody Maker* team frantically phoned round photo agencies for a suitable image of the northern DJs.

Digital technology has made life so much easier. You take the photo and can see if it's any good in an instant. Any improvements can be made straightaway – without any stress – before you perform the post-production magic in Photoshop. In the Eighties it would be hours, sometimes even days, before we saw the results. Scary. No wonder there were very few photographers back then – not many could take the heat.

MORE GEEK

When I turned professional in November 1985 I was using two Pentax ME Super camera bodies. They were very lightweight, which I liked, and their automatic film winders made them fast and spontaneous to use. Unfortunately this came at the expense of a robust build and I had to replace the bodies every 18 months as I wore them out! I replaced the ME Supers with the sturdier Pentax LX around 1987. I knew of only one other professional photographer who favoured Pentax above Canon and Nikon back then and that was the great portrait photographer Jane Brown.

In those days Pentax made some optically amazing lenses for the professional market, such as the 135mm F2, which contained heavy pieces of the highest quality glass and worked wonderfully under low light conditions.

Around 1992 I completely changed my 35mm camera system to the more versatile, albeit heavier, Nikon, favouring the F90 and eventually the F5 models.

CELLAR DWELLER

I converted the cellar of 191 Oswald Road in Chorlton-Cum-Hardy into a photographic darkroom, where I chemically developed, by hand, all the black & white films I had shot into negatives. I also developed black & white prints down there, in the comfort of my cosy, under-ground workshop, with an eerie red light on and rock music blasting through the speakers. Me or one of my assistants (I salute and thank you all for all your skill and great work) spent hundreds of hours developing thousands of films and prints over the years.

I built an eight-foot long bench against one wall, with a ceramic sink plumbed into it. It was here that we processed the films I'd shot, in light-tight Paterson developing tanks – up to six rolls of 35mm films at a time. We washed them in cold running water for an hour, then hung them up to dry from grey plastic Paterson film clips, suspended from the low ceiling. Excess water was carefully wiped from the film surface, using a very soft yellow chamois leather cloth, so as not to scratch the surface of the precious films.

Drying at room temperature took about two hours, and this stage was often hastened by careful use of a hand-held electric hairdryer. The long strips of negatives were accurately cut into shorter strips of six using sharp kitchen scissors, then slid or 'bagged' into clear plastic sheets to protect and store them.

They were then ready for the next stage, which was turning the negatives into positive image proof sheets on photographic paper, commonly known as a 'contact sheet'. This is a sheet of photographic paper which displays all the images from one roll of film. Its purpose is to help the photographer and the band to distinguish the cool photos from the 'turkeys'.

ALWAYS LOOK AT THE FINE PRINT

The favourites are then printed in the darkroom by focussing light through the film negative on to light sensitive photographic paper using a machine called a photographic 'enlarger' (mine was a DeVere M670).

The paper was then developed or put through a series of three trays of liquid chemicals to produce a handsome print. For me this process was satisfyingly absorbing and artistic, because choices are made at this stage concerning the overall contrast (how soft looking or how 'punchy' the print should be) and those areas to be made lighter or darker.

The mood, atmosphere or ambience of the photograph was controlled at this crucial moment. For example, skies and clouds can be made to appear darker and heavier by exposing the photo paper to the projected light for longer. This would be called 'burning' the skies in.

If, to take another example, someone's face needed to appear lighter, then the area would be exposed to less light by blocking it out using a 'dodger' (a piece of card stuck firmly to a thin handle of wire) held in one's hand.

This process is, not surprisingly, called 'dodging'. The paper, once exposed to the light through the enlarger, was then placed in the 'developer'. This was a shallow tray containing a developing liquid. The chemicals would slowly react with the exposed paper to gradually, over a period of about a minute, reveal a magnificent positive image, almost as if by magic! Well, that's the theory anyway.

In practice a successful print is achieved by trial and error, varying the amount of time the area is 'burned' or 'dodged'. Even though I was highly proficient, this process could require four or five attempts before I felt satisfied. The print then went into a tray known as a stop bath and at last a final one called the 'fixer', before being washed and dried.

Don't bother reading the following if you feel you're not interested in additional darkroom details. Those of you who thought you'd simply bought a coffee-table book of my Stone Roses photos have done well to read thus far. Congratulations!

The liquid chemicals had to be accurately mixed to the correct dilution and temperature for developing for the black & white photographic paper. I always used ILFORD paper, which had a high silver content, thus producing good rich blacks. The chemicals were poured into three large separate plastic trays, about three inches deep. The three trays of chemicals were then placed next to each other in the following order:

1. PRINT DEVELOPER: Kept at just above room temperature by being placed on a purpose-made Paterson heater, the same size as the chemical trays, ie 20 x 24 inches.

2. STOP BATH: To halt the chemical action of the developer and prevent contamination of print developer mixing with the fixer within the porous paper surface. The print would be ruined if this happened.

3. FIXER: To make the print image permanent and prevent it fading over the years.

The 'fixed' prints were then washed in cold water for a minimum of one hour in a large plastic, cream-coloured, barrel-like 'tumble washer'. If the fixer wasn't washed off properly, or for long enough, then the prints would turn yellowy-brown after a few months, and the image eventually faded away. So every stage was crucial to making a good print and preserving it.

ILFORD FP4 ILFORD FP4

23 23A 24 24A 25 25A 26 26A 27

BIBLIOGRAPHY

BACON, T — 50 YEARS OF GRETSCH ELECTRICS
Backbeat Books: San Francisco 2005

BEZ — FREAKY DANCIN': ME AND THE MONDAYS
Pan MacMillan: London 1998

CHAMPION, SARAH — AND GOD CREATED
MANCHESTER
Wordsmith: Manchester 1990

GATENBY, P & GILL, C — THE MANCHESTER
MUSICAL HISTORY TOUR
Empire Publications: Manchester 2011

GODFREY, J *(edited by)* — A DECADE OF i-DEAS:
THE ENCYCLOPEDIA OF THE 80s
Penguin Books: London 1990

MIDDLES, MICK — BREAKING INTO HEAVEN:
THE RISE AND FALL OF THE STONE ROSES
Omnibus Press: London 1999 & 2012

PILCHER, TIM — E: THE INCREDIBLY STRANGE
HISTORY OF ECSTASY
Running Press: London 2008

ROBB, JOHN — THE NORTH WILL RISE AGAIN
Aurum Press: London 2009

ROBB, JOHN — THE STONE ROSES AND
THE RESURRECTION OF BRITISH POP
Ebury Press: London 1997

ROBB, JOHN — 'LINDER: INTERVIEW WITH
THE GREATEST ARTIST FROM THE PUNK GENERATION'
*http://louderthanwar.com/linder-interview-
with-the-greatest-artist-from-the-punk-generation*
Louder Than War: 2011

RYDER, SHAUN — TWISTING MY MELON:
THE AUTOBIOGRAPHY
Transworld: London 2011

SHAPIRO, HARRY — WAITING FOR THE MAN:
THE STORY OF DRUGS AND POPULAR MUSIC
Helter Skelter Publishing: London 2003

Cut magazine article available at:
www.thestoneroses.co.uk/press/cut-july-1989

IAN TILTON

Ian Tilton is a professional, award-winning photographer with over 30 years' experience. After losing his hearing at the age of 14 Tilton studied to become a photographer, refusing to let his hearing difficulties get in the way of pursuing the creative career he desired.

Based in the north-west of England, he began his career in the Eighties, taking photos of bands as diverse as Nirvana, Guns N' Roses, Iggy Pop, The Smiths, The Stone Roses, The Happy Mondays, James and Oasis. He has since spent years shoving himself in front of the loudest rock 'n' roll speakers in the world and in the process captured some of music's most iconic moments. He was the first European photographer to shoot Nirvana and his picture of an exhausted and tearful Kurt Cobain in Seattle was hailed by Q as one of the six best rock photographs of all time. His photo of The Stone Roses' frontman Ian Brown with an orange in his mouth has also gone down in rock photography legend.

Ian Tilton comprehensively documented the famous Manchester club the Haçienda and his colour shots of the interior, alongside fantastically atmospheric photos of the club in full swing, capture the design and excitement of that legendary place.

His images have been published in numerous books and exhibitions on The Stone Roses, Guns N' Roses, Nirvana, The Charlatans and Manchester music, and he's undertaken many commissions for Sounds, Select, Melody Maker, Mojo and Q.

Today Tilton retains a strong interest in music photography and is also an acclaimed theatre photographer. He also enjoys promoting and working in the fields of disability and mental health and is a qualified counselor and personal assistant.

Tilton has stated that he's determined that his deafness was and never should be an issue. Life is about what's possible – not about disability.

CLAIRE CALDWELL

As a teenager growing up in the north-west of England, Claire immersed herself in the acid house and Manchester rave culture, developing a particular love for The Stone Roses, The Smiths, Happy Mondays and Primal Scream. Her bedroom walls were adorned with band photos, which included Ian Tilton's work from such magazines as Select, Sounds and Q. She has worked as a photography stylist, script editor and film-maker in the UK and Bollywood, Mumbai.

Claire is also a specialist in drug abuse and substance misuse and has worked as an outreach worker and mentor for disadvantaged young people. She is currently finishing a degree in Occupational Therapy at the University of Cumbria, specialising in Mental Health. Claire also writes music articles for the online magazine Louder Than War.

She loves being a mum to her young son Zac and together they dance every day to his favourite tunes by, not surprisingly, The Stone Roses and Gorillaz.

THE STONE ROSES

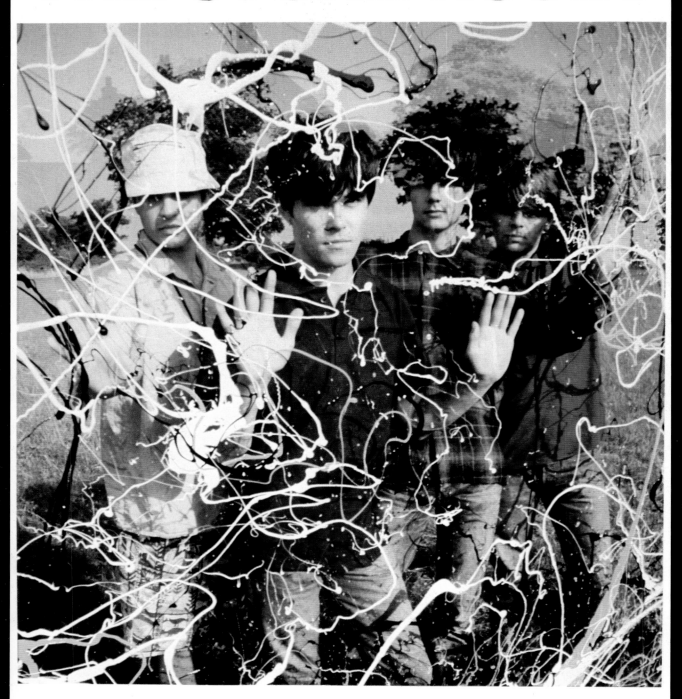

ELEPHANT STONE

NEW SINGLE ON 7″ (ORE 1) AND 12″ (ORE T 1)

PRODUCED BY PETER HOOK SILVERTONE RECORDS PHOTOGRAPHY BY IAN. T. TILTON